D0634544

LOVE DOG

MASHA TUPITSYN

PENNY-ANTE | EDITIONS

PENNY-ANTE EDITIONS
PO Box 691578 Los Angeles CA 90069 USA

Success and Failure Series
Catalogue No. PA-012

This is an art object.
Edition size: 800.

978-0985508548

SCREEN images captured by Masha Tupitsyn.
PHOTO images by Masha Tupitsyn.
All other images provided by the author.

© 2013 Masha Tupitsyn.
Printed in the United States of America. No part of this object
may be used or reproduced in any manner whatsoever without
written permission from the author, except in the case of brief
quotations embodied in critical articles and reviews.

Cover/design by Rebekah Weikel.

For my mother and father, true lovers.

TABLE OF CONTENTS
PART I—PATIENCE

Note to reader: This book is polyphonic. It should be read, listened to, and watched.

"Recently I've sensed an accumulation of many things which cannot be expressed by an objective form like the novel."

YUKIO MISHIMA

"These are the days of my romance."

KATHY ACKER, *Don Quixote*

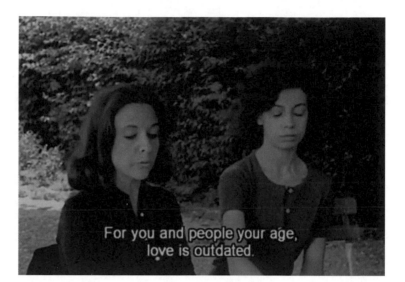

For you and people your age,
love is outdated.

▪ **IMAGE**
Claire's Knee (1970), Eric Rohmer.

For months *Hamlet* has been floating around. Its book cover popping up everywhere. Non sequitur references during my classes with Avital Ronell. In other texts. In my letters to Elaine and in her letters to me. The other night, in my laundry room, someone left a copy on a shelf of donated books. On tables at work. I even stole one copy and took it home with me as a token, as proof.

▪ PHOTO
William Shakespeare's *Hamlet*.

Ronell says, "In *Hamlet* readiness is all" and "All of *Hamlet* happened in the ear." A few weeks later, Žižek came to Ronell's class and said that *Hamlet* is about the way the beginning of ethics is trying to decide something and decision always involves indecision and procrastination. How an act always comes both too early and too late, so there is never really a "right"moment for an act. One begins with the wrong moment because it is always the wrong moment.

A few days ago, Elaine sent me a quote by John Berger:
"In the minute that's still left we have to do everything."

The day X. came to class Ronell brought up *Hamlet*, again, and suddenly all the ghosts had a name, making them real. I couldn't believe my ears. Yet even though we were finally in the same room together, how can you know what someone hears—(what X. heard)—when we never really know this about anyone.

When I asked a female acquaintance at the bar we were at if she thought X. had heard what I said under my breath the night we were together, she answered: "He doesn't *need* to hear you. He *knows*." The question is, how did *she* know? When I mumbled something cutting to him as he went outside to smoke a cigarette, taking a risk by saying anything at all, he asked me to repeat what I'd said. I pretended I hadn't said anything and he pretended he didn't hear anything. Denial is one of the ways cognition works. *You're just hearing things* and *You're just seeing things* are both spectral idioms. They are about the ghosts you see and hear as well as the ones you pretend not to see or hear. The spectral interrupts ordinary reality, puts you somewhere else. Somewhere interstitial. Somewhere you can't prove.

There is what you see. There is what you don't see. The knowledge that crawls into you. Knowing even when you don't know.

Hamlet is also about a self-naming dog and so am I. It's important to make a name for yourself in a world that calls you names.

When your name isn't called and other people's names are.
When you don't even want your name called.

I walk around foraging for a heartland that almost only exists in movies now. Movies, which have taught us to be cynical idol worshippers, as much as they have taught us to believe in love. I

now find myself running to movies more and more because in movies things still matter. People still matter to people. Love still matters, and readiness is all. In the movies, the world is still held together by more than just a string.

• **PHOTO**
Jean-Jacques Rousseau's
Reveries of the Solitary Walker.

The Hamletian stance: You don't let go of your object.

Of course you are a fool for not letting go in the 21st century, which is all about not holding on and always letting go.

A text can be a recurring dream. A ghost. A sound in your head like an alarm in your heart. The Great Dane that knocks Rousseau down and sends him careening in the Second Walk of *Reveries of the Solitary Walker* is also Hamlet, another Great Dane, Ronell says. By the time she said this on the first day of class (a class on the Debilitated Subject), I'd already been thinking about the relation between X. and *Hamlet* for weeks.

Ronell:
"If something is meant to happen, and it has the power and weightiness of destiny, then it's no longer chance or an accident. It's destinal… Rousseau's physical harming is only secondary to the mutilation of his texts. He's in the air when he falls—in a ghost-like pose." In Rousseau's case, the unforeseen is something that breaks off with destiny and destination.

The Strokes ("Take It Or Leave It"):
I fell off the track, now
I can't go back
I'm not like that.

You, X., have become a book. The person for whom I read everything now and will write this year, making the "you" into a world (the you that came into mine)—an Event. I think all I've ever wanted to do is rise to an occasion, to answer a call.

The you will make this a love letter at times, or all the time. It will be a form of address. The you will make this intimate—you, close—but will also refer to the you that is never here and might never be. The you I am dreaming of. Calling forth. Writing to and for a you will make it easier to write. I need an imaginary person on the other side of the page—for a speech act, which is always for the Other. You. Both X. and not X. I need an *addressee*—someone to whom I write, and just one is enough—because everything I write is really just a letter to One. Elaine and I talk about this all the time, as we write letters to each other.

To whom do you tell things and to whom do you not tell things? The Web has collapsed all of these distinctions, making the reader—the intimate—anyone, everyone, and no one all at once. It also collapses the where and when of writing. Sometimes even the why. In the end does it matter if the you to whom you are writing, to whom you are dedicating, and towards whom you are

moving in order to become, never or always hears us? I don't know. There are different kinds of presence and absence. Silence and testament. Now disappearance and silence are tied to failure. But writers used to disappear all the time. Lovers too. ▪

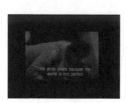

▪ **ANDREI TARKOVSKY**
Andrei Rublev (1966)
CLIP: "Tarkovski on Arts, Solitude and Life"
TEXT: *The artist exists because the world is not perfect.*
LINK: http://youtu.be/-BsV57JJ_bM

11 23 2011—OH, TO BE IN LOVE, AND NEVER GET OUT AGAIN

▪ **KATE BUSH**
Oh To Be In Love (1978)
LINK: http://youtu.be/YXeHBGgMMRs

Oh! To be in love,
And never get out again.
–KATE BUSH

11 28 2011—"I AM THE MAN" (ON LOSER KIDS)

Even when we act like adults—like men, like women; even when we claim not to need anyone; that love is liquid and dissolves; that we have nothing to be sorry for; no one to be sorry to; that we can be in rooms by ourselves or with many others; that everything and everyone is replaceable—we can't shake off the profound dependency of childhood. How much we need. How much we've never gotten over needing. How we spend our entire lives trying to shake off our dependencies. Our obligations to others. The way we started out.

Little kids acting like adults. Adults acting like little kids. Bodies at the wrong time and place. Bodies with the wrong people. Bodies too soon and too late. Time all scrambled up. Time at the wrong time. ▪

▪ **JOHN CASSAVETES**
Gloria (1980)
LINK: http://youtu.be/8ATjBGUtZQA

▪ **CARLOS SAURA**
Cria Cuervos (1976)
TEXT: *I can't go on!*
LINK: http://youtu.be/GA7apyYvsE8

When asked about his 1976 film *Cria Cuervos* (*Raise Ravens*), the Spanish director Carlos Saura said:

"*Cria Cuervos* is a sad film, yes. But that's part of my belief that childhood is one of the most terrible parts in the life of a human being. What I'm trying to say is that at that age you've no idea where it is you are going, only that people are taking you somewhere, leading you, pulling you and you are frightened. You don't know where you're going or who you are or what you are going to do. It's a time of terrible indecision."

· CARLOS SAURA
Cria Cuervos (1976)
LINK: http://youtu.be/HpGv5NL3x8A
TEXT: *And the heart*

· SCREEN
Hamlet (1948), Laurence Olivier.

As I wrote in my first post, in class Slavoj Žižek stated that: "*Hamlet* is about how the beginning of ethics is about trying to decide something, and deciding something involves procrastination and oscillation. Going back and forth. How an act always comes too early. How there is never a right moment for an act. The paradox is you can be too late and too early for something at the same time. So you have to begin with the wrong moment because it's always the wrong moment and it will always be the wrong moment."

According to Wikipedia, the title *Cria Cuervos* comes from the Spanish proverb, "Cría cuervos y te sacarán los ojos." "This translates as, 'Raise ravens, and they'll take out your eyes' and is generally used for someone who has bad luck in raising children, or raised them badly. It may also imply rebellious behavior or that every bad act will return to haunt you."

In *Cria Cuervos*, fascism is the ghost that haunts not just the house of the film, but the house of being. The mother is gone. And the father, a fascist military man, dies while making love to another woman. His heart stops.

What decisions do you have to make in order not to die? In order to really live? To not walk around as though you are dead? Hamlet paces back and forth trying to decide.

After Elaine sent me a quote by Victor Shklovsky this morning on "love being a play with short acts and long intermissions," I wrote back and compared theatrical intermissions to cinematic time-jumps. In film, time-jumps are the lapse in time between people (most often lovers) and events. Often the lapse in time, the duration, is noted at the bottom of the screen.

Elaine responded: "Yes—the intermission as time-jump and time-jump as intermission. The intermission in a play, too; intermission in *Hamlet*. And how Hamlet is himself in a kind of intermission or entr'acte, between the acts, hesitating, about to act but not yet…"

When I was little, I couldn't wait to get older. I felt as though everything was decided—

controlled—and I hated going to school. Now, I feel that everything is decided—limited—in adulthood, and often miss not childhood per say, but its total undecidability. The way so much is left open. The way everything could still happen. The way that's the point.

I want the reason this love didn't happen to be because you are between acts, "hesitating, about to act but not yet." I want it to be because you, X., are trying to decide. How to really live, and therefore, maybe, how to really love. ▪

II 30 2011—WHILE YOU ARE AWAY (WOMEN OF THE SAGAS)

▪ BJÖRK
Unravel (1997)
TEXT: *Unravel*
LINK: http://youtu.be/G4Qe5K7UV_0

I felt my heart, and now my heart will burst…

▪ **THE CLASH**
Long Time Jerk (1982)
LINK: http://youtu.be/yfTJQ-GQX48

The Clash sing in this song (the B-side on the EP "Rock the Casbah," 1982) that I'd never heard until this Thanksgiving, while I was away in Riverside, NY.

Staying with friends of friends in a little beach house that hangs over the ocean, which I could hear while I slept. I could probably live here, I thought. Write here. By myself. Write all the time, with no interruptions. Maybe not come back for a while.

▪ **PHOTO**
Riverside, New York.

I could do it because my heart is bursting, and also when it isn't. And when it isn't, I almost wonder if something is wrong.

We watched *The Wizard of Oz*, which all the adults loved and knew better than the kids. One woman knew all the lines. When the Tin Man's solo—"If I Only Had A Heart"—came on, I was bursting like I've always wanted to burst when I hear him croon the words: *When a man's an empty kettle / He should be on his mettle / And yet I'm torn apart.*

▪ **VICTOR FLEMING**
Wizard of Oz (1939)
CLIP: "If I Only Had A Heart"
TEXT: *Regarding love and art*
LINK: http://youtu.be/6aE-nMS9Mnk

It's the Tin Man's buttery voice and old show-biz accent, how smooth and free of rust it is. It's the obvious fact, of course, that all four of them want what they already have so much of. It's also the way the Tin Man tells Dorothy: "Now I know I've got a heart, 'cause it's breaking" when she says goodbye to everyone and goes back to Kansas. It's the way they all say goodbye. The way they thank each other for things. For everything.

I danced to "Long Time Jerk" in these people's living room. Guests took turns changing the 10 EPs on the record player. One song per album. Or two, if we played both sides. But often B-sides are better than A-sides. B is A's well-kept secret. That's what "Long Time Jerk" is. It's the jerk that's always been there, the B to the A. The jerk in someone sweet and someone sweet in the jerk. The jerk that makes your heart combust. That jerks you around. That plays you like a broken record. Like a nightmare you've grown used to and that's grown comic. And then the song itself is also out there and clownie (the word "jerk" even has roots in American carnival slang). It sounds like some kind of reggae, country, punk-polka.

Playing records for two days, after I had just written about listening to vinyl in my radio monologue for Performa. The way a record crackles and trips—imperfect—alongside a song.

Joe Strummer's voice is like the Tin Man's. Even when Strummer was shouting in punk songs, his tough, flippant voice always sounded so vulnerable and impassioned, like it could crack at any moment. The jerk in his voice was so sweet. Then Strummer's voice stretched wide open in The Mescaleros.

▪ **PHOTO**
Driving into Manhattan.

Although I couldn't see the ocean out my window in bed at night (no moon), I could hear it playing in the dark. I think I slept well and came back more tired.

I saw this view of Manhattan as we drove back to the city and then I walked home by foot. ▪

If you play all the clips at once, after you've watched each clip on its own, you will hear the way the music (sound) from each film (*Lancelot* at 2:03; *Joan of Arc* at 3:19; *Walker* at 0:07; OWS beating at start) works together. Overlaps and folds into each other, creating a diegesis.

One long song about the world. ▪

▪ **CARL DREYER**
The Passion of Joan of Arc (1928)
LINK: http://youtu.be/8CV5KFMygkM

▪ **ROBERT BRESSON**
Lancelot du lac (1974)
LINK: http://youtu.be/dwzMjBDA8X0

▪ **ALEX COX**
Walker (1987)
LINK: http://youtu.be/GKn_2ptJvV0

▪ **OCCUPYTVNY**
Occupy Wall Street, November 17 (2011)
LINK: http://youtu.be/xFlpAqZJGYQ

If I say anything about this song, it will be too much because the song is already too much. An excess. A deluge. But The Flamingos' "I Only Have Eyes For You" is quite possibly the most romantic and intense love song ever written. When you listen to it, it stops time and time stops. Or: it extends time, drops you into it. Stretches it and melts it around these two people, whoever they are.

▪ **THE FLAMINGOS**
I Only Have Eyes For You (1959)
LINK: http://youtu.be/MCPHXt2Q_iA

I used to tell my ex, W., who was very romantic and a great dancer (I've always wanted a boy-friend who could dance with me), that my dream was for someone to ask me to dance to this song. But I guess I'd have to be living in the late 50s, early 60s, for that to happen. All the times that I have seen it happen, it's been in retro-movies about the 1950/60s, like *Peggy Sue Got Married* who, as the trailer states, "disappears in time," which is what I imagine the lovers who dance to this song do. They get lost. They go somewhere else. They stand still with each other. In the thing between them. For the song is literally about something and someone being in time with you. Being an everywhere for you.

The lyric: "You are here and so am I" sums up the song's acutely subjective temporal moment. It means: I can't see anyone but you, and I won't. I don't want to.

Enough is enough. ▪

"I remember what should be remembered."

In the opening scene of *Days of Being Wild*:
He comes in for the third time, after he's told her that she will see him in her dreams, and asks her why her ears are red? I think: why is this whole movie red? And green. Green tinted (made green) and truly green (the jungle, the trees). Green like Robert Bresson's *Lancelot du lac* and Hitchcock's *Vertigo*. Red like *Marnie*. But parts of *Days of Being Wild* are shot like *The Third Man*, only all the shadows on the narrow streets are green. Outside, the angles belong to that noir. It's overwhelming to see these two colors together like this in one movie after everything they have meant to me the past few months. Maybe always.

· WONG KAR-WAI
Days of Being Wild (1990)
LINK: http://youtu.be/5A4P6YAl3Uc

· SCREEN
You'll see me tonight in your dreams.

She's embarrassed. Embarrassed because she is excited, so she can't look at him. I like people, no *love* people, who take looking and being looked at this seriously.

He tells her: "Look at my watch."
He is standing so close to her.
She says: "Why should I?"

At the party up in the mountains, out of sheer frustration I took your (X.) watch and put it on my wrist and you took my watch and put it on yours. All we could do was wear each other's time. You were so callous that night. You actually looked pissed off when I walked in. It was late and I showed up with another man. At some point, you asked if you could try on my watch. Actually, no one *asked*. It was more like we both just suggested it at the exact same time and all of the sudden we were both taking our watches (not our clothes) off and putting each other's watches on. Why? To see how they would *look*? A watch is a weird thing to borrow and time is a weird thing to trade. But that's what we did: we handed each other's watches over to one another and wore each other's time in front of everyone like wedding bands. Even though we weren't together. Even though we weren't even talking.

He says: "Just for a minute, okay?" She looks at his watch.

We can hear the big clock on the wall ticking. Beating. But it's the time around his wrist that changes everything. He moves closer to her. It is 3 o'clock in the afternoon. It was 3 o'clock the first time, too.

She says: "Time's up. What now?"
He asks: "What's today's date?"

She says: "The 16th."

He says: "Yeah, April 16th, 1960. One minute before 3. We were here together. I'll always remember that minute because of you. From now on, we're one-minute friends. It's a fact. You can't deny it. It's already happened."

• SCREEN
He'd remember me forever because of that minute.

He stares at her and tells her: "I'll be back tomorrow."

It always looks like he's about to kiss her, but that's because he already is. Because their desire for each other is already in motion, the kiss is already there between them. There all along.

• SCREEN
Watching time.

In voice-over, she asks: "Would he remember that minute because of me? I don't know. But I remembered him. He came back every day after that. We started as one-minute friends, then 2 minutes. Soon we were spending an hour a day together."

Clocks hanging on walls. Cleaning clocks. Their tick-tock. Watching time. Telling time. Sharing time. Counting the minutes, the days, the women. Is she really the only one as far as time is concerned? When she asks him, he tells her he won't know which woman mattered to him the most until his life is over.

But some people don't need to wait until the very end to know who or what matters to them most. Some people don't need time. Some people know all along. When I told a friend about how you (X.) couldn't let go of someone you once loved, and still claim to, she said knowing that should make me "sick." "It means he doesn't know how to let go," she said.

Why isn't loss allowed to feel like loss anymore? Why does everyone want to let go and be let go of so badly?

When the policeman in *Days of Being Wild* tells Maggie Cheung to forget about Leslie Cheung "starting this very minute." She screams: "Don't mention 'this very minute'!" And then a giant clock strikes midnight.

"I used to think a minute could pass so quickly. But actually it can take forever. One day a guy pointed at his watch and told me he'd remember me forever because of that minute. That sounded so sweet. But now when I look at that clock, I tell myself I have to forget that guy starting this very minute."

In her film *ENVOI*, Elaine Castillo splices Wong Kar-wai's *Happy Together* with *Days of Being Wild*;

looping one scene from each movie, and then the two scenes, from the two films, creating a diegesis of loss that recalls "The Other's Body" from Roland Barthes' *A Lover's Discourse: Fragments*:

"1. The Other's body was divided: on one side, the body proper—skin, eyes—tender, warm; and on the the other side, the voice—abrupt, reserved, subject to fits of remoteness, a voice which did not give what the body gave. Or further: on one side, the soft, warm, downy, adorable body, and on the other, the ringing, well-formed, worldly voice—always the voice."

Happy Together is almost entirely about the other's Body and the other's Voice. In *ENVOI*, Elaine blows the voice and the body up like a still photograph. Tony Leung dispatches his voice (grief) into Chen Chang's tape recorder in order to

▪ SCREEN
Do you bring girls home often?

▪ SCREEN
I'll never know which woman is my true love.

compensate for the remote, reserved body (Leslie Cheung) he's lost. A voice—"always the voice"—that Leung inscribes into Chang's warm, tender body. A disembodied voice. A voice with no body and a body with no voice. We can't hear what Tony Leung is actually saying into the Chang's tape recorder—if he's able to say anything at all. It's more like he's wrapping his mouth around the tape recorder, using his mouth like an ear. Instead of using his mouth to say something, to talk, Leung is trying to take the voice in the tape recorder in through his mouth. Putting the voice in his voice and the voice in the mouth. Maybe Leung is only able to dedicate his voice to Chang, who will carry these tapes with him til the end of the earth, by using it symbolically. By being voiceless.

In "Dedication," Barthes writes:
"1. The amorous gift is a solemn one; swept away by the devouring metonymy which governs the life of the imagination, I transfer myself inside it altogether... 5. Powerless to utter itself, powerless to speak, love nonetheless wants to proclaim itself, to exclaim, to write itself everywhere."

When I tell Elaine how incredible Leslie Cheung is in the first minutes of *Days of Being Wild*, she writes: "How he comes in close and then goes away. Every person whose heart he breaks, he breaks just like that. By coming in close—unbearably close—and then going away." And that's exactly how *Days of Being Wild* begins: with Cheung up close, and later with Cheung in slow motion, walking away from his mother's house in the Philippines. His hands clenched into fists. An inversion of that unbearably close proximity.

The color green works that way too in the film—it is behind the characters as well as in front of them. Up close and far away. Intimate and remote.

Green light. Green curtains.
Green trees. Green walls. Green gate.
Green dress. Green tea cup.
Green jungle. Green sorrow. Green time.
Green loss.

Roland Barthes, *A Lover's Discourse*:
"Sometimes an idea occurs to me. I catch my-self carefully scrutinizing the loved body… To *scrutinize* means to *search*: I am searching the oth-er's body, as if I wanted to see what was inside it, as if the mechanical cause of my desire were in the adverse body (I am like those children who take a clock apart in order to find out what time is)." ▪

▪ **ELAINE CASTILLO**
ENVOI (2011)
LINK: https://vimeo.com/22334794

When it comes to movies about Los Angeles, the LA River Basin *is* Los Angeles for me in many ways. All the River Basin film scenes—the drives, the car chases—are like a recurring dream. One long loop on repeat. One place, over and over again. Or, to quote Samuel Beckett's "All Strange Away," "A place, that again."

In *Los Angeles Plays Itself,* Thom Andersen argues that we only know Los Angeles through the movies. As a movie.

It's fitting then that I've only ever seen the LA River Basin on celluloid. All the times I was in LA, I tried to go in person, but never made it. It was always out of the way for the people who were driving. In the 70s, skateboarders rode the slanted walls of the basin like a wave. But those California boys turned everything into water.

But all these film clips have something in common besides the LA River Basin itself: Men in cars. Cars dueling, swaying back and forth in the viaduct, as though it were the open sea (a history of terrible floods haunt the culvert and Los Angeles itself); the Wild West. This is a man's story. This is a man's place.

Riding modernity. The flow of concrete. The beauty of an eye sore. The death drive.
The hard blow of concrete. Cars crashing. Diving. Flipping. Breaking away and chasing. Men wrecking their lives. Everyone's lives. ▪

▪ **RANDAL KLEISER**
Grease (1978)
LINK: http://youtu.be/b08DChU5qsg

▪ **ONDECKVIDEO.COM**
CLIP: "1938 Calif Killer Flood"
LINK: http://youtu.be/sAQ1gxYvvmw

▪ **WILLIAM FRIEDKIN**
To Live & Die in L.A. (1985)
LINK: http://youtu.be/1qkjY85Wgul

▪ **NICOLAS WINDING REFN**
Drive (2011)
LINK: http://youtu.be/5bKGu45zHxo

12 10 2011—ALL I'M INTERESTED IN IS LOVE

John Cassavetes: "How can I be in love so that I can live?…I have a one-track mind. That's all I'm interested in… is love."

• **MARTIN SCORSESE & MICHAEL HENRY WILSON**
A Personal Journey with Martin Scorsese Through American Movies (1985)
LINK: http://youtu.be/UR3jKqsMI_c

12 11 2011—YOUR FACE IS MY FACE (ON EMMANUEL LÉVINAS)

"I often talk about love as one of the few places where people actually admit they want to become different. And so it's like change without trauma, but it's not change without instability. It's change without guarantees, without knowing what the other side of it is, because it's entering into relationality. The thing I like about love as a concept for the possibility of the social, is that love always means non-sovereignty. Love

• **GEORGE STEVENS**
A Place In The Sun (1951)
LINK: http://youtu.be/wEuFNnJSIw8

is always about violating your own attachment to your intentionality, without being anti-intentional. I like that love is greedy. You want incommensurate things and you want them now. And the now part is important."

–LAUREN BERLANT, from "No One is Sovereign in Love: A Conversation Between Lauren Berlant & Michael Hardt"

12 12 2011—DEFINITE TIME (EVERYTHING IS TIMING)

"If I drive for you, you give me a time and a place, I give you a five-minute window. Anything happens in that five minutes, and I'm yours. No matter what. I don't sit in while you're running it down. I don't carry a gun. I drive."
–RYAN GOSLING, *Drive* (2011)

▪ CHROMATICS
Tick Of The Clock (2007)
LINK: http://youtu.be/vWD7k6TrJ-g

In *Drive*, driving is a modus operandi and emotional schematic. Driving is also a way of steering man-hood. Driving keeps this driver in line. Puts the breaks and hits the gas on desire. But we know that drives and desires are not the same thing. He's a *get-away* driver. He pulls stunts. He crashes, escapes. Driving kills time, the circuit of time, his time, by keeping it (himself) on a very short leash. The designated and deluxe "Driver" is like the grim reaper—the designator of life in relation to time and time in relation to desire. With him, whatever happens on either side of time—the time he gives you, the time he sets aside for you; where he waits and will wait, for whatever happens, for wherever you need to go; the time during which he is "yours," completely—is also the difference between life and death. Ethics. Whatever happens, before or after the five minutes, have nothing to do with him. He's no longer on your side. He's no longer responsible. That's the deal. Time has expired. Everything is in this small window of time. ▪

12 13 2011—THE WHOLE WORLD IS ACTUALLY RED AND GREEN

For the past four months, it's been all about the colors red and green for me. It started with Robert Bresson's *Lancelot du lac* and Elaine Castillo's blog post[*] on red and green in Bresson's film. Elaine and I talk about red and green all the time. Of course, these colors are especially prominent right now, with Christmas coming. Once you start to see it, to look for it, to notice it, it turns out that everything is red and green. Money is green and car lights are red. Red is the color that alerts you to danger. That tells you to stop. Green is the color of signs. The color that tells you to go. Graffiti and signatures are often red. Buildings and stairwells, green. Doors to houses are red. The door to my first apartment in London was red. Someone kissed me against it one night after a party. Green is also the color of forests—or the feeling of being lost in one. The growth of feeling; the budding of love and coming into being. As the poet Fanny Howe writes in her poem, "After Watching Klimov's Agoniya":

> *Love is the green in green. Does this explain its pain?*

When I looked for the poem to re-read it, these lines of Howe's were in the poem too:

> *Since love came over and knocked me down*
> *Then kicked me in the side and fled,*
> *I have suffered from a prolonged perplexity.*

[*] http://elainecastillo.tumblr.com/post/9875797600/had-not-realized-that-i-need-to-write-a-book

Lancelot du lac is filled with forests and the bodies of armored men who bleed through their metal. Into the ground, as though blood were water.

Red and green almost always go together.

For the past two days, red and green have literally been everywhere. I see people in red hats and green book bags. Red lights glow at night. When

• **SCREEN**
Lancelot du lac (1974), Robert Bresson.

I take the elevator to and from my apartment every day, the numbers in the elevator are red. For years my door in New York was green before management painted it beige. But the paint is chipped by the lock, so there are flecks of green there, still. Netflix, which I use every night to watch movies, is red. And tonight: an elderly man at my gym had ten little red hearts tattooed all over his left arm.

And on and on.

Red isn't possible without green and green isn't possible without red. One (green) comes from inside, and one (red) is an expression of it. Green hurts, shocks, aches, vibrates and hums—perplexes, as Howe notes. Red pours over everything. It's how you express the green. How the green comes out. So if red comes, it comes *after* green. Green is first. Red second. Everything starts with green because green is onset. Red is feeling deeply—deeper—and losing something or someone deeply, too. So red has its violence. Its trauma. Its horror. It explodes and spills. Saturates.

One of my favorite Dario Argento films is *Deep Red*, but I've always preferred the Italian title, *Profondo Rosso*—*profound* red. Because that's what the color red is, profound. In the same way that green makes your eyes water because it thaws you. Wakes you. Is your awakening. Green allows things to grow and live again, if they've died—if you've died, if something has died in you—and also if they've never been born before, or yet. Red and green alert you to the world, so they are the colors of *being* alert. If you are in love or awake, you'll notice these colors around you. See them everywhere, on everyone. ▪

12 14 2011—80'S FORMULA #1

You have no one.
You win everyone.
You lose everyone.
You win everyone.
You realize you only want the right people.

- **STEVE RASH**
Can't Buy Me Love (1987)
LINK: http://youtu.be/hiS42RHaKyg

- **ROD DANIEL**
Teen Wolf (1985)
LINK: http://youtu.be/2lNvXTnXp3k

12 14 2011—MIXED-UP SHOOK-UP GIRL & HE'S SO FINE

- **PATTY & THE EMBLEMS**
Mixed-Up, Shook-Up, Girl (1964)
LINK: http://youtu.be/_jgl1f_cl4c

- **THE CHIFFONS**
He's So Fine (1962)
LINK: http://youtu.be/rinz9Avvq6A

After I posted my red and green essay the other night, I watched a documentary on the Swedish cinematographer Sven Nykvist, *Light Keeps Me Company* (*Ljuset håller mig sällskap*), which isn't very good at all, which doesn't show what it tries to show, but was full of all sorts of red and green mise-en-scène, both in the documentary itself and the films within the film. The films that Nykvist shot and lit with Bergman, with Woody Allen, with Polanski. Red and green seemed to follow Nykvist around.

Later in the documentary, red starts to appear—in *Light Keeps Me Company*, in Bergman's *Cries and Whispers* and *Autumn Sonata*. In these instances, Nykvist makes the red—arranges it—himself. Surrounds others with it. But sometimes, red simply pops up on its own and surrounds him: in the film crew, at award ceremonies, at his home, on a farm, in the movies he lit.

I wonder what Nykvist's relationship was to color when he wasn't looking through a camera. Did he see it? Need it? Did it matter to him? As a person, as a man, Nykvist seemed recessional. So starved of light and color. It might be that after he got divorced and lost his older son to suicide, much of the color in his life faded, or was drained out of him. That any light or color he had left (in the film, Nykvist comes across as pale in every sense of the word), or had ever had, was put into film. But, the documentary tells us, like Bergman (with whom Nykvist can be seen holding hands while strolling through a garden on set), long before his marriage ended, and his son committed suicide, Nykvist had made the decision to separate not just family and work, but life and film, dedicating all his time to movies. At one point, Bergman tells the camera that his "feelings for light were the same" as Nykvist's. In this case, light is another word for life, or more specifically, a man's historically problematic and dangerous relationship to everything and everyone outside his work.

It's hard for me to imagine that kind of stark contrast between life and work. *Life* pallor and *cinematic* (artistic) vibrance. Why were the films so bright and saturated and his life so wan? So washed out. Was the film color because of a muted life, or was a muted life desirable—tolerable, bearable—because of all the film color? Where does one store or hoard light? Everyone in the film—actors, directors, friends—kept saying how light and airy and warm—easy-going—Nykvist was, but I didn't see the signs. I saw someone who seemed mostly detached, sad, reserved; closed. In the film, whenever there is color around him, especially green and red, Nykvist is the palest thing in the room. In the picture. A wallflower, almost. ▪

12 16 2011—THE POISON FOR FEAR IS LOVE

"What you should do, said Socrates, is to say a magic spell over him every day until you have charmed his fears away."
–DERRIDA, "Plato's Pharmacy"

▪ **SCREEN**
Plato's Pharmacy.

12 19 2011—80'S FORMULA #2

"[*Phantasm*], like many low-budget horror films of the period, seems to take place in a land where it is always late summer, the streets are strangely deserted, and the parents strangely absent."
–JED MAYER

▪ **STEVEN SPIELBERG**
E.T. the Extra-Terrestrial (1982)
LINK: http://youtu.be/NHH5pPCeyrs

Where do we live? Only in these houses. What are these houses but surrogate families. We are alone or with each other in this American sprawl the size of California. Watching TV, acting like movies. The world is packed into these houses, or left out. We barely ever see our parents. Things come down from space to love and parent us. There's this sense that there is no society—only us and them. Us and whatever strong-arm this movie is about. These houses are lost like we're lost. Lost in America. But it's not sad because you don't have a father, because you're stuck with a mother. It's sad because you don't have a world. No one's around. When we meet, it's like ghosts. ▪

Last Saturday, at a friend's Christmas party, I talked to this one man I didn't know for hours. We ran around together like teenagers and smoked cigarettes on the balcony. We hit it off immediately. One of the things we talked about was love. I told this guy I was trying to give people (men) a chance, "but…," I started to say and then didn't finish my sentence. "*But…* he's not your *boy*," he said. "No," I concurred. "He's not my *boy*." How did he know? What does it mean for someone to be someone who's yours? Who can't be replaced. Not in the sense of belonging to me, but in belonging together; cut from something that is the same, similar, of one piece. In her book *Eros: The Bittersweet* (which can and should be read alongside Roland Barthes' *A Lover's Discourse*), Anne Carson reminds us that the Greek word *Eros* denotes "desire for that which is missing." If that's the case, at least it is in mine, what is missing is also who is missing (that is, the *who* who represents the *what*, as well as the *what in you*). I am not missing or in need of everyone or anyone. Therefore, not just anyone can spark desire or be tied to lack. My particular lack. "When I desire you a part of me is gone," Carson writes.

In the preface to *All About Love*, bell hooks writes:
"When I was a child, it was clear to me that life was not worth living if we did not know love. I wish I could testify that I came to this awareness because of the love I felt in my life. But it was love's absence that let me know how much love mattered."

Like hooks, I've always believed that life is not worth living without love, only I came to this conclusion for the opposite reason. It was *because* of love's presence (in my family; between my parents); *because* I had always known love growing up, that I could not bear its absence. That I didn't know how else to be or live. Love matters precisely because love has always mattered.

Last Sunday, I was finally able to watch the Aryton Senna documentary, *Senna*, in its entirety. In the scene where Senna wins the Brazilian Grand Prix in 1991 (after he won the race, Senna actually passed out, so great was the anguish of his ecstasy. Victory.), he suffers unbearable shoulder pain from the tremendous stress of the race. He is literally pulled out of the race car and driven off the track. He can barely move. But when Senna sees his father, he calls over to him, "Dad, come here. Come here." His father hesitates, but Senna insists. "Come here. Come *here*! Touch me *gently*," he orders. His father, much taller, stands beside his son, as Senna rests his head against his father's chest for a moment. When he starts to walk back, Senna tells everyone else (even before anyone actually touches him; even if no one is trying to touch him at all), "Don't touch me! Don't touch me!" He commands everyone but his father to get away from him. This scene, which is the difference between *touch me gently* and *don't touch me at all*, between everyone else and you, between a son and his father, beloved and not-beloved, can also be read as a love story. *Your boy* as opposed to every *other* boy. Everyone is not *you*, X. Everyone can't be. (On a side note: The day Senna won the Brazilian Grand Prix, he was wearing a red racing uniform and the Brazilian flag, which he waved when he accepted his trophy, was green. In almost all of the film's footage, Senna is wearing either red or green. At one point he even has a red watch on. The older he got, the closer he came to death, the more he knew and the more he understood— about the sport, about the world, about life—the more red and green Senna wore.).

As Senna demonstrates in the scene with his father, sometimes we are so sensitive to love, to the one we love, it allows us to know exactly who we *don't* want love from. In a series of lectures for

children called *God, Justice, Love, Beauty: Four Little Dialogues*, Jean-Luc Nancy explains:

"We are captivated by this person because of his or her absolute uniqueness… What I receive in love or what creates passion is what we call the uniqueness of the person. It's him or her, and that's all that matters. There is a word for this, *the beloved* [l'élu]. Perhaps you've heard of the expression, 'the one my heart has chosen

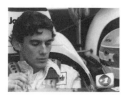

▪ SCREEN
Senna (2010), Asif Kapadia.

[*l'élu de ma cour*]' …But the élu in love involves a choice that is not made by a majority. Choice means that a person is chosen, distinguished or set apart from all others."

In November, a Tarot card reader told me: "There are 200 hundred men, right now, in New York City, who you could fall in love with. Who could make you happy," which fundamentally goes against all my core beliefs about love. How can so many people all do the same thing? And, according to the Tarot reader, at the same time and place, no less. How can so many men all make me feel the same way? And if that's really the case, if love is one-size-fits-all, what makes love so rare, so unique, so hard to find—so difficult to recover from? If there is something that makes someone singular and unique—*for you*—then the inverse must also be true: everyone else *cannot* be singular and unique—*for you*. Having a beloved, that is, knowing *who* is beloved, means that one is also acutely aware of and sensitive to who is not-beloved. That the beloved and not-beloved are not simply interchangeable or reproducible. That the beloved is outside the economy of the love market, or love *as* market, as Zygmunt Bauman notes in *Consuming Life*.

This may also be the difference, as this same Tarot card reader pointed out, between love and soul mates. "You want a soul mate," she scolded gently, "and soul mates take fifteen years to recover from." Soul mates are hard, if not impossible, to find; impossible to shake, forget, let go of. Whereas love is something you can have with 200 people, right now. All the time. Love is something you can go in and out of unscathed—an economy with concrete value. Value you can manage, control, and trade.

After I wrote the above paragraphs, I saw a poster of a Rumi poem on the street. It read:

> *Love is the blazing flame*
> *which burns away*
> *everything except*
> *the Beloved.*
> —MEVLANA

Like the scene between Senna and his father, these visual texts by the artist Jenny Holzer can be read as the ultimate love letter, if a person were also a love letter. A thing that walks around in the world telling a story about the person they love—to themselves and to others. Becoming not just a body in love, but a body of love. I am writing something on the wall as much as I am the wall on which love has been written. By someone. Engraved. Inscribed. I am stone with light carved into me.

Using Holzer's images I have composed a love letter.* The love letter I already am to someone. For someone. For, as Carson points out, "Mix-up of self and other is much more easily achieved in language than in life… Selves are crucial to writers." ▪

Jenny Holzer:

1. *You are my own*

2. *I feel you*

3. *All thigs are delicately interconnected*

4. *I say the word*

5. *I am awake in the place where women die*

6. *It is in your self-interest to find a way to be very tender*

7. *I am losing time*

8. *In a dream you saw a way to survive and you were full of joy*

* For a visual of this love letter, visit: ttp://mashatupitsyn.tumblr.com/post/14531963363/i-the-writing-on-the-wall

12 24 2011—WEEP FOR HIM, FOR HE DESERVES IT

"It is great when the poet, presenting his tragic hero before the admiration of men, dares to say, 'Weep for him, for he deserves it.' For it is great to deserve the tears of those who are worthy to shed tears. It is great that the poet dares to keep the crowd in awe, dares to castigate men, requiring that every man examine himself whether he be worthy to weep for the hero. For the waste-water of blubberers is a degradation of the holy. — But greater than all this it is that the knight of faith dares to say even to the noble man who would weep for him, 'Weep not for me, but weep for thyself.'

▪ ANTONIO PINTO
Strange Justice
Music from the Motion Picture: *Senna* (2011).
LINK: http://youtu.be/99klJhZhZsg

"...A man can become a tragic hero by his own powers—but not a knight of faith. When a man enters upon the way, in a certain sense the hard way of the tragic hero, many will be able to give him counsel; to him who follows the narrow way of faith no one can give counsel, him no one can understand. Faith is a miracle, and yet no man is excluded from it; for that in which all human life is unified is passion."
–SØREN KIERKEGAARD

12 27 2011—IS MY TIMING THAT FLAWED

Here are three different versions of "Love Will Tear Us Apart" by Joy Division. For the full effect, for a complete chorus, play all three versions at the same time. Have them overlap and talk over each other, some versions finishing before others. Some dragging on.

▪ JOY DIVISION
Love Will Tear Us Apart (1975)
LINK: http://youtu.be/qHYOXyy1ToI

▪ BROKEN SOCIAL SCENE
Love Will Tear Us Apart (2009)
LINK: http://youtu.be/z5PcW0kguCM

▪ HONEYROOT
Love Will Tear Us Apart (2005)
LINK: http://youtu.be/Yht4Anc4Vdk

▪ **SCREEN:** *Ashes of Time* (1994), Wong Kar-wai.

"Do you remember how we met?"
"If Haung loves her..."
"why did he leave her?"
"Some people don't realize who they love..."
"until they've left that person behind."
"Because he's in love with another woman."
People always find ways to mask their pain.
Actually, Murong Yin and and Murong Yang were just two sides of one person.
Hiding behind these two identities...
was a wounded soul.
"How could I forget you?"
"You were drunk. You touched my face."
"You knew I was a woman in disguise."
"Why did you say that?"
"A drunk man's words..."
"can't be taken seriously."
"Those words..."
"have kept me waiting for you all this time."
"I asked you to take me with you..."
"but you refused."
"You said your heart did not have room for two."
"I've asked myself so many times..."
"am I really the woman you love most?"
"But I no longer want to know."
I suddenly understood why they are a couple...
Because they both are true to their hearts.
As I watched them leave...
I was filled with envy.
I once had this chance.
I don't know why...
I let it slip away.

From the womb of the 80s, woman is a mother-dream. He makes her up. He builds her from scratch. He wishes her into being. He invents the feminine. Him and his friend, or him all by himself. He talks to her the way no one else can. He's the only one she talks to. The future is all these images in his head. In a magazine, on TV, in the deep blue sea. Men give birth to women. ▪

▪ **JOHN HUGHES**
Weird Science (1985)
LINK: http://youtu.be/0eejklj3d9Q

▪ **MICHAEL GOTTLIEB**
Mannequin (1987)
LINK: http://youtu.be/N6gpndlepiM

▪ **RON HOWARD**
Splash (1984)
LINK: http://youtu.be/7Hxp3S6upbM

12 29 2011—THE IMAGE OF LOVE I LIVE FOR

▪ **SCREEN**
Say Anything (1989), Cameron Crowe.

Last year, I published the video essay *Lost Highway* (after the David Lynch film) on Ryeberg.com*. In the story, a song is playing in the car while me and my ex, W., are driving in the middle of the night. We are driving to California from New York City, but our first stop is North Carolina.

Lost Highway is about the ontology of the road, but it's also about the way that reading is like driving, so the text is a road too. That's why the video clip is meant to play while you read.

The Bowie song, "I'm Deranged," which narrates the textual road trip is from the movie *Lost Highway*. But "I'm Deranged" was not the song that me and my ex were listening to while we were driving that night. That song was "Fevered" by The Stills.

▪ **THE STILLS**
Fevered (2003)
LINK: http://youtu.be/esBmKaYZQPk

We were gliding, in the clear, when the song came on. If you read the piece, you'll know what I mean by that. That the song is called "Fevered" makes sense, because we were. And the album is called "Logic Will Break Your Heart." That makes sense too. What we were doing wasn't exactly logical, but after ten years in the making, it was finally right and it was time. In the end, logic (his) did break my heart. Suddenly he became relentlessly logical, so nothing was ever the right time again. Sometimes logic not only breaks, it kills.

When "Fevered" came on, we reached for each other, and I think we both said we liked the song, though neither of us especially like the band. We were honestly happy to be alive. To have the road to ourselves, like a room to ourselves. We both had a lone wolf thing. That part of the drive—the last 45 minutes or so—were like end credits to a horror movie. We had survived the killer cars on the road.

Here is a road movie by Elaine.

▪ **ELAINE CASTILLO**
Ang Katunayan, Sana'Y Pakinggan (2011)
LINK: http://vimeo.com/32773832

Elaine's drive takes place during the day. While we were on our way to California, Elaine is already there, only I don't know her yet. Won't know her for years. W. and I made this trip on Highway 1 many times. Often at dawn, on the way back from an all-night date, when the misty hue of everything is dyed green and looks like the movie *Vertigo*, which is set in San Francisco. In October 2004, we went on drives and all-night adventures around the Northern California coastline. Less than five months later I moved to California to be with him. He did his field work in Santa Cruz and it almost always looked like this there.

* http://www.ryberg.com/curated-videos/lost-highway

Elaine shot her road film on Highway 1, at various locations between Half Moon Bay, Monterey, and Carmel. She used the songs Ruben Tagalog's "Ikaw ay Akin" and a version of Zazen Boys' "Cold Summer," which she edited herself. When I asked Elaine about her song selections for Highway 1, she told me:

"The title of the film is *Ang katunayan, sana'y pakinggan*, which comes from the lyrics of Tagalog's song; it means, 'The proof, listen to it.' It's a love song, so he's telling his beloved that the proof of his love is in the lyrics of the song he's singing. It's so cheesy."

▪ **PHOTO**
Pigeon Point Lighthouse (Pescadero, CA).

▪ **SCREEN**
Vertigo (1958), Alfred Hitchcock.

Elaine and I often send songs to each other as "proof"—shorthand—for what we're talking about or feeling. In our emails to each other, we often include lyrics, or some part of them, to a song. The songs fill in the blanks, add, say *everything*. Say it to the point of over stating. I think we both like that though. The excess. The hyperbole, because honestly, if not in music, where else are we going to come that loose? What else is going to let you have it like that?

W. and I had some of our first dates in Santa Cruz and Half Moon Bay. We once we stayed in a lighthouse called Pigeon Point that we had all to ourselves. The lighthouse and its location looked like it belonged in *Vertigo* too. Instead of sleeping in the two wooden bunk beds we paid for, we pushed all the couches together in the common area and slept there. We also drank tea on the kitchen counter, half naked, after we had sex for the first time.

It was often foggy on our drives. Sometimes you couldn't even see what was in front of you. Sometimes the fog was so thick you couldn't see anything at all. The world disappeared. Softened up. In David Lynch's *Lost Highway*, the male double Pete/Fred disappears, transmogrifies, splits—vaporizes on the road. Turns into fog. Something happens when you drive. Something happens on the road. When I was a kid driving around Europe for hours and hours with my parents, my favorite thing was to be in a car at night. And it still is. It's like being a plug in an electrical socket. Few things are more thrilling, comforting, or sensual to me. Driving at night is as close as I can get to a power source. The long yellow band that stretches across a highway is like a vein or a life-line that runs through your whole body.

When did I exist? Then? Now? Not then, not now? Does love make you exist?

In Santa Cruz (from Spanish and Portuguese, Santa Cruz means "Holy Cross"), we parked the truck in the woods, by the beach, and slept there a few times. Smoked cigarettes and talked. Ate dinner. Had a lot of sex. Made up for lost time. Ten years worth. Never slept. We asked ourselves how we would ever be able to do anything but be together? Being together, we both

agreed, was something you could spend a life doing, if life and love are one and the same for you. The way you can spend a life just reading or watching movies. But as Jean-Luc Nancy points out in *God, Justice, Love, Beauty: Four Little Dialogues*:

"Even the truest love can be lost. It is never guaranteed. If a love were guaranteed, it would not be love." Given that love cannot be guaranteed to last, you have to risk loving even more, which means you risk losing love even more. Derrida makes a similar argument about forgiveness, which is of course also tied to love and risk, as well as loss and grief. Derrida states that if forgiveness isn't impossible (a form of insanity; forgiving the unforgiveable), it isn't real forgiveness. I lost love even though it was guaranteed to me; even though I guaranteed it myself, and forgiveness is still impossible. Mostly, I don't feel anything about my last relationship. In fact, I often compare it to a dead nerve or a lost tooth. The catheterized roots take you with them.

Looking up the lyrics for "Fevered" I am surprised to discover that the first few lines of the song are: *Strange light skin that I believe in / It stretches over bone and smells like honey on the wind / Oh so strange I can't remember / Where the heartache ends and the fever ache begins.*

I didn't know the words to "Fevered" that night in the car, nor did I know them when I wrote *Lost Highway*. About the moon's light on the road in front of us. About finding a face you can believe in. That can't be replaced. What Elaine always refers to as, "the face that is for you" when we talk about the face I love now, which means, to quote Emmanuel Lévinas, that *the face that is for you* is also the life you are responsible for.

A couple of weeks ago I kissed a man at the OWS Verso Books party, a week before Christmas. He was a good kisser. Yet afterwards, as I looked at him while he talked to me on the subway, I knew he didn't have the kind of face I really wanted or needed to look at. His face just wasn't for me.

But somehow faces are the first thing I forget once a person is gone. They become a blur— foggy—because they have to. Because it's too painful and burdensome to carry a face (a life) you knew so well—*a face that was for you*—around once it's gone. A face you took that seriously. It can drive you crazy. I've been driven crazy by things like this. Love and faces, and responsibility. To the other. In this way, writing is not only a substitute for love, it's a substitute for the face (life) you've lost. ▪

> "Anything can be said by a glance, and yet one can always repudiate a glance because it cannot be quoted word for word."
> —STENDHAL, *De L'Amour*

01 03 2012—TRAP DOORS THAT OPEN

▪ RADIOHEAD
In Limbo (2000)
LINK: http://youtu.be/Q6-sTkVdAqQ

I listened to this song when I lived in London. This song (this album) was my whole head. My whole life. On the train, on the bus. Back and forth, going to graduate school. I was dreaming. I was thinking. I was alone. I was looking. I was a kid. I was sad. No, sad is not the right word. I was bereft. This song was like burning. Thawing. What the filmmaker Catherine Breillat once described as "the fire underneath the ice." A trap door that opens. A spell. And now it's back. It's enough and it's not enough. Everything is a mystery. Everything is happening. Everything all over again. You (X.) know who you are. ▪

"Be sure of having used to the full all that is communicated by immobility and silence."
—ROBERT BRESSON

When I saw her, she told me that X. was in "The Hanged Man space"—"that space of silence"—but that I was too. I like the idea that we are in the same state for different reasons. That we have the same card in common. The same thing at stake.

The Hanged Man "tells us that we can 'move forward' by standing still. By suspending time, we can have all the time in the world." Is there such a thing though? Such a thing as "all the time in the world?" Sometimes I think that's all we have. All anyone has. An eternity. Other times I think I, we, no one, has any time at all. That everyone is running out of time, and that thinking we have all this time is the problem. Movies don't teach us that. Movies and books (the fairytale ones) tell us: *You must go for it*. Him/her. You must come out the other side.

- **SCREEN**
The Hanged Man (Rider-Waite Tarot).

- **ALAIN RESNAIS**
Muriel (1963)
LINK: http://youtu.be/Mps49Z9hap8

Given how much of an issue time has been for me my entire life, even as a little kid, and now in all of this—with X.—The Hanged Man card isn't an easy pill for me to swallow. What time is left, what time isn't. And is time really all there is to it? To us, or not us. And if that's the case, when will time finally make sense? How much time needs to pass for that to happen? For time to do what it needs to do. Time comes together, but time is also broken, backwards, split, like in an Alain Resnais film. Continuities in discontinuities. War-torn time lapping at time, at people and their time, like a wave. Pulling time in, back. Spitting it out, forward. For Resnais, all we have are fragments. Pieces of things and memories in pieces. This goes on forever.

The Hanged Man is about suspension. Time is suspended, left hanging. When you are in The Hanged Man space, you stay still rather than move—act.

You do nothing.

Lecturing about God in a series of dialogues for children called, *God, Justice, Love, Beauty,* Jean-Luc Nancy states:
"God is perhaps a way of answering: there is no point, no rhyme or reason, and that's why it is good. It is open, it is available. Available for any number of things, but at the same time for nothing. Sometimes what we do best is nothing, doing nothing, letting things be... Now I am not telling you to do nothing... But, more deeply, when one really thinks about one's life, about what one does. A little while ago, when I spoke to you about joy or love, even about justice in the sense I tried to describe, what is all that about? It is really nothing. What do people who love each

other do? Nothing, nothing but love each other. That doesn't mean that we must do nothing."

The nothing that Nancy is describing is really everything, in the same way that when Morrissey sings, "William, it was really nothing" in the great Smiths song by the same name, we know that what was, or is, between him and William, was/is really *everything*. That even if it amounted to nothing, came to nothing, sometimes nothing is worth it because it is important (everything) to risk everything. Knocked down by someone or something, like the Great Dane that knocks Rousseau down in *Reveries of A Solitary Walker*. We also know that everything that currently runs the world, and gets heralded as good and great—important—is mostly really nothing. *Really* nothing. But in the song, Morrissey is also telling William that all this nothing (the sacrifice, the risk, the love) was worth it. That the everything he gave William, that was between them ("It was his life"), was really nothing. In other words, he is telling William (bitterly, lovingly), "Don't mention it."

This idea (or reading) of nothing is particularly important for Western culture, especially in our 21st Century moment, which constantly tells us that whatever you can't see, whatever you aren't doing or showing, whatever isn't being seen or heard about you, doesn't exist. Doesn't count. Isn't really there. Is *nothing*. But our contemporary understanding of nothing is really the problem. In the Tarot's Hanged Man, nothing is not nothing because without knowing how to be in the nothing, without knowing what to do with the nothing that you are privately assigned to work through, you will never get (understand) anything. In contemporary American culture, something is only something if it is *SOMETHING*. Loud. Silence is empty, non-active. Failure. But to hear nothing, to be in the nothing, to feel what the nothing has to say, to tell you, is maybe more powerful than to hear what is strictly meant to be heard. What pronounces itself directly, without glitches or stutters.

When Nancy says that people who love each other do "nothing, nothing but love each other," it's an ironic play on the everything of nothing because, as we all know, nothing is more challenging, difficult, or important than truly loving someone. For Nancy and others, faith is not a question of knowing or being sure (belief). It's a question of being faithful to someone or something despite not knowing whether your faith will be rewarded. You have faith in the face of not-knowing. As I have pointed out in other posts, Derrida says this about forgiveness, and Nancy says this about both God and love: You love anyway. You forgive the unforgiveable. You forgive because you can't. All these thinkers are talking about faith, which means they are also talking about risk.

In response to a question about damnation and reward, Nancy states:
"It's just that it does not have to do with saying, 'After death you will be punished or rewarded for what you have done in life,' but rather, 'Are you able during your life-time to be faithful to what I tried to explain earlier, that is, are you able to remain faithful to something that infinitely exceeds you?' This is hard. And it's just as hard for me as it is for you and for everyone else. Hell means that if you are unable to do this, you are condemned. It means that you condemn yourself. You condemn yourself not to burning in hell among a bunch of demons that torture you, but, rather, you condemn yourself to shriveling up and withering away as you are, in your life, right now."

This brings us back to The Hanged Man card, which asks: Are you able to be silent for nothing? For the everything that might come of the nothing you risk everything for, as well as the everything that might turn out to be nothing? Are you willing to love and have faith even if nothing comes of it? Even if you stand to lose everything.

Being faithful to what you cannot even see. To what might not ever happen.

This is hard.

Writing about Christianity, Kierkegaard notes: "The contradiction which arrests [the understanding] is that a man is required to make the greatest possible sacrifice, to dedicate his whole life as a sacrifice—and wherefore? There is indeed no wherefore… At first glance the understanding ascertains that this is madness. The understanding asks: what's in it for me? The answer is nothing."

The Tarot's Hanged Man is also the card of inbetween. The space between the "man" who hangs—which is the tree and the ground; the space between different times, and the space between two people, in all senses of the word. Notice that only one of the hanged man's legs is tied to the tree. What does this mean? It means that with one leg bound and the other leg loose, you can get free. That you are not really stuck here. That this stillness, suspension, and silence is temporary; dependent on a situation, a condition. A trial, a commitment.

I don't want to wait, but I have to. And after all of my resistance, indecision, and frustration, I'm somehow riding the wave of time now, letting it sink in. I am living in the time-jump. The time-jump, which I knew was coming for months, but dreaded. The time-jump is the time inbetween the wrong time and the right time. The time between me and you (X.). Now and then. Present and future. In the movies, two characters meet at the wrong time and time needs to pass, to—*jump*—in order for them to be able to meet again. Sometimes time has to jump over and over for this to happen. To pass and pass. Sometimes it takes one time-jump. Sometimes it takes many. Sometimes six months pass, sometimes ten years. The point is that while we, the viewers, are aware of the time—the time that's passing between two people—the characters onscreen are not. Not knowing what they know or must know. They (the unsynchronized lovers) are in the back of each other's minds, and the forefront of ours, but they are not aware of the time that's passing. That's passed. They are living their lives, often with other people. Major things happen in between. Things that might be extremely difficult, but not impossible to undo. They don't know what's coming. You have to be almost unconscious, or at least only semi-conscious, of time when you are in the time-jump. It's on *our* minds (the viewers), not theirs. So if I am self-conscious about the time-jump I'm in, is it really even a time-jump? In fact, time is not jumping at all for me. I am literally watching the clock.

If. When. How many times.

The Hanged Man is an allegory. The Tarot reader said: "He (X.) has things to do and learn that you have already learned and done." We are not in the same place. Not in the same time either. She shrouded him in allegorical mystery; in that old language of inner odyssey and turmoil. She

said he could end up staying in this position, this freeze-framed moment, forever. Making it his whole life, instead of the way to me. Us. Himself.

In The Hanged Man space, you don't struggle, you submit. You go quiet. Into a search. But as much as this is its lesson, the Tarot reader said he could also get lost there—"lost in The Hanged Man Space." That he may never come out. May never become the man he could become. That he could go either way. She said, "He has swords to work through." Another name for the swords is the Dark Night of The Soul.

From *Saint John of the Cross: The Dark Night of the Soul*:
"Once in a dark of night, Inflamed with love and wanting, I arose (O coming of delight!) And went, as no one knows, When all my house lay long in deep repose / All in the dark went right, Down secret steps, disguised in other clothes, (O coming of delight!) In dark when no one knows, When all my house lay long in deep repose. / And in the luck of night In secret places where no other spied I went without my sight Without a light to guide Except the heart that lit me from inside. / It guided me and shone Surer than noonday sunlight over me, And lead me to the one Whom only I could see Deep in a place where only we could be. / O guiding dark of night! O dark of night more darling than the dawn! O night that can unite A lover and loved one, A lover and loved one moved in unison. / And on my flowering breast Which I had kept for him and him alone He slept as I caressed And loved him for my own, Breathing an air from redolent cedars blown. / And from the castle wall The wind came down to winnow through his hair Bidding his fingers fall, Searing my throat with air And all my senses were suspended there. / I stayed there to forget. There on my lover, face to face, I lay. All ended, and I let My cares all fall away Forgotten in the lilies on that day."

In her book *All About Love*, bell hooks writes about one of her favorite Biblical stories as a child, Jacob's confrontation with the angel on his way home. "Jacob was not just any old Biblical hero," hooks writes, "he was a man capable of intense passionate love. Coming out of the wilderness, where as a young man he fled from familial strife, Jacob enters the land where his relatives live. He meets there his soul mate, Rachel. Even though he swiftly acknowledges his love for her, they can unite only after much hard work, struggle, and suffering."

The Hanged Man. The time-jump.

hooks:
"We are told Jacob served seven years for Rachel, but it seemed to him only a few days so great was the love he had for her. Interpreting this story in *The Man Who Wrestled with God*, John Sanford comments: 'The fact that Jacob could fall in love at all shows that a certain amount of psychological growth had taken place in him during his journey through the wilderness. So far the only woman in his life had been his mother. As long as a man remains in a state of psychological development in which his mother is the most important woman to him, he cannot mature as a man. A man's *Eros*, his capacity for love and relatedness, must be freed from attachment to the mother, and able to reach out to a woman who is his contemporary; otherwise, he remains a demanding, dependent, childish person."

The Hanged Man. The Dark Night of The Soul. The time-jump.

hooks:
"Here Sanford is speaking about negative dependency, which is not the same as healthy attachment. Men who are positively attached to their mother are able to balance that bond, negotiating dependency and autonomy, and can extend it to affectional bonds with other women. In fact most women know that a man who genuinely loves his mother is likely to be a better friend, partner, or mate than a man who has always been overly dependent on his mother, expecting her to unconditionally meet all his needs... As Jacob labors for Rachel, making wrong choices and difficult decisions, he grows and matures. By the time they wed he is able to be a loving partner."

hooks:
"Meeting his soul mate does not mean Jacob's journey toward self-actualization and wholeness ends. When he receives the message from God that he should return to the home he once ran from, he must once again journey through the wilderness. Again and again wise spiritual teachers share with us the understanding that the journey toward self-actualization and spiritual growth is an arduous one, full of challenges. Usually it is downright difficult. Many of us believe that our difficulties will end when we find a soul mate. Love does not lead to an end to difficulties, it provides us with the means to cope with our difficulties in ways that enhance our growth. Having worked and waited for love, Jacob becomes psychologically strong... On the long journey home Jacob continually engages in conversations with God. He prays. He meditates. Seeking solace in solitude he goes in the dead of the night and walks by a stream. There, a being, he does not fully recognize wrestles with him. Unbeknownst to him, Jacob has been given the gift of meeting an angel face to face. Confronting his fears, his demons, his shadow self, Jacob surrenders the longing for safety. Psychologically he enters a primal night and returns to a psychic space where he is not yet fully awake... The angel is not the adversary seeking to take his life, but rather comes as a witness enabling him to receive the insight that there is joy in struggle. His fear is replaced by a sense of calm... As Jacob embraces his adversary, he moves through the darkness into the light."

Silence. Love. Faith. Risk. Love.

John Sanford:
"Jacob refused to part with his experience until he knew its meaning, and this marked him as a man of spiritual greatness. Everyone who wrestles with his spiritual and psychological experience, and no matter how dark or frightening it is, refuses to let it go until he discovers its meaning, is having something of the Jacob experience. Such a person can come through his dark struggle to the other side reborn, but one who retreats or runs from his encounter with spiritual reality cannot be transformed. It should reassure us that the blessing the angel gives to Jacob comes in the form of a wound."

I have been Jacob. I have had to be Jacob. I have been him willingly and against my will. I have made wrong choices and difficult decisions. Wandered alone. Failed and labored and waited. Tried again. Been in the dark. Had faith. Time, years and years, have passed. And now I am at once tougher and softer than I have ever been. I am and/both. ▪

01 06 2012—LOVE ON THE DANCE FLOOR

For Elaine. Who, like me, loves that other great
dance scene of Fatih Akin's—Cahit in *Head-On.*

▪ FATIH AKIN
Soul Kitchen (2009)
LINK: http://youtu.be/eK_YVa6ZLKs

01 07 2012—80'S FORMULA #4

The magik of childhood. Of kids in groups. On bikes.
Against corporations, institutions, corruption. Kid as rebel against world.

▪ RICHARD DONNER
The Goonies (1985)
CLIP: "Cyndi Lauper - Goonies - Good Enough - HQ"
LINK: http://youtu.be/lOurKhAlpOA

01 10 2012—DIVINE TIME

▪ PHOTO

01 11 2012—THERE YOU ARE (WOLF MOON)

▪ PHOTO

"First wedding night.
But first mourning night?"
—ROLAND BARTHES, *Mourning Diary*

In her book *Precarious Life: The Power of Mourning and Violence*, Judith Butler writes: "I am not sure I know when mourning is successful, or when one has fully mourned another human being. Freud changed his mind on this subject: he suggested that successful mourning meant being able to exchange one object for another; he later claimed that incorporation, originally associated with melancholia, was essential to the task of mourning. Freud's early hope that an attachment might be withdrawn and then given anew implied a certain interchangeability of objects as a sign of hopefulness, as if the prospect of entering life anew made use of a kind of promiscuity of libidinal aim. That might be true, but I do not think that successful grieving implies that one has forgotten another person or that something else has come along to take its place, as if full substitutability were something for which we might strive."

Butler is mostly talking about political violence and death in *Precarious Life*—the sphere of political marginalization, persecution, subjugation, occupation, erasure, annihilation. But given that her book is about "Who counts as human?" and "What *makes for a grievable life?*," who and what gets (deserves) to live, I think one can talk about love here, too. How love (and lovers) survives in the world—gets to live—and how it doesn't. How love gets beaten out of our system (ours and the greater systems at large), or never taught to begin with. When does one let someone or something go and what does it mean to do such a thing? When should one let go and when should one hold on? And how do we let go rather than simply replace, which only fills (or pretends to fill) a space (gap, person) symbolically? How do we grieve what and who we've lost in a way that let's us love more, not less?

Knowing when to go and when to stay has been a major struggle in my life. Therefore the greater question for me is: are we becoming the kind of people (culture) who can never really let someone in to begin with, and so can never really mourn a loss? Who never truly risk being wounded and affected; who never allow themselves to get to the point of being imprinted or dented, or god forbid, hurt. For what do we do—how do we live, love—once, *after*, we've been wounded? Once we've been left and once we've left. Once we've loved and lost. Let go or not let go. And *do* we love again? As Butler puts it at the beginning of *Precarious Life*, "Let's face it (the face being an important ethical trope here, as Butler's final chapter looks at Emmanuel Lévinas' theory of the face and human sociality), we're undone by each other. And if we're not, we're missing something." The question of replacement, as Freud defines it, becomes much easier if you never risk such losses and imprints at all. If you fill yourself up with an endless cycle of people (watch *The Bachelor* and *The Bachelorette*. Reality TV shows are themselves predicated on an on-going replacement cycle). Butler's reading of loss here is especially interesting to me because it suggests that it's the *inability* to miss or grieve—to be, or admit to being, undone—that's missing. That missing itself is not a sign of lack or loss, it's the not-missing (not acknowledging our precarity and the precarity of others) that is the real danger.

As a teenager, one of my favorite remarks about suffering was by the Romanian poet, E.M. Cioran

from his book, *On The Heights of Despair*: "I owe to suffering the best parts of myself as well as all that I have lost in life." When it comes to love, it takes a lot of time and mourning for me to let someone go. If it isn't even going to hurt, and if I'm not going to live with the hurt, why even let someone in? If there isn't even a chance of being hurt—undone? So much emphasis is placed on narcissistic individuation as a sign of health and function. *My needs, my space*, instead of *our needs, our space* living together. Entering each other, mixing, communing, so if the two spaces (hearts and bodies), the "ties and bonds that compose us," were to ever split apart, the tear would be unbearable. Would *have* to be. Rather than focusing on and emphasizing our delicate and complex proximities and vulnerabilities, we focus on the illusory delineations (boundaries) between people.

But, as Butler notes: "Loss has made a tenuous 'we' of us all… Perhaps, rather, one mourns when one accepts that by the loss, one undergoes that one will be changed, possibly forever. Perhaps mourning has to do with agreeing to undergo a transformation (perhaps one should say *submitting* to a transformation) the full extent of which one cannot know in advance… Maybe when we undergo what we do, something about who we are is revealed, something that delineates the ties we have to others, that shows us that these ties constitute what we are… It's not as if an 'I' exists independently over here and then simply loses a 'you' over there, especially if the attachment to 'you' is part of what composes who 'I' am. If I lose you under these conditions, then I not only mourn the loss, but I become inscrutable to myself. Who 'am' I without you?"

As a culture we have become much more preoccupied, if not solely preoccupied, with a precautionary formulation of relationality; a relationality that is built on a hermetically narcissistic subjectivity: who am I when I am with you and what would I continue to be, or be able to be regardless, and in spite of, whether I am with you? How can I act as though we are never really together (part of each other); as though we are always-already split, or as though we might break apart at any moment? How can I always be prepared to lose you?

But what constitutes a break? An end? And what needs to happen in order to love again? Love another and anew in a way that isn't simply about erasure, recuperation, and replacement? Hardening and cynicism, so that the next person you love never gets to experience or have access to your original thrall and openness. There are many reasons to hold on, not least of which to do for others, for the other, what others may not do, may not have done, for you—hold on. What if you give up (let go) too soon? What if you hold on for too long? When should you leave and when should you stay? When are you pushing someone away and when are you letting someone in? I don't know the answer to these questions, but I am always wrestling with them.

"For Lévinas, coming face to face with the Other is a non-symmetrical relationship. I am responsible for the Other without knowing that the Other will reciprocate… Thus, according to Lévinas, I am subject to the Other without knowing how it will come out. In this relationship, Lévinas finds the meaning of being human and of being concerned with justice."[*]

[*] Elder Lindahl, "Face to Face" (http://www.pietisten.org/summer02/facetoface.html)

What if I stay and you don't want me to? What if my loving you despite you telling me you don't want me to is what will ultimately bring us together? What if waiting and holding on is part of what makes a love possible? What if one person has to learn to let go and the other person has to learn to hold on? What if that's the bond at stake? What if that's the road to, the test of, love?

• SCREEN
Guinevère in Robert Bresson's *Lancelot du lac* (1974).

In Robert Bresson's *Lancelot du lac*, Guinevère, who is stronger than Lancelot, who knows more about strength, and therefore love, than Lancelot does; and who knows that God is love, not death, tells Lancelot, "you can use my strength." Guinevère, who can feel Lancelot even when he isn't there, who knows that he is with her, even when he isn't. Guinevère, who can feel—love—through the distance. See through the invisible.

Guinevère, who says, "I know he's alive" when everyone tells her Lancelot is dead.

So much depends on just the right pressure, just the right time, just the right amount—not too much and not too little. Faith, when then there's no reason to have it. Love, when maybe there's no reason to give it. To know these things, we can't rush—can't be in a rush, with ourselves or with others. But we are living in a culture of disposability and speed, after all, and in *Consuming Life* Zygmunt Bauman writes about how this precarity and liquidity (the dissolve of bonds) also applies to love in a society of consumers, where subjectivity is increasingly defined by consumption and consumerism.

I treat the whole idea and task of "moving on" with suspicion and always have. Mourning is often synonymous with forgetting and denial. So I think I will always prefer (trust) people who mourn—even people who can't "get over" someone or something; who take too long—to people who don't mourn or take any time at all. Who promiscuously and indiscriminately claim to do everything in the name of love; who call everyone a lover.

I want to hold on and I like others who do the same. Character is formed there and devotion is made possible. I've always been bad at the exchange part, partly because I never wanted or set out to exchange or be exchanged in the first place. The whole process terrifies me. I've been called an obsessive and a die-hard romantic because of it. And it's true, I am one. I want to wrestle, grapple, stay, linger, hold on, remember, recall, retrace, ruminate, honor, know, understand—*hold on*. So when it comes to what Freud refers to as incorporation, I take (absorb) everything in order to fiercely guard what comes in and what stays out. That is, the relation between the two, for you can't do or understand one without the other. "Perhaps we can say that grief," writes Butler, "contains the possibility of apprehending a mode of dispossession that is fundamental to who I am."

After the break-up of my first adult love (P.), the constant command for me to "get over it," move on, love and/or fuck someone else, was just as traumatic as the dissolution of the relation-

ship itself. I was simply talked out of my mourn-ing. Talked out of holding on. I was constantly being told to let go. I refused this command though, and even wrote a story—"Solace"*—about it when I was nineteen, the same year I read Barthes' *A Lover's Discourse*.

In a 1977 interview called "The Greatest Cryp-tographer of Contemporary Myths Talks About Love," Roland Barthes states, "Love-as-passion

▪ **DEREK JARMAN**
Blue (Part 1) (1993)
LINK: http://youtu.be/wVaC3XKSi5M

(the love I talk about in *Lover's Discourse*) is almost 'frowned upon,' it's considered to be an illness from which the lover must recover, and no enriching aspects are attributed to it any longer."

So much of love—and mourning—is about language. The way we handle love and loss in words. The way we get talked into and out of love. The way we say things we don't mean and don't say the things we do. What we say and don't say about love, and what we let others say about it. But if it can't come out, where does mourning go—happen. This silence and internalization only further isolates us and privatizes our suffering. Maybe that's how and why replacement works; is so reassuring. There is simply no place for real, and therefore radical, heartache in this culture. No time and no place. We teach ourselves and each other what it means to love by what we say about it. What we're allowed to say and what we're not allowed to say. What we're trained to say (our ready-made vocabularies and cultural discourses) and what we've already said. Women have historically been permitted to say more about it, but that's because of the trivialization not just of women, but love in general. When it comes to love, we circulate either a repressive and reactionary set of values and narratives, or disposable platitudes. Sometimes we give up too soon and sometimes we don't try at all. We miss the opportunity to try. We don't say enough, when we should say everything. As Heidegger points out in *What Is Called Thinking?*, "Words are constantly thrown around on the cheap, and in the process are worn out. There is a curious advantage in that. With a worn-out language everybody can talk about everything... To speak language is totally different from employing language. Common speech merely employs lan-guage. This relation to language is just what constitutes its commonness." Which is what James Baldwin meant when he noted that true rebels are as rare as true lovers. This is also what I was trying to talk about in "Solace." Love and grief as something rare and precious and difficult and necessary. As Butler puts it, "...I am speaking to those of us who are living in certain ways *beside ourselves*, whether in sexual passion, or emotional grief, or political rage." ▪

* "Solace" featured on p 233

01 13 2012—TIME-JUMP

"The sign is the same for all."
—*Lancelot du lac* (ROBERT BRESSON)

▪ **NEW ORDER**
Thieves Like Us (1984)
LINK: http://youtu.be/HQdUsXmfHN8

01 14 2012—HERE I AM HONEY

▪ **SOLOMON BURKE**
Cry To Me (1962)
LINK: http://youtu.be/MjyzUDlhqNs

▪ **JOHN CASSAVETES**
Faces (1968)
LINK: http://youtu.be/BR6E_tMvyTs

I was ten years old when I first heard this track shoot out of my walkman. I was in a car, driving down St. Mark's Place in New York with my parents. I thought the song was sexy and tough. Untamed. The song was called "Tattooed Love Boys" and I was already dreaming, obsessing, about boys in that way that only a passionate teenage girl does.

‣ THE PRETENDERS
Tattooed Love Boys (1980)
LINK: http://youtu.be/vj3GdGk2B7c

I felt cool—alive—listening to this song on my way to some East Village art opening or party with my parents. I was their only kid. We were a close-knit family, and yet a part of me still felt like Jim in *Empire of the Sun*. I liked feeling that way though, imagining myself as some lost drifter. Loner.

My parents were cooler than everyone else's parents and they were young and smart and in love, and I had this whole life—my whole life—mapped out in my head, coursing through my body. I couldn't wait to meet the first boy of my dreams, and that summer in Provincetown, I did. I already loved The Pretenders and Chrissie Hynde. Her punk-bravado. So when I first heard "Tattooed Love Boys" I recognized Hynde's fire-underneath-the-ice toughness because I had it too.

"Tattooed Love Boys" shows up as soon it starts, like the most exciting person at a party. The person who walks in the door, into the room, and changes it—fills it. You. And you may not even like this person at first, but your life has shifted because of them. Changed directions. They've hit you like a drug. There is no warning when something—someone—like this happens; shows up. And "Tattooed Love Boys" is like this person. The person who suddenly, and without warning, appears in your life, as well as the person who recognizes the person who appears.

You… are… that are the last three dragged-out words of this song.

The lyric, *I, I, I, I found out what the wait was about* conjures a time-jump. So what is this wait? This wait, still. This wait, again. How do we know when we're waiting and not simply living our lives? That we're doing something extra, in addition to living. That there's an added element involved. The element of something future coming. Something not-yet.

I'm waiting to find that out, but to do that I have to wait some more. It's possible that I don't understand "Tattooed Love Boys" at all. Maybe Hynde is singing about something else entirely. Not boys, not love, not dreaming. Not waiting. Maybe what she's singing about is already happening. Already here. There. Maybe the words and the vim (charge) of the song are two different things. Or maybe the sound is the meaning.

But I love how hungry and free the track is. The way it rushes in unexpectedly. The way it can't catch its fucking breath. ▪

01 17 2012—YOU LOST A LOT WHEN YOU LOST ME

Sometimes I am Duckie in *Pretty in Pink*.

▪ THE RAVE-UPS
Positively Lost Me (1986)
LINK: http://youtu.be/AfdcbZxzKWc

01 18 2012—TIME-JUMP #2: 1984

Urban dictionary:
"A time-jump is a period of time during which an event is not seen but is mentioned or referred to. This happens constantly in movies and soap operas, especially when they are trying to create the illusion of movement."

▪ FUTURECOP
Class of 1984, Anoraak Remix (2010)
LINK: http://youtu.be/-85z6Ty_HTg

01 21 2012—I'M LOOKING FOR AN ANSWER

Me and a million others
Disbelievers
Deserted lovers
Dear God,
You better not let me down this time.
—P.J. HARVEY

• **P.J. HARVEY & JOHN PARISH**
Cracks In The Canvas (2009)
LINK: http://youtu.be/_UT2BkkMXuw

01 22 2012—ALMOST EVERYTHING DOESN'T HAPPEN

"Thomas Hardy wrote about people failing to meet as if these failures are scandalous occasions. What didn't happen astounded him… How can it happen and how can it not happen? If a person has said he will be in a certain place, shouldn't his body be as good as his word?… A chance meeting is a meeting that seems to exist with a great probability of not meeting circling around it. As we all know, almost everything doesn't happen."

—FANNY HOWE, *The Wedding Dress*

• **CAROL HUGHES**
Let's Get Together Again (1966)
LINK: http://youtu.be/S2d_gDS-L6Y

• **ROBERT BRESSON**
A Man Escaped (1956)
TEXT: *In 1943, in this world of cement and iron...*
LINK: http://youtu.be/QwqeEm9ocdk

For the one who needs it.
Lines I strung together from Bresson's *A Man Escaped or The Wind Bloweth Where It Listeth*:

"In this world of cement and iron."

"Your door. I'll try again."

"I unconsciously prepared myself."

"To fight. To fight the wall. The door."

"The door just had to open. I had no plan for afterwards."

"We thought, let's get as much silence in there as we can."
–ARTO LINDSAY, on DNA

▪ SCREEN
Acupuncture diagram of ear.

What has this been like?

It has been like turning you (X.) into music. It has been like listening all the time. They say: *listen* to your heart, not *feel* your heart. They say: what does your heart *tell you*? Your absence is loud and clear. Love is all ears and the word "heart" has the word "ear" in it.

My ears have been hearing things, things which aren't even words, or messages, while my eyes, along with everyone else's, are forever telling me that nothing is there. That nothing is happening. It is the difference between inward and outward. Between me and everyone else.

Sound is often the beginning of horror. In horror movies the non-believer often tells the believer: "I can't see anything. You're imagining things," which means that there is nothing there. By the time the non-believer actually does see or hear something (what's happening)—the horror made visual or audible—it's too late. In *The Exorcist* the Devil starts off as just a sound (rats?) in the attic. In *The Entity*, the poltergeist that rapes Barbara Hershey over and over makes a sound but never materializes. It remains unseen. But what it does to her is real. The bruises and cuts are real. The rape is real. The horror is real. *The Entity* is the misogyny of "it's all in your head" (or in the case of *The Exorcist*, it's all in your female body) taken to a horrific extreme.

In his book *Listening*, Jean-Luc Nancy writes:
"After it had designated a person who listens (who spies), the word *écoute* came to designate a place where one could listen in secret. *Être aux écoutes*, to 'listen in, to eavesdrop,' consisted first in being in a concealed place where you could surprise a conversation or a confession. *Être à l'écoute*, 'to be tuned in, to be listening,' was in the vocabulary of military espionage before it returned, through broadcasting, to the public space, while still remaining, in the context of a telephone, an affair of confidences or stolen secrets... One aspect of my question will be: What secret is at stake when one truly *listens*, that is, when one tries to capture or surprise the sonority rather than the message? What secret is yielded—hence also made public—when we listen to a voice, an instrument, or a sound just for itself? And the other, indissociable aspect will be: What does *to be* listening, *to be* all ears, as one would say, 'to be in the world.' mean?"

What does one risk feeling, discovering, when one listens as though everything were a secret? The ear hyper-extends. Goes in, above and beyond, and out of its way—defenseless, an opening you can't close. The ear is also a spy listening for clues. Elaine and I call ourselves, call each other, spies. Detectives. The way we don't just think (about books, movies, songs, love—people), we press our ears to things.

Nancy:
"The sonorous outweighs form. It does not dissolve it, but rather enlarges it; it gives it an

amplitude, a density, and a vibration or an undulation whose outline never does anything but approach. The visual persists until its disappearance; the sonorous appears and fades away into its permanence... What is the reason for this difference, and how is it possible? Why and how can there be one or several difference(s) of 'senses' in general, and also difference(s) between the perceiving senses and the perceived meaning, 'sensed sense' [*les sens sensibles et le sens sensé*]? Why and how is it that something of perceived meaning has privileged a model, a support, or a referent in visual presence rather than in acoustic penetration? Why, for example, does acousmatics, or the teaching model by which the teacher remains hidden from the disciple who listens to him, belong to a philosophical Pythagorean esoterism, just as, much later, *auricular* confession corresponds to a secret intimacy of sin and forgiveness? Why, in the case of the ear, is there withdrawal and turning inward, making *resonant*, but in the case of the eye, there is a manifestation and display, a making *evident*? Why, however, does each of these facets also touch each other, and by *touching*, put into play the whole system of the senses? And how, in turn, does it touch perceived meaning? How does it come to engender it or modulate it, determine it or disperse it? All these questions inevitably come to the forefront when it's a question of listening... Here we want to to *prick up the philosophical ear*: to tug the philosopher's ear in order to draw it toward what has always solicited or represented philosophical knowledge less than what presents itself to view—form, idea, painting, representation, aspect, phenomenon, composition—but arises instead in accent, tone, timbre, resonance, and sound... What does it mean for a being to be immersed entirely in listening, formed by listening, formed by listening or in listening, listening with all its being?"

■ **BRIAN DE PALMA**
Blow Out (1981)
LINK: http://youtu.be/rDve1A5EAvk

The ear strays, luring the eye away from what it sees or doesn't see. While the ear stretches and cranes its neck to hear, the visual is either there or it isn't. And depending on which, we're either interested or we aren't. We see or we don't see. What you see is what you get. Out of sight out of mind. Yes or no. The visual filters, cuts, leaves things out. Composes. Sets limits. Denies.

Nancy:
"The visual persists until its disappearance; the sonorous appears and fades away into its permanence... Shouldn't truth 'itself,' as transivity and incessant transition of a continual coming and going, be listened to rather than seen?"

In Brian De Palma's *Blow Out*, sound is spied. A microphone that is there to witness something else discovers a secret (sound) that no one was supposed to know (The *Blow Out* trailer informs: "It began with a sound that no one was supposed to hear."). The sound in *Blow Out* is a "murder that never happened," and had Terry not been listening at the moment he was, that sound would have been lost forever. The murder (instead of a death) would have been a tree in a forest.

In *Notes On A Cinematographer,* Robert Bresson states that one should know "what business that sound (or that image) has there" and "What is for the eye must not duplicate what is for the ear."

So what is for the ear in Bresson's *Lancelot du lac*? What kind of ear and/or eye must one have for this film? What is sound doing in the empty forest of *Lancelot*? Why should we look at it when there is "nothing" there? When the visual is incomplete—missing something? Missing action, missing presence. What is the purpose of *showing* us how the forest sounds? Feels? The way it looks when it isn't full of

▪ **SCREEN**
Guinevère's blue scarf.

warring bodies. The forest as a silent witness, a repository; a space that hears and sounds; picks up on things like a microphone (inverting the acoustic schema of *Blow Out*). Records the sounds that bodies make and leave behind. Or rather, *is* that sound.

Both *Blow Out* and *Lancelot* invoke the idiom "for your ears only," bringing us back to espionage and secret. Radical listening. "While music flattens a surface, makes it into an image," Bresson explains, "sound lends space, relief. It arrives and the screen deepens, thus bringing on the third dimension." For Bresson, sound should never duplicate an image with a sound ("a sound must never come to the aid of an image, nor an image to the aid of a sound….the image and sound must never reinforce each other, but must each work in turn in a sort of relay"). Perhaps Brian De Palma's ideas about the verisimilitude of sound in *Blow Out* came from Bresson's *Au hasard Balthazar* (1966), and not just *Blow Up*'s meditation on the image (also 1966). In *Balthazar*, the first car accident is seen, the second is heard. Bresson, who recorded all his sounds separately to be able to "mix them in the correct proportion," believed that "a tape recorder captures true sounds, whereas the camera greatly deforms the real." It is significant, then, that with *Blow Up* and *Blow Out*, we start with the lie of the camera and end up with the truth of (recorded) sound.

How should we read Guinevère's blue scarf in *Lancelot du lac*?

She has been there in this spot. Lancelot has too. As well as a third person, who is neither Guinevère nor Lancelot. This cloth has in it the vibration of Lancelot's touch and Guinevère's body. It means something to Guinevère, and to Lancelot who greets Guinevère by putting her cloth to his mouth as if it were a mouth—hers. In *Notes on a Cinematographer*, Bresson quotes Cezanne: "At each touch I risk my life." And so, the scarf, laid there, left there, is the distance between Guinevère and Lancelot. But it is also the proximity. Their intimacy. The touch *and* the risk.

In her blog post* about *Lancelot du lac*, Elaine quotes from film scholar Bliss Cua Lim's chapter "The Ghostliness of Genre" in her book, *Translating Time: Cinema, the Fantastic, and Temporal Critique*: "The ghost film's core conceit, visualized in its mise-en-scène, is that space has a memory." A forest has a memory. A room has a memory. A scarf has a memory. The sound of touch. The ghost of touch. The touch of sound. Both Bresson and Elaine make ghost films. That is, films that are informed by the ghostliness of living. "…What has being and has been in being" (Heidegger).

* http://elainecastillo.tumblr.com/post/14175845569/many-thanks-to-the-very-kind-editors-at-juked-for

In *What is Called Thinking?*, Heidegger writes: "What keeps us in our essential nature holds us only so long, however, as we for our part keep holding on to what holds us. And we keep holding on to it by not letting it out of our memory. Memory is the gathering of thought. Thought of what? Thought of what holds us, in that we give it thought precisely because It remains what must be thought about."

▪ ELAINE CASTILLO
Holy Forest (2011)
LINK: http://vimeo.com/21658543

The impression (as in pressing *into*, or indenting) a person makes when they come, and leaves behind when they go—when they appear/disappear—is not, after all, a presence/absence that you see. It is one that you feel. One that leaves a dent in you. In *Lancelot du lac*, Guinevère knows that Lancelot isn't dead even though everyone insists that he is. How does she know this? Because Lancelot's life is (makes) a sound that Guinevère can hear. That is for her ears only.

Elaine Castillo's film *Holy Forest* is an example of what Nancy calls "visual sound" or "vision that is sonorous." In *Holy Forest*, green is born, unfolds, grows, vibrates. It is the whole world's sonority; "the whole system of the senses" (Nancy) touching and shuddering at touch. *Holy Forest* is like the secret sound that *Lancelot du lac*'s forest makes. It is also the mourning of all its dead bodies.

"To be listening," writes Nancy, "is thus to enter into tension and to be on the lookout for a relation to *self*: not, it should be emphasized, a relationship to 'me' (the supposedly given subject), or to the 'self' of the other (the speaker, the musician, also supposedly given, with his subjectivity), but to the *relationship in self*, so to speak, as it forms a 'self' or 'to itself' in general, and if something like that ever does reach the end of its formation. Consequently, listening is passing over to the register of presence to self."

Arto Lindsay:
"We thought, let's get as much silence in there as we can…"

Bresson:
"Be sure of having used to the full all that is communicated by immobility and silence."

The sound of you (X.) coming. The sound of you not coming. The sound of you wanting to come. The sound of you not wanting to come. It's not that I can hear you exactly—the *message of you*, or us. It's not even that there's a message *to* hear. Though I think there is. It's that we make a sound even if the picture looks empty. ▪

▪ SCREEN
Au hasard Balthazar (1966), Robert Bresson.

Who says things like "Passionate for the appropriate"?

Robert Bresson does.

"'Craft' literally means the strength and skill in our hands. The hand is a peculiar thing. In the common view, the hand is part of our bodily organism. But the hand's essence can never be determined, or explained, by its being an organ which can grasp. Apes, too, have organs that can grasp, but they do not have hands. The hand is infinitely different from all grasping organs—paws, claws, or fangs—different by an abyss of essence. Only a being who can speak, that is, think, can have hands, and can be handy in achieving works of handicraft. But the craft of the hand is richer than we commonly imagine. The hand does not only grasp and catch, or push and pull. The hand reaches and extends, receives and welcomes—and not just things: the hand extends itself, and receives its own welcome in the hands of others. The hand holds. The hand carries. The hand designs and signs, presumably because man is a sign. Two hands fold into one, a gesture meant to carry man into the great oneness. The hand is all this, and this is the true handicraft. Everything is rooted here that is commonly known as the handicraft, and commonly we go no further. But the hand's gestures run everywhere through language, in their most perfect purity precisely when man speaks by being silent. And only when man speaks, does he think—not the other way around, as metaphysics still believes. Every motion of the hand in every one of its works carries itself through the element of thinking, every bearing of the hand bears itself in that element. All the work of the hand is rooted in thinking."
—HEIDEGGER, *What Is Called Thinking?*

Some people's fame and success is really just a barometer for what a mess the world is.

"A text is not a text unless it hides from the first comer, from the first glance, the law of its composition. A text remains, moreover, forever imperceptible."
–DERRIDA, *Platos's Pharmacy*

"We forget too easily that a thinker is more essentially effective where he is opposed than where he finds agreement."
–HEIDEGGER, *What Is Called Thinking?*

"One of Cassavetes' strengths, which he had in common with many great artists, was his stubborn phobia about being ackowledged by any form of right-on thinking, no matter where it came from."
–OLIVIER ASSAYAS, on John Cassavetes

In *Outlaw Culture*, bell hooks points out that we should be suspicious of any film (its politics) that wins an Oscar, for whatever gets unanimous praise is rarely also progressive.

"A man for whom nearly all books have become superficial, who has kept faith in only a few people of the past that they have had depth enough—not to write what they knew."
–NIETZSCHE, *Notebooks, GW XIV, p. 229, Aphorism 464 of 1885*

"They all talk about me… but nobody gives me a thought."
–NIETZSCHE, *Thus Spake Zarathustra*

"The superman is the man who passes over, away from the man as he is so far, but away whereto? Man so far is the last man. But if this manner of living being, 'man,' in distinction from other living beings on earth, plants and animals, is endowed with 'rationality;' and if ratio, the power to perceive and reckon with things, is at the bottom a way of forming ideas; then the particular manner of the last man must consist in a particular manner of forming ideas. Nietzsche calls it blinking, without relating blinking explicitly to the nature of representing or idea-forming, without inquiring into the essential sphere, and above all the essential origin, of representational ideas. But we must nevertheless give its full weight to the term Nietzsche uses for this kind of ideation, namely, blinking, according to the context in which it appears. We must not take it to be the same thing as the merely superficial and incidental wink by which we signal to each other on special occasions that in fact we are no longer taking seriously what is being said and proposed, and what goes on in general. This kind of winking can spread only because all forming of ideas is itself a kind of blinking. Ideas formed in this way present and propose of everything only the glitter, only the appearance of surfaces and foreground facets. Only what is so proposed and so disposed has currency. This type of representation is not first created by blinking, but the other way around: the blinking is a consequence of a type of representation already dominant. What type? The type that constitutes the metaphysical basis of the age called the Modern Age, which is not ending now but only just beginning."
—HEIDEGGER, *What Is Called Thinking?*

01 30 2012—TIME-JUMP #3: WHAT'S UNDERNEATH IS WHAT'S AHEAD

▪ DAVID BOWIE
Subterraneans (1977)
LINK: http://youtu.be/Yke-c1z8_9Q

OI 3I 2OI2—TIME-JUMP #4: WHILE YOU WORK, YOU SHOULD THINK

"Dig deep where you are. Don't slip off elsewhere. Double, triple bottom to things."
—ROBERT BRESSON

▪ **NEW ORDER**
Elegia (1985)
LINK: http://youtu.be/3LY3ftiLqmE

O2 OI 2OI2—HOW MUCH LONGER UNTIL WE GET THERE

Did you stroke my face when we kissed? I can't remember. But that's what I remember. That you did.

I read this (which he writes in all caps) by Bresson today:

THE BONDS THAT BEINGS AND THINGS ARE WAITING FOR, IN ORDER TO LIVE.

▪ **SCREEN**
Ten of Wands (Rider-Waite Tarot).

There has been a lot about waiting in what I've been reading lately. I am waiting and I am reading about waiting. I am waiting in a world where no one waits anymore. For anyone. Where nothing waits. For anything. Waiting is one of the hardest things to do. Waiting is a discipline. A test. A phenomenology. A gift in disguise. Waiting is a test because it asks you to prepare. To believe that time is not wasted in the silence. Waiting asks you to be ready for things you can't even see. Be ready anyway. Be ready just in case. Be ready in order to have it. Be ready in order to be it. Be ready in order to make it be. Be ready as if "nothing" is always everything and can, at any moment, be all.

Last week I pulled the Ten of Wands. I pull this card all the time.

How much longer until we get there?

Some days my face is buried in the sticks.

In class yesterday I told my teacher, Avital Ronell, the people who can't let go are the ones I like the most. She liked that I said that. She said she is that kind of person too. Later *Hamlet* came up again; the poison in the ear, "the Hamletian stance." Brooding, mulling, remembering, listening, obsessing. Holding on and latching onto. Not letting go of your object for another object. In *Hamlet*, Ronell says, "readiness is all." ▪

In response to L.'s letter and Tumblr post.

Whatever I I have is always for a We. Whatever I I'm striving for is always for a We. Whatever I that's worth owning, using, defending, living, is always for You. Anything that's mine just for the sake of it, and just for its own sake, isn't worth much; that isn't put to use for the Other, for another, with another, to see what kind of I I *really* am. When it comes to being more than my I, more than our I's, if my I means anything, it has to be for You. Us. The agency of the I is about how we use it and what we use it for—in relation, in relatedness. The I is a dream that is only worth having—dreaming—if I can leave it behind for a much more modest and radical We. My I will only ever be as good as our We. In what my I does for You. Another. This is where my I gets tested, activated, acted out, and pushed out of (its) narcissism, hermeticism, abstraction, self-satisfaction, hypothesis. Its self-referentiality and sovereignty. Selfishness and tyranny.

Last week in class, we discussed Heidegger's concept and vision of the We in *What Is Called Thinking?* The We in thinking, in thanking, in remembering, in being human, "Underway," as Heidegger would say. We questioned the ethics and in/ex-clusiveness of that We, of course— who fits into Heidegger's We and who doesn't. Who is Other to that We, and who is insider. But we also recognized that Heidegger insists upon and privileges a We, rather than an I. A related-ness and relationality, and not simply a subjective crusade that drives itself against a world of Others. The militancy of the I. The straight line. The force. Most of all, the We expresses a gratitude that the I just can't. Falls short of. When the We is really a We, a loving and thoughtful and generous We, it is gratitude itself.

The relationship between thanking and thinking that Heidegger points out:
"The *thanc* means man's inmost mind, the heart, the heart's core, that innermost essence of man which reaches outward most fully and to the outermost limits and so decisively that, rightly considered, the idea of an inner and an outer world does not arise… The *thanc*, the heart's core, is the gathering of all that concerns us, all that we care for, all that touches us insofar as we are, as human beings."

The *inmost* mind, not the outmost. Like the inmost heart. The heart of the mind and the mind of the heart. If you go from the inside out, you can start to dissolve the whole binary of inner and outer. I/you. Also, "rightly considered" because I think love is that. The person who con-siders you rightly. The rightest of consideration is love. What does it mean to think of/about another? On a side note, it's not just time that's out of joint (*Hamlet*, Derrida's *Specters of Marx*), it's you, X. This person I thought could be mended. Could be healed by and in time. That deli-cate bone—joint—that puts everything (you) back together again. That everything-joint, which contains the word 'join.' Will you ever know anyone who believed in you that much again? Isn't that a gift you never even knew you had?

Everyone is out of joint, not just you or time. Everyone breaks your heart. Falls short of what could be. Again and again. ▪

When I think about you, X., I also think about what-how you think. How you "think" in order not to think. How you use what you think you know as armor. How you wear what you know as a bulletproof vest. To block. Not to open or connect things, but to shut them down. To isolate them. To close them. This would always have been a problem between us. But maybe this is also where love starts? Could have started. Would have had to. Everything starts with what you will and will not do.

Who do you become when you begin to think? Who do we? Your mind on my mind. Your mind in my heart.

"…And yet, you're saying yes, almost automatically, suddenly, sometimes irreversibly. Your picking it up means the call has come through. It means more: you're its beneficiary, rising to meet its demand, to pay a debt. You don't know who's calling or what you are going to be called upon to do, and still, you are lending your ear, giving something up, receiving an order. It is a question of answerability. Who answers the call of the telephone, the call of duty, and accounts for the taxes it appears to impose?"
—AVITAL RONELL, *The Telephone Book: Technology, Schizophrenia, Electric Speech*

Heidegger: "Such listening is up to us alone."

In *What Is Called Thinking?*, the text performs a call and answers a call. Waits for a call. Asks what it means to wait for and answer a call. It dials. It thinks as though thinking were holding the receiver up to your ear. Remember the words we used to use to describe the telephone, which is now just referred to as my cell phone? We have removed the distance (the ontological trope—the *tele*) that made a connection (answering) possible.

What's closer, easier, has in fact become farther, more difficult.

Cell phone. Tele (télé, from far) vs. cell (cellularis, from cellula "little cell").

What's close to us now. What leaps we aren't making. What distances we aren't going. What's contained in our cells. The techno inside of us, the us inside the techno. The machine of tissue. The machine of inside.

Thinking in vain. Thinking as vanity instead of gratitude, gift, devotion—*thanc*. The kind of thinking that isn't thinking, that gets you nowhere. That shows off and is loud and clear. Has an answer but doesn't listen.

Avital Ronell: "Philosophy is never where you expect to find it."

All my life I've wondered how people can say that what you think or don't think (what happens in your mind) about the one you love is not as important (or important at all) as what you actually do. Why else would we have the idiom, *I have you in mind*? ▪

I don't really know what it is about the end credits of *Jaws*. Even after seeing it so many times. After writing so many essays and stories about this movie. A lifetime of this ending. This watery credit in real time. It's a movie I love but also hate. A movie I've eviscerated. That I don't trust. That I am spellbound by. That I always watch when I find it playing on TV. That I can never say no to, at least not entirely. That I've been obsessed with since I was a kid. A kid who

▪ **JOHN WILLIAMS**
12 End Title, Theme from Jaws (1975)
LINK: http://youtu.be/xe_hhSo9Trw

summered on the Cape and had a thing about the ocean. And sharks. And that triangle of men. And Roy Scheider because he does male dread—weariness—so well. Maybe even better than Robert Shaw. A movie that reminds me of home, wherever that is. Of childhood, whenever that was. And that sounds like it too. The music here says something the rest of the film doesn't. There is something non-diegetic about these end credits. Something sad, but there is also such relief. So much pro-filmic beauty, "the blue of reality itself," it stings. William Gass, who wrote *On Being Blue*, would say all this blue gives the scene (which I couldn't find on YouTube) an interior life, as "blue and green have the greatest emotional range." *Jaws* is one of the most beautiful real-water movies. The water, the color, the moon, the shooting stars above the Orca boat at night are real. And the fact that it's real, that it's the last of the real, only makes what this kind of film did to film that much more haunting. So it's a farewell and a salutation. A coming to shore and a going deeper, further, away into something else. Into a sea that has no shore. No break. No real place. It took months of actually being on and in water. With water. Nearly two years. And you can feel it. And this end theme is the long goodbye. ▪

02 10 2012—FAKE INFESTED WRITERS (AND ARTISTS) AND THE PEOPLE WHO SUPPORT THEM

"Imagine for a moment that I have gained possession of the famous talisman of Gyges, a ring (as Plato tells) which confers invisibility upon its wearer when the bezel's turned. Of course I can kiss, kill, and steal easily. Without paying, I can get in all the games. I can play tricks in a world of rubes. But what else? …They know what it is: being blue; but who can feel how this world was once, counterfeiting has so changed it."
—WILLIAM GASS, *On Being Blue*

I wonder if people realize just how radical *Say Anything* is. Take this one scene, for example. It's radical for a brokenhearted woman to publically voice and display her broken heart. Her anger. And it's radical for her to have a best friend who's not only this kind of best friend, but this kind of man (in a later scene Corey will explain the important difference between being a guy and being a man to Lloyd):

· CAMERON CROWE
Say Anything (1989)
CLIP: "That'll Never Be Me"
LINK: http://youtu.be/jAOHcqhGkMc

A man who chooses the humanity and friendship of the women in his life over the sexism and insensitivity of men (this is *not* "bros before hos." What interests me about this horrible idiom is its fundamentally misogynistic organization. The statement could have been "bros before sisters," emphasizing the primacy of friendship over sex. This would still be problematic and sexist—men come first either way; there's no "sisters before cocks," after all—but it would have been mildly better).

And most radical, a man who actually confronts other men about their insensitivity towards women. Who sticks up for them (Lloyd sees Joe coming without even looking at him)—not just as girlfriends (perfunctory chivalry), but as women, as talents—as "human beings."

Then touchingly: Lloyd actually makes Joe look at him when he tells him all this because Joe isn't paying any attention to what Lloyd is saying. Lloyd adjusts Joe's face to face him. This isn't simply a man paying lip service to feminism and this woman's pain isn't a spectacle.

A real face (Lloyd) for a fake face (Joe).

A man and a guy.

This friend, this man, is the real deal. And that's why Lloyd "gets the girl." ▪

The camera is always on, so how do we live? We live like it is always on. Like without it, we're nothing. We live like there is no other way. Like being off is being dead. We live like life is one episode after another. We have to be reminded of what we've seen, what and who we're seeing, over and over. There is this unbearable loop of image. This horrible rub of spectacle and knowingness that erodes.

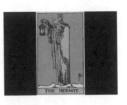

▪ SCREEN
The Hermit (Rider-Waite Tarot).

You see mistakes being made all the time. You see everyone relishing everyone's mistakes. A culture, an epoch, a style of mistakes. Of sloppiness, of no attention. But you have never been allowed a single mistake. Forgiven a single mistake. People wait for you to do nothing wrong. Nothing counts but with you it counts. Why? What is the difference? You live watching your own every move and still no one gives you an inch. Everything is on record but that record is never held responsible. Never remembered. So what is the record of? Who is it for?

The new reign of media, in this case Reality TV, is not just about watching the way others live, or turning life into something you watch, then live, or live in order to watch. It's the way we have learned to live through and from the camera, as though the camera and screen are subjectivity itself, and so our lives are only worth the show. Worth the showing. Life becomes a new instrument, a new technology, a career move.

Where would we be without this camera? In it, on it, behind it, because of it. We are just like what it shows. We learn by example. By watching. Life becomes mis en abyme. Everything we get by the time we get it has passed through a visual system. Through what we've already seen and heard. Do we even believe anything we see and hear anymore or do we see the end at the very beginning? The beginning at the very end. Behind the scenes, behind the curtain, has almost never counted. Only covering it up counted. Counts. The being that was there never mattered.

Since you always hide; since you only want to be with the people you choose; since you always want to be for your writing and in your writing—only; since you think this is enough; since you do not want to perform or supplement the writing with performance; since you do not want to perform the writing or for the writing anywhere but in the writing itself, what will you do and who will you be and what will become of you?

Your idea of the writer, your way of being a writer, is outdated, outmoded, anachronistic. Shy, quiet, serious, slow, alone. Private. There is no public persona, there's only who you are, whatever and whoever that is. So will the writing die because of it? Is the writing enough? Is the book enough? Are the ideas enough? Is being a real human being enough? Will it not show or count, or will people not see it because you won't clown around for it? You won't and can't be everywhere or everyone. And if it's not enough, it only makes you want to do what you don't want to do, even less. The filmmaker and Tarot historian Alejandro Jodorowsky says, "the Tarot will teach you how to create a soul." You often pull The Hermit.

All your life, in fact. Jodorowsky describes The Hermit as, "deep connection with yourself, to go through a crisis to rise to the lamp, that is, to find your inner light."

Your fantasy has always been to run away. To a faraway place, into a book and into love with just one person. Into the writing, into the place you need in order to write. In order to live, in order to think, in order to get away.

▪ ALEJANDRO JODOROWSKY
CLIP: "Tarot of Marseilles"
LINK: http://www.dailymotion.com/video/x5merh_
alejandro-jodorowsky-tarot-of-marse_webcam

When will you stop despairing over people and just get cynical and detached and used to it like everyone else? Last night, you accidentally ended up watching all these old interviews with Boy George on YouTube because you loved him as a child. Because you thought he was delicate and tough. Last night you discovered that all his Culture Club love songs were about his romantic relationship with the straight-acting Jon Moss. You couldn't believe the way he spoke his mind in a world where that might be the worst thing you can do and where you lose everything because of it. In one interview he said, "Love is like God. You just have to believe it exists."

You don't know. You are starting to think maybe it doesn't. There are certain things you haven't lost because of what you've lost. This is the irony. ▪

02 20 2012—TIME-JUMP #5: TIME IS LIKE A CLOCK IN MY HEART

Time won't give me time.

▪ CULTURE CLUB
Time (Clock of the Heart) (1982)
LINK: http://youtu.be/uWqADGubxG8

The other night I watched a movie about two lovers who can't be together, aren't together, but come together. Who weren't even supposed to be lovers. Who don't start out that way. Who start off just having sex. It's a long story why. But sex is a threshold. Through sex these two people cross over into love. At first the two lovers are just two people who have sex for one specific reason. Who don't and can't look at each other when they do. Who go through the motions because they have to. But then something happens, something changes, the two bodies latch on and lock, and we see sex turn into love. We see the difference between the two. Two separate bodies start to see each other, feel each other, and the form changes, even though the medium—sex—is the same. Their bodies fall in love even before they know how they feel about each other. Their bodies tell them first.

▪ **SCREEN**
Vera Farmiga in Gina Kim's *Never Forever* (2007).

▪ **SCREEN**
Jung-woo Ha.

After they reunite and make love in a way they never have before, the male lover asks the female lover, "You wanted to say something the last time we saw each other, but you didn't. What was it?" The female lover answers, "I wanted to say, thank you." It's a long story why. The male lover says, "That's it? Why didn't you say it?" Because, the female lover tells the male lover, who is like a female lover, "I thought it would separate us forever." I understand what the female lover means. How even one word can change everything, so you don't use it. You don't say it. How one word is a catalyst for a breach or a copula. You hold onto a word or you let a word go. You let it do its breaking. How something like "thank you," which is meant to conjoin, can actually separate. How one word becomes a thread that snaps or a thread that ties. You and another person, like in Pasolini's *Decameron*, where one character tells another, "Say just one word and you'll save both my life and yours."

And now I understand why you, X., didn't say goodbye. Why you just got up and walked away on our last night at school. Only now it doesn't matter why you did what you did. Why you didn't say what you didn't say. Sometimes a reason is not enough. Sometimes a reason expires. And at the end of the movie, even though the male lover is not in the final frame, he is in the big picture. The way when you have love, it's anamorphic, so it's there even when it's not there in plain view. Like cinemascope it wraps around. Is wider than you can imagine. Shows the entire picture, the whole picture, even the picture that doesn't show. The picture you can't see.

It was his picture first. His life hanging on his wall. It was their future and she saw it. Went forward. It was his past and she would one day be on the other side of time. An image that belonged to him, that he said he didn't miss, but reminded him of home. Still a stranger, she noticed the picture, which was really a crystal ball, a divination, a poster of a vast ocean from a travel site, and asked him about it. Where is that? It is a beach in Korea. It is where he is

from. But later this is where she ends up with their son. On this beach. This picture was hers, her life, all along. Half of her, half of him.

They are seeing things before they are even there, or those things are there because they have come together and want to see them. Need to seem them. Are capable of this sight, and their unity make these visions possible. They are connected and this is why they are connected. Seeing and following the signs. They are signs too. For each other.

▪ **GINA KIM**
Never Forever (2007)
CLIP: "(Outstanding Love Scene)"
LINK: http://youtu.be/WhPdvOOiCvo

He sees (feels) her without seeing her. She sees (feels) him without seeing him. Has an orgasm at the thought of him; at the thought of him doing what he hasn't even done yet, what he will do, his face between her legs, him fucking her the way he hasn't fucked her yet, but will.

She has this orgasm while sitting with her husband and his family, while celebrating her pregnancy, her marriage to another man. What is a marriage? She makes a sound as if she is coming, to echo the silent sound (vibration) of his coming, and when everyone turns around to look at her, she blames the sound, the one that accidentally leaks out of her mouth, on pregnancy pains. What is pregnancy? What is laborious? What is giving birth? What is being inside of someone and someone being inside of you? She says she is too hot. She feels, gets aroused, by his trace, by the idea of him showing up. *Coming.* He comes (cums), she comes (cums). Orgasm becomes a reunion.

For months I felt you, X., everywhere. I thought it was real. The feeling, which felt like your actual body coming towards me. The law of physics, which says we must both be doing this— thinking this, feeling this at the exact same time—for such a magnetic pull to occur. I thought you were actually somewhere near me, all the time. Thought that like a character in a movie, it meant you were coming.

The trace he leaves behind. The residue of his brief presence there. Minutes before, he had actually tracked down where she lives from a dry cleaning receipt for a coat her husband had tried to kill himself in, in a bathtub of water, and showed up at her house. Just stood outside of it in an orange t-shirt, dressed like a teenage boy, and her husband came out to ask if he was a guest and he said no. Said he had the wrong house. He is an immigrant, an outsider, all he does is work, all these menial jobs, while her husband's family are immigrants with a son who has made it inside as an outsider. But outsiders—some outsider—always remain.

So he's there, he was, and suddenly, through her husband's body, which was just next to his body, she knows he was there even though she doesn't know it, and knowing this in the way that she knows it, which is to sense it, gives her this enormous surge of pleasure. This overpowering rush (premonition) of touch, which is also an epiphany. Intelligence. Maybe alien, but destiny is really desire's true dwelling. A body showing up, arriving, reaching yours. Like a telegram. The

other's body as a home for your body. When everyone in class, including Avital Ronell, says that unity with the other is impossible, I know better. As Badiou puts it, "Love is proof of Two." I know it's been possible. I know all the opposing theories, I just don't believe them. At the end of the day, I believe in the possibility of the impossible, in communion, in the other as the only faith, in the odds, the stakes, the signs. ▪

02 25 2012—TIME-JUMP #6: NEW WAVE BABY

▪ **JOHN MAUS**
Keep Pushing On (2011)
LINK: http://youtu.be/7Ms9ip08xRg

There is no way to know anything quickly. There is also no way to know anything just by reading alone. To think quickly and deeply at the same time is an oxymoron. And, contrary to popular belief, to read everything is not to know everything. Nor does knowing everything mean you're thinking. Philosophy is (as are so many other disciplines) in crisis today, for in order to be in the game (which is what knowing has become—a game) of knowing, one is required to read ("know") everything. One must read and cite all the books that are constantly being published: to get the job, to be part of the academic clan, to be heard, to be valued, to get known, to be on the intellectual circuit. And yet philosophy is time-intensive. Life-intensive. It isn't something you can do quickly. Understanding, if it happens at all, happens over time. A lot of time. Philosophy isn't easy or light. It isn't quick reading. It isn't even cumulative. It insists on a pace that is cripplingly slow and elusive; a slowness that is in complete opposition to the pace and demands of late modernity. In late modernity, one has to do everything—including philosophy—fast in order to make "progress." 21st century modernity contradicts and compromises the possibility of ever really knowing or thinking in a way that isn't purely technical. So what kind of relationship to philosophy are we assuming then? Will we *ever* assume, assuming we ever even assumed it? One of speed and performance, one-upmanship, jargon, and regurgitation. We don't think. We use philosophy to answer philosophy instead of using it to answer the world. ▪

03 02 2012—DREAMS KEEP YOU FREE

▪ **SUICIDE**
Dream Baby Dream (1979)
LINK: http://youtu.be/5LayQ98lR8l

I go on. I go in. I come back out.
When I am too far in, I can't imagine ever being out again.
When I am out, I can't imagine being in.
As far in as I was.
I quickly recover.
I never recover.

Downstairs in the laundry room, and no one is there. Thank god. I get to just do my chore in peace. A little radio whispers on a shelf. I'm near it. A boy, 19, the same age as Lloyd Dobler in *Say Anything*, calls up a radio station and tells the female DJ that he wants her to play a song for the woman he loves. The song is called "In Your Eyes." The woman asks him a few questions on the air. Like: Why do you love her? He says: Because we're always there for each other. Because she's my best friend. And the

- **PETER GABRIEL**
In Your Eyes
Music from the Motion Picture: *Say Anything* (1989).
CLIP: "Say Anything...// Lloyd Dobler & Diane Court"
LINK: http://youtu.be/OFRdhRVMTEs

female DJ, who's in her 40s or 50s, tells the boy: I wish I'd had your wisdom at 19. I spent most of my life thinking there were the nice guys and the gorgeous and funny guys. And I wanted the gorgeous and funny guys. And it wasn't until after many years that I realized that just looking for gorgeous and funny is not love. The boy says: Thank you. Then the DJ plays the song. And since there's no one in the room, and *Say Anything* is a movie I love, and Lloyd Dobler is a boy I love, and I know all the words to this song, and I've been singing them for half of my life, and this is really what I need to hear right now, I turn up the volume and sing the song out loud. ▪

03 06 2012—TIME-JUMP #7: TELLING TIME

- **PHOENIX**
Definitive Breaks (2000)
LINK: http://youtu.be/fJ2l5GeCOas

"The witness will be said to be time itself."
—ANNE DUFOURMANTELLE, *Blind Date: Sex and Philosophy*

This quote, which is the sister of "only time will tell," applies to every single time-jump in the time-jump series.

This song is the Mother.

"It's been five years since
my last dream came true."
—TERI GARR, *One From The Heart*

▪ **TOM WAITS & CRYSTAL GAYLE**
One From The Heart (1982)
LINK: http://youtu.be/iaUl8M5GZHE

I took the soundtrack *One From The Heart* with me to California, where I went to write at an artist's retreat for a month. W. and I had gotten in touch a week before I left New York and made a plan to meet. It had been ten years, and we'd found each other on the internet. That sounds obvious now, but in 2004 it was less obvious. The internet wasn't the first place you went to find things yet. First I found W.'s handwritten letters in a box, and then I typed his name into Google. Unbeknownst to me, he'd been doing the same thing all week, only he wasn't getting anywhere. He was easy to find, I wasn't. When he called the artist's retreat, which listed the dates of my residency on their website, to ask them for my number, he was told that the information was confidential. He didn't know what else to do, so he kind of gave up. And then, a couple of days later, he got my email.

It all started, he later told me, with our common friend, C. (who'd known the both of us back then) asking him, "Whatever happened to Masha?" on the phone every year.

I listened to "One From the Heart" in my room after we saw each other again.

A week before my trip to California, I purchased a bunch of movie soundtracks to take with me. I had been watching 80s Coppola—*One From The Heart, The Outsiders, Peggy Sue Got Married*. His Time Trilogy. His Genre Trilogy, which is how I think of these films.

How does a film show up again and why? How does a person? Who are they the second time around? Who are you? The history of genre is also the history of emotion. Genre and gender are allegories of time. Coppola's boys in *The Outsiders* are like girls. Like Natalie Wood in *Splendor in the Grass*. I remember how much the score to *The Outsiders* made me cry as a kid. What was I so sad about? Why did movies always unleash such a barrage of tears? Why did the film's pink sunset color? Two feminine-looking and feeling boys talking about what's pretty and turning pink like the sky. As a boyish girl this, among other things, really got to me. People making the world beautiful again just by talking to each other in a way they're not supposed to because they are boys. There is a lot of cinematic history in the back (not even the back) of this scene from *The Outsiders*—Kazan and Sirk. *Splendor in The Grass* and *East of Eden*.

Writing about Coppola's *Dracula* in her essay "From Dracula—with Love," film theorist Vera Dika points out something that defined much of Coppola's work in the 80s and early 90s, "By including the name of the novel's author in his work, Coppola refers us back to the 'original,' but does so precisely at the close of the twentieth century, in an era that has been called post-modern and where the original is often hopelessly muted." In Coppola's 80s films, the original isn't simply the film that came before, it's *before* coming *later*, and then *again*. A film at one time, passing through time, and returning as something else. Something extra. This is not the

same thing as reflexivity, but rather, as Dika puts it, "a postmodern neo-mythification." Neo-mythic is epic, as is blatant emotion in a time when we are supposed to have receded from emotion even in movies. Emotion is retro. Feelings are history.

A few weeks ago I remembered the song, "One From The Heart" for some reason, heard it in my head. I remembered how I listened to the song on my headphones in my room in California while I worked, replaying the first time he touched me again. It felt like the inside of his hand, which is the first way he touched me after 10 years. I thought I was going to melt when it happened and then thinking about it, to this song afterwards, in my California room, just blew it all out of proportion. Luckily he meant it the way I took it.

At the retreat, he would show up at my door to pick me up for our all-night dates, agitated but soft for me. I think that's maybe my favorite combination. Agitated but soft. People who are like forbidden cities. People who only love people who have the key to them. People who unlock each other.

- **FRANCIS FORD COPPOLA**
The Outsiders (1983)
LINK: http://youtu.be/TwJ-ppxCGPk

- **FRANCIS FORD COPPOLA**
One From The Heart - Trailer (1982)
LINK: http://youtu.be/g6aYLln9zXs

- **FRANCIS FORD COPPOLA**
One From The Heart - Trailer (2003)
LINK: http://youtu.be/5sepPvX12m8

Movie love. The look of love. How movies do love. What movies have done to love. How we love or don't love because of the movies. How we let ourselves love in movies but not in real life. What came first, movie love or real love? Which one is real and which one isn't? Which one still exists? Which one doesn't? *One From The Heart* is about all these things, whether it means to be or not.

We were sitting in the car, which we'd stopped in the middle of the road, up in a forest of redwoods. It was 3 o'clock in the morning and he was doing field work. It was raining. We were following his friend's (also a biologist) car, who stopped because he saw a huge Tiger salamander that had been hit and run over. Still alive, its head was crushed and it was suffering, barely breathing, so we had to put it out of its misery. When he touched me afterwards, for the first time, it broke all the ice and unleashed a flow of touch that didn't stop for years. He looked at me, sighed, and cupped the back of my head and the side of my face in his hand. His look. It was the same look he gave me when we were kids. From across a room. He knew I'd been injured, crushed, like that salamander. I was suffering and he showed up and put me out of my misery.

"He held me like the mother I had never had," Fanny Howe writes in *The Wedding Dress*. Except I do have a mother like that, so I know how rare it is for a man to love you, to touch you, like a mother. Mother instead of father. We need more mother love. Wanting mother love is queerer than the standard girl wants her father and boy wants his mother. Nothing really gets challenged in that binary. There is Daddy's girl and there is Mama's boy, but is there a Daddy's boy or a Mama's girl? The feminine and the maternal in men is rarer than the phallic and the masculine in women, for women (both straight and queer) are taught to identify with sexism in order to access power. But what man is taught that strength is synonymous with vulnerability and femininity? What man is told that he'll be rewarded if he cares for you like a mother?

I played that night over and over again in my head like a song. Whenever I listened to "One From The Heart" at the writing retreat in California, I remembered the way he touched me in the car.

Why am I writing about him? It's not because I want anything from him anymore and it's not because I feel something now. That person/those people is/are gone. That ship has sailed. But sometimes I still remember what it/we used to feel like. The way he/we used to be.

The confusion of the "yous" here is a comment on intimacy as well as distance. How close someone gets. How in and out of closeness. How it's one person, then another. Mixing personal pronouns is like a riddle. Sometimes there are three different yous in a story. Sometimes three different yous in a you. Sometimes a you is a dedication. Sometimes a summoning. Sometimes a seance. How many times am I going to raise you —all of you—from the dead?

In *Blind Date: Sex and Philosophy*, Anne Dufourmantelle writes, "Why, and how, do you exist? Since 'I' comes from 'you'… Since we are born of another, and we die alone… Philosophy is a language for coming to terms with the foreign body that I call 'you,' the plural world that persists in being other than itself, the language that makes beings of words and desire."

Of course this is what *Dracula* is about, too. The foreign bodies that "I" call "you." The foreign body (mine) that I put into you (yours).

I've been writing in the second person for years. In my story "Proverbial" from *Beauty Talk & Monsters* and in "Solace." I don't know if anyone has picked up on this. Sometimes I don't know what people read when they read my work. Judging by what they say, or don't say, it seems like they mostly don't know how to read it. But if they can't read it, does that mean I didn't write it, and vice versa? Maybe writers always feel this way. Unread and misread. And maybe they should. Maybe lovers do too.

"A text is not a text," Derrida writes in "Plato's Pharmacy," "unless it hides from the first comer, from the first glance, the law of its composition. A text remains, moreover, forever imperceptible." Roland Barthes says similar things about love and the lover in *A Lover's Discourse*. Some days it feels hopeless. What should we have more of and what should we have less of? Hope?

A text is for someone. Not for everyone. The way someone is for someone. Not for everyone.

I reveal what I hide and hide what I reveal, both as a woman and as a writer, because all my work is like a noir. Echoing Derrida, in *Notes on the Cinematographer*, Bresson writes: "Hide the ideas, but so that people find them. The most important will be the most hidden."

And, "To have discernment (precision in perception)."

Choose your revelations wisely. Everything is not *what* you show, but *how*, and also *why*, *when*, and to *whom*.

Bresson: "Your images will release their phosphorus only in aggregating. (An actor wants to be phosphorescent right away)."

I wonder if readers see the connection between Bresson's idea of aggregation and the lines in *LACONIA: 1,200 Tweets on Film?*

Bresson: "See your film as a combination of lines and of volumes in movement apart from what it represents and signifies."

In this case words also apply.

In an interview about *LACONIA*, I said: "The entire book is an answer song, a noir, and given how I'm a digressive and analogical thinker—how I almost can't think otherwise—it's no wonder that a book like *LACONIA* came out of me. In an essay called 'Bewilderment,' Fanny Howe writes, 'One definition of the lyric might be that it is a method of searching for something that can't be found… It says, 'Not this, not this.' instead of, 'I have it.' I think my whole life works this way."

To have discernment (precision in perception). ▪

I would like to walk into a room and have it feel this way. Like the score to this scene from the movie *Klute*. I would like to feel like this song, for the walk to feel like this song, for the person on the other side of the room to feel like this song.

• **MICHAEL SMALL**
Goldfarb's Fantasy
Music from the Motion Picture: *Klute* (1971).
LINK: http://youtu.be/5ZcQGyU9onw

03 13 2012—JULIE, OU LA NOUVELLE HÉLOÏSE

A woman leaves Venice to go back home to her family in the Italian film *Bread and Tulips*. She goes back to her lame sons, her awful husband. Temporarily leaving behind the new life she's discovered. Made, little by little. A real life, which is to say, her own life. Something she's never had before. The man who loves her (who isn't her husband) tells his grandson: "Once again happiness knocked on my door in vain." This is how I feel about what happened with X. You aren't my happiness, but maybe I was yours? It can work like that sometimes. Sometimes one side makes both sides. Sometimes one side ruins the whole thing. •

• **SCREEN**
Pane e tulipani (2000), Silvio Soldini.

03 14 2012—MOTHER LOVE

▪ WALT DISNEY
Dumbo (1941)
CLIP: "Baby Mine-Dumbo & His Mommy"
LINK: http://youtu.be/y7JvL2ap3Cg

03 16 2012—LAST WORDS LAST FOREVER

Vincent van Gogh's last words were to his brother.

Purportedly they were:
"The sadness will last forever."

More than anything Robert Altman's film *Vincent & Theo* is about how you lose your mind being in the world.

▪ SCREEN
Vincent & Theo (1990), Robert Altman.

If a decade is also a color, what color were the 70s? They were blue and yellow, like the cover of my book *LACONIA*, which was inspired, in part, by the 70s. Specifically, 70s cinema. In the 70s, yellow and blue were the colors of disaster and progress—or, the disaster of progress. The two went hand in hand. Modernity on earth. Earth in modernity. Sun, sky. Ocean, glass, metal.

• **JOHN GUILLERMIN**
The Towering Inferno - Opening Titles (1974)
LINK: http://youtu.be/4YTrsAKg-rU

In the 70s, movies open with a brightness that lies. Blinds.

Jaws
Dirty Harry
Visconti's The Leopard (1963)
The Towering Inferno

• **SCREEN**
The Towring Inferno (1974), John Guillermin.

In *The Towering Inferno*, Fred Astaire, a relic of old Hollywood, shows up in New Hollywood. Astaire's entrance into the new era is introduced by his encounter with the "Glass Tower" skyscraper. It is daylight when he first sees it. The sun is out. Before he walks in, Astaire (*a-stare*) looks up at the Tower in awe and shakes his head. He can't believe his eyes. The sight (*site*) calls for pause.

Since the monstrosity of modernity is blinding, like the sun—cause for both awe and alarm—it should not be faced head-on. Mediation (a buffer) is required. And yet, at the same time, when one is confronted with the spectacle of a modernity that stupefies, one *has* to get a better look, which is why Astaire removes his sunglasses when he first sees the Tower.

A look, especially in cinema, is also a warning. An omen of things and people to come. When a person sees another person, a monstrous skyscraper, a huge dorsal fin.

Awe at what you see is also apprehension and horror; at something so grand and imposing and wrapped in its time; so upright, straight, and sure of itself; so costly in all senses of the word (world), it simply cannot last. Which means it can only come down. Can only crash and burn, like it did in 2001, taking the world down with it while refusing to register the world that fell.

Horror is also wish-fulfillment. You are afraid of dying and you want to die. You are afraid to look, but you must look. You fear something will fall and you long for it to fall. You build something that cannot collapse and you build something that will.

My mother and I used to look up at the Twin Towers the same way Fred Astaire does in *The Towering Inferno* when we first moved near them to TriBeCa. For years, the towers continued to awe and terrify us. We were convinced the buildings were destined to fall.

In an article published in *Le Monde* on November 2, 2001, Jean Baudrillard wrote:
"…We dreamt of such an event… everyone without exception dreamt of it, because no one could not not dream of the destruction of any superpower having attained such a degree of hegemony."

Laurie Anderson's 1981 oracular song "O, Superman," in which she chants, "Here come the planes," is just one of many dreams (visions) of the destruction of a superpower.

Modernity is a burning building we are all trapped inside of.

The sky is the limit.
The sky is the end.

▪ **LAURIE ANDERSON**
O Superman (1981)
LINK: http://youtu.be/0hhmONHhCBg

▪ **SCREEN**
Twin Towers in New York City (September 11, 2001).

Wikipedia: "On February 13, 1975 a three-alarm fire broke out on the 11th floor of the North Tower. Fire spread through the core to the 9th and 14th floors by igniting the insulation of telephone cables in a utility shaft that ran vertically between floors. Areas at the furthest extent of the fire were extinguished almost immediately and the original fire was put out in a few hours. Most of the damage was concentrated on the 11th floor, fueled by cabinets filled with paper, alcohol-based fluid for office machines, and other office equipment. Fireproofing protected the steel and there was no structural damage to the tower. Other than the damage caused by the fire, a few floors below suffered water damage from the extinguishing of the fires above. At that time, the World Trade Center had no fire sprinkler systems."

In the 70s, the chimera of progress began to disintegrate, resulting in the modality of scope, height, vista. Of soaring and falling. In wide angles that tried to show just how far and deep. In rooftops and windows with glass-encased views of the world (The World Trade Center had a Top of the World observation deck), with helicopters coasting over water and small, antiquated wooden boats dwarfed by the infinity of sea. In his film *Blue*, Derek Jarman's narrator notes, "Atomic bright photos… with yellow infection bubbling at the corner… Blue is the darkness made visible."

When the Twin Towers went up in flames in 2001, the disaster resulted in two colors—yellow and blue. When the fire breaks out in *The Towering Inferno*, chief firefighter Mike O'Hallorhan (Steve McQueen) arrives at the Glass Tower and meets Doug Roberts (Paul Newman), the architect behind the enormous and poorly constructed skyscraper.

McQueen: "Architects."
Newman: "Yeah, it's all our fault."

McQueen: "Now you know there's no sure way for us to fight a fire in anything over the 7th floor, but you guys just keep building them as high as you can."
Newman: "Hey, are you here to take me down or the fire?"
McQueen: "This is one building I didn't think would burn."
Newman: "So did I."

During a press conference in 1973, the year the first Trade Tower was completed and *The Towering Inferno* was made, Minoru Yamaski, the architect of The World Trade Center, was asked, "Why two 110-story buildings? Why not one 220-story building?" Yamaski answered: "I didn't want to lose the human scale."

In exchange for its disavowal of human scale, *The Towering Inferno*'s single tower takes human lives. But then again, so did cutting the one inhuman tower into a more humane two.

Wikipedia: "Plans to build the World Trade Center were controversial. The site for the World Trade Center was the location of Radio Row, home to hundreds of commercial and industrial tenants, property owners, small businesses, and approximately 100 residents, many of whom fiercely resisted forced relocation. A group of small businesses affected filed an injunction challenging the Port Authority's power of eminent domain. The case made its way through the court system to the United States Supreme Court; the Court refused to accept the case.

Private real estate developers and members of the Real Estate Board of New York, led by Empire State Building owner Lawrence A. Wien, expressed concerns about this much 'subsidized' office space going on the open market, competing with the private sector when there was already a glut of vacancies. Others questioned whether the Port Authority really ought to take on a project described by some as a mistaken social priority.

The World Trade Center design brought criticism of its aesthetics from the American Institute of Architects and other groups. Lewis Mumford, author of *The City in History* and other works on urban planning, criticized the project and described it and other new skyscrapers as 'just glass-and-metal filing cabinets.' The Twin Towers' narrow office windows, only 18 inches (46 cm) wide, were disliked by many for impairing the view from the buildings.

The trade center's 'superblock', replacing a more traditional, dense neighborhood, was regarded by some critics as an inhospitable environment that disrupted the complicated traffic network typical of Manhattan. For example, in his book *The Pentagon of Power*, Lewis Mumford denounced the center as an 'example of the purposeless giantism and technological exhibitionism that are now eviscerating the living tissue of every great city.' For many years, the immense Austin J. Tobin Plaza was often beset by brisk winds at ground level. In 1999, the outdoor plaza reopened after undergoing $12 million renovations, which involved replacing marble pavers with gray and pink granite stones, adding new benches, planters, new restaurants, food kiosks and outdoor dining areas."

Both *Jaws* and *The Towering Inferno* were filmed in 1973. But *Jaws* was released in 1975, a year after *Inferno*. The dialogue between Roberts and O'Hallorhan in *Inferno* foreshadows and runs

parallel to what happens in *Jaws*, with Mayor Vaughn refusing to equate his corruption and deception (the real monster of *Jaws*. Vaughn decides to profit off of the 4th of July holiday instead of closing down the beaches) with the shark disaster that ensues in Amity.

Moreover, *The Towering Inferno*'s score almost sounds like the extra or discarded scraps of the *Jaws* score. *Inferno* even turns to water by the end. According to John Williams, who wrote the soundtracks for both films, monstrous buildings and monstrous sharks are similar aberrations. As a result, the two, the Tower and the shark, sound alike. Just as the score marvels at the technological prowess and grace of the helicopter that soars over San Francisco in the opening credits of *The Towering Inferno*, the score delights in the impressive speed, efficiency, and grace (technology) of the shark in *Jaws*, a "perfect eating machine."

"It is my sense in the fall of 2001," Judith Butler writes in her preface to *Precarious Life*, "that the United States was missing an opportunity to redefine itself as part of a global community when, instead, it heightened nationalist discourse, extended surveillance mechanisms, suspended constitutional rights, and developed forms of explicit and implicit censorship."

In Robin Wood's *Hollywood: From Vietnam to Reagan*, which examines the ideology of 70s cinema, Wood anticipates Butler's *Precarious Life*: "Yet this generalized crisis in ideological confidence never issued in revolution. No coherent social/economic program emerged, the taboo on socialism remaining virtually unshaken. Society appeared to be in a state of advanced disintegration, yet there was no serious possibility of the emergence of a coherent and comprehensive alternative."

Finally back on terra firma again, Paul Newman and Faye Dunaway are huddled together and wrapped in blankets. Newman tells Dunaway, "Maybe they should leave [the Tower] the way it is. A kind of shrine to all the bullshit in the world."

In order for anyone to survive the towering inferno, for there to be any future at all, the Glass Tower has to come down, which also means nothing like it can ever go up again. Therefore the film ends with Roberts promising O'Hallorhan to consult with the fire department about the construction of all future skyscrapers in the city of San Francisco. A cool down (the fall, water) after the pump-up (erection, fire). "At once phantomal and commanding, the paternal," writes Avital Ronell in *Loser Sons*, "like Hamlet's father, directs the way the whole house comes down, falling apart around a shared name that seals the demise of a split son."

But no such pact was made after the Twin Towers came down and designs for the Freedom Tower (or the New World Trade Center, as it's being called) were drawn. States became State. One censored two. Nation-building became just that, nation-as-building and building-as-nation. No alternative to the disaster or even an illusion of the end. No end to end times. Not even a faux unitary one. Only: Never again would we be cut to human size or scale back for anything human.

In the preface to *LACONIA*, I discuss the architectural trope of modernism that became my cover, Mies van de Rohe's twin Chicago high-rises in skeletal form, built in 1950. Mies van der Rohe was German. In the introduction to Avital Ronell's *Loser Sons*, she reminds us that

Mohamed Atta, who crashed into the North tower of the World Trade Center, had studied architecture in both Cairo and Hamburg. At the end of *The Towering Inferno*, both the end and the future of human life, as well as the end and the future of architecture (i.e. modernity and capital) are placed on the shoulders of Paul Newman's architect.

In *Theatricality as Medium*, Samuel Weber writes, "The situation of this spectator is akin to that of the child described by Lacan as the mirror stage, characterized by an Imaginary identification with an image of wholeness. The internal contradiction of such identification is that it institutes an image of unity while occupying two places at once: the desired place of wholeness and the feared place of disunity."

While the cultural architects of the Twin Towers imagined and projected the towers as a unified, hegemonic whole, this symbol of capital nevertheless demonstrated its internal contradiction when it was split in two—into disunity—and, as Weber puts it, made to "occupy two places at once." One tower not only a double of the other, but each tower an other to the other. It is worth noting, too, that the number 11 in September 11 is a numerical double of the two towers. Two towers, two planes, two 1s, reminding us that the dream—the image—of a wholeness as ruthless as this one, was never and could never be whole, and has always contained its own binary split. As Ronell points out above, when it comes to the Twin Towers, the whole house did come down, making them one of many split sons. ▪

03 18 2012—TIME-JUMP #8: NIGHT VISION

▪ **DAFT PUNK**
Night Vision (2001)
LINK: http://youtu.be/g2UyZiXSFDk

In *Blind Date: Sex and Philosophy*, Anne Dufourmantelle writes:
"The other essential signifier of Greek thought insofar as human behavior is concerned is the kairos, the opportune moment. This is among the most important, and the most delicate, objectives in the art of making use of pleasures. Plato reminds us of this, again in Laws: happy is he who knows what must be done when it must be done and the extent to which it must be done."

I read this the other night.

In *Written on The Body*, Jeanette Winterson writes:
"It's a sin this not being ready, this not being up to it."

And in the same book:
"I know the stigmata of presumption. The wound that will not heal if I take you for granted."

And then again, towards the end of the book:
"There won't be another find like you Louise. I won't see anybody."

I read *Written On The Body* in Berlin, during the summer of 2000, when all I did was read and go to the movies. When I talked to almost no one.

The way these sentences of Winterson's tie to this, from Deleuze's *The Logic of Sense*, which appeared so many years later: "Either ethics makes no sense at all, or this is what it means and has nothing else to say: not to be unworthy of what happens to us."

Elaine sent me this quote last summer while I was at graduate school in Switzerland—in a time of need, of losing my head at exactly the moment I was expected to have it on straight, of coming out of broken-hearted slumber into broken-hearted panic.

I read the quote over and over, remembering Winterson, but also everything I have ever believed about love and responsibility and ethics and answering a call. When I gave the Deleuze quote, which I'd written on a tiny piece of notebook paper, to X. one night, he responded with: "What does this mean? Now I'm going to be up all night trying to figure out what this means." He studied the quote on the dark street we were sitting on.

Deleuze, whose description of ethics echoes the sentence that appears in so many Winterson novels, over and over, like a lifeboat. A leitmotif. Reminding us of what we keep forgetting to remember. Keep forgetting to do: "What you risk, reveals what you value." ▪

It took time for Wim Wenders to appreciate Pina Bausch. He didn't have what he calls the "antenna" for her work the first time he saw it. For twenty years he was stuck. For twenty years he wanted to make a film about Bausch but "stalled for time" because he didn't know how to make the film. He didn't know what he was waiting for, or that he was waiting at all. He didn't even know he was waiting. He was waiting, he says, for a form (3D) in film that could do justice to the form of not just dance, but her dance. But it wasn't just that, he wasn't ready. Like anything, making work is about timing.

I don't trust artists who approach a subject or a work head-on or straight-away. Rather, I like when people know they have to make work about someone or something but don't know how to make that work. Who don't know how to do what they want to do, so they begin the hard work of waiting in order to do the hard work of work. Only of course waiting is not simply waiting, it's preparation. Working while you wait and waiting while you work, and waiting to work, and working through the work of waiting to get to where you're going. It's a mission.

▪ **SCREEN**
A young Pina Bausch.

▪ **SCREEN**
A young Wim Wenders.

▪ **WIM WENDERS**
PINA - Trailer (2011)
LINK: http://youtu.be/CNuQVS7q7-A

There is the work you make and the work that makes you. The work *through* which you become—a human being, an artist, a thinker.

Twenty years, and then she dies. She dies before the film is made. Before he figures out a way to make it. And then he doesn't want to make the film anymore. How can he? He can't. She's gone. And that also required a way. Time. More time. Sometimes recognition happens the second time around, the way it did for Wenders and Bausch. He didn't get it, feel it—understand—the first time around. He didn't see it. It was the second time he saw her dance that he says he broke down in tears. But he had to be forced to see her the second time. He didn't want to go. What if he hadn't gone? What then?

Work is destiny. Destinal. It never happens straight. It never happens the way you want it to. He became possessed and obsessed. He realized her work was a calling for his work. Part of his work began when her's ended.

It took twenty years. It took a time-jump. ▪

03 23 2012—TIME-JUMP #9: DOWN, DOWN, DOWN

▪ JOHN MAUS
And The Rain (2011)
LINK: http://youtu.be/iMIdGrx1KgY

03 24 2012—THE DOUBLE BIND

▪ SCREEN
A view of Hollywood.

Hollywood gives the illusion that everything works out.

Hollywood gives the illusion that nothing works out.

03 25 2012—UNTITLED

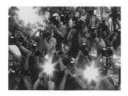

▪ SCREEN
Paparazzi.

Some people should be embarrased, but they're not.

03 25 2012—THE PRICE OF THE TICKET

The arc of my writing has been three-fold.

1. *What do I write? What do I think?* This went on for years. It still goes on. There were and are many false starts. I took these two questions very seriously. I took them to heart. There's no point otherwise. I thought of the way James Baldwin once said of his boyhood, "I didn't know how I would use my mind or even if I could. But that was the only thing I had to use."

Then, 2. *How do I write what I think? What form will this writing take? What form does it need and how do I learn to make it?*

Then, finally, 3. These are the things I think and this is the way I'll try to write them. And the work is hard, but it is less excruciating. Or, there is some balance between excruciation and the necessary effort that begets the pleasure of doing one's work. There is no "self-esteem." There is only internal fortitude. ▪

03 27 2012—RADICAL ACTS

"I was trying to make a connection between the books I was reading and the life I saw and the life I lived."
—JAMES BALDWIN

▪ **KAREN THORSEN**
James Baldwin: The Price of the Ticket (1989)
LINK: http://youtu.be/4_hYraYl2J8

03 28 2012—TO ALL THE BOYS

You make music that is deep.
You live lives that are shallow.
When will this get old?

▪ **SCREEN**
Rod Stewart with wife, Rachel hunter, on
the cover of *Rolling Stone* (July 1991).

03 29 2012—I THOUGHT I SAW YOU (LOOKS KILL)

In *Witness to Murder*, it's not what a man does that's deadly.
It's what a woman sees a man do.

▪ **SCREEN**
Witness to Murder (1954), Roy Rowland.

03 30 2012—OVER BEFORE IT BEGAN

In *The Grifters*, the beginning is really the end. The opening score
introduces what's already over. Ruined. The end is inscribed into the
beginning from the start. And this mother and son never stood a chance.

▪ **STEPHEN FREARS**
The Grifters - Trailer (1990)
LINK: http://youtu.be/ocCWEBSC4-0

Pushing my face in the memory of you.

> • **THE CURE**
> *Untitled* (1989)
> **LINK: http://youtu.be/y3perp_eFj8**

04 02 2012—DUAL ROLE (EVERY MOVE A PICTURE)

The Nutty Professor (1963) is one of my favorite movies. As a kid, it riveted me and made me swoon. It was on TV at least once a year, usually on Sundays. I loved Lewis' performance of "That Old Black Magic," and I still love it today. Also: the color of Buddy Love's baby blue suit. The bright pink shirt. The purple bar. Love's invisible, off-camera, audible-only walk into the nightclub, just before we see him sing for the first time. The sound of his shoes clicking against pavement. The ridiculous expressions of shock on people's faces at the sight of "ultimate man" Buddy Love. The seduction of the Jerk or the Jerk as seduction. The performance of machismo as that old black magic. The deconstruction of the performance that is masculinity. The havoc being a man wreaks. A male Medusa, Love freezes both men and women, stopping them in their tracks. •

• **JERRY LEWIS**
The Nutty Professor (1963)
CLIP: "Jerry Lewis - That Old Black Magic"
LINK: http://youtu.be/p1oJnzBn2H4

04 03 2012—GOOD GRIEF

When love is lost and despair sets in, it can go like this.

When I used to go out I'd know everyone I saw. Now I go out alone, if I go out at all.
When I used to go out I'd know everyone I saw. Now I go out alone, if I go out at all.
When I used to go out I'd know everyone I saw. Now I go out alone, if I go out at all.
—THE WALKMEN, "The Rat"

▪ **FOOTAGE-FILE.COM**
Bronx New York 1970s
LINK: http://youtu.be/kqawnkoCi1Y

04 05 2012—DIGITAL LAMENT: SEEMS LIKE WITHOUT TENDERNESS THERE'S SOMETHING MISSING

▪ **GENERAL PUBLIC**
Tenderness (1984)
LINK: http://youtu.be/n9fcmDhcHxk

04 07 2012—SOME THINGS NEVER CHANGE

This is a journal entry I wrote when I was 21.

July 25, Provincetown:
"Three weeks ago we celebrated the 4th of July in the dark. Up against the beach, underneath the sky, the fireworks exhaled off MacMillan Wharf. At first I was excited; the evening was radiant in many ways. I felt connected and full, a balloon of anticipation and energy.

▪ **PHOTO**
Fireworks in Provincetown.

Hunger. Am I always hungry for something? For *the* thing. The one. I am embarrassingly prepared. I want to live entirely and everyone knows it. But after music at Bubalas, then the madness of the 1am Spiritus pizza rush, someone mentioned P., and then I wasn't okay. I was sore in every vein, all bones struck by the name, a dull ache all over me. I went silent, trying to push away tears. What could I say to anyone? What did they know? So I gave nothing after that. Said nothing after that.

In the car, on the way back to Truro with I., D., and others, it got even darker, and I sat in the back of the car, silent, waiting for the moon to show up. And during the drive, I think that I braced everyone with my inability to pretend that I did not feel sorrow and a loss of grace at the reminder of pain. Finally after a few minutes, I.'s voice rose from the front, and she said, "Masha, I can *feel* you thinking."

To which D. added, "That is a constant, isn't it? Feeling Masha think?" ▪

04 09 2012—THEORY VS. PRACTICE: A NOTE ON MALE CHAUVINISM

If, time and time again, brilliant male artists, writers, and philosophers have proved to be nothing like their work; who are uninfluenced by their own work; who don't practice what they preach (if in fact they preach anything worth preaching or practicing when it comes to sexual and gender politics), the reverse has also proven to be the case. That a male chauvinist pig in theory is sometimes capable of loving a woman (not *women*, this is the catch. The suspension of sexism becomes personal. *For one woman only*. Although we know the personal is always political and the political personal) deeply. Sometimes more than the man who spends his life verbally and theoretically denouncing sexism. Who talks the talk, but still doesn't walk the walk. Sometimes people are nicer than their words, their texts, their ideas and ideals, and vice versa. And if this is the case, and unfortunately it is, what do we do with this gap that never closes? Never ceases? With this difference between theory and practice that appears in our lives over and over? How do we mend it? Close it? Can we, will we, when? ▪

Me:
They say that god makes problems just to see what you can stand
Before you do as the devil pleases
And give up the thing you love.

You:
The first time I saw you, I knew it would never last
I'm not half what I wish I was
I'm so angry, I don't think it'll ever pass
And I was bad news for you, just because.

▪ ELLIOTT SMITH
Pitseleh (1998)
LINK: http://youtu.be/rSfu37wKhMM

▪ LAURIE ANDERSON
O Superman (1981)
LINK: http://youtu.be/-VlqA3i2zQw

04 12 2012—FACE OFF

Morrissey understood the power of the/a face to the degree that he could write a lyric like:

And did I ever tell you, by the way?
I never did like your face.

▪ THE SMITHS
You've Got Everything Now (1984)
LINK: http://youtu.be/t1gAKAqCkEs

It means so much—a face, this face that he's singing about—that to have it all go wrong means he can't even bear that face anymore. ▪

▪ PHOTO
Wall graffiti.

04 13 2012—THE BEAUTY THAT WAS

This is from *Hot Pursuit*. It is 1987. John Cusack is 20. He has the most beautiful face. You believe him when he loves a woman onscreen. Even in a stupid movie like this. Even before *Say Anything*, you could believe him.

▪ SCREEN
Hot Pursuit (1987), Steven Lisberger.

04 14 2012—LOVERS IN A DANGEROUS TIME,
OR THE TIMES WILL ALWAYS BE DANGEROUS FOR LOVERS

Leave your world, that doesn't care.

▪ SARA GÓMEZ
De cierta manera (One Way or Another) (1977)
LINK: http://youtu.be/NXww6UxjWRo

04 15 2012—TEENAGE HEART: *LOVERS OF THE ARTIC CIRCLE*

I still have teenage desires. I still have a teenage heart.

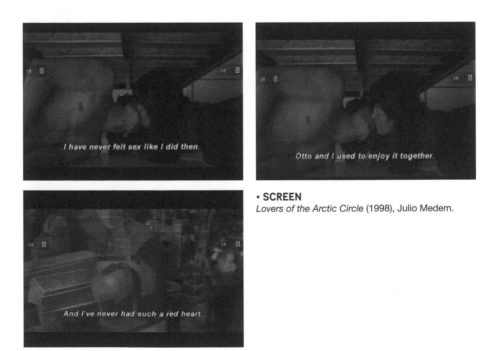

▪ SCREEN
Lovers of the Arctic Circle (1998), Julio Medem.

04 17 2012—TEENAGE HEART #2: *35 SHOTS OF RUM*

▪ **SCREEN**
35 Shots of Rum (2008), Claire Denis.

04 19 2012—TIME-JUMP #12: DECADES

Weary inside, now our heart's lost forever.

▪ **JOY DIVISION**
Decades (1980)
LINK: http://youtu.be/PMAB3r6EjcM

04 20 2012—TEENAGE HEART #3: *SOUL KITCHEN*

- **SCREEN**
Soul Kitchen (2009), Fatih Akin.

04 21 2012—TIME-JUMP #13: INTIMACY

- **STEVEN SODERBERGH**
Sex, Lies, And Videotape (1989)
LINK: http://youtu.be/fPVMCWUISIQ

Propaganda while you suffer and wait.

- **SCREEN**
The Terminal (2004), Steven Spielberg.

1.
Marcello Mastroianni:
"The more the world changes, the more it stays the same.
Houses, palaces, skyscrapers. And in the middle… An old
story like ours."

Sophia Loren:
"It's an 'old story' because you want it to be old. There are
skyscrapers in America, too. And inside those skyscrapers
there are old stories. That's not the problem. The problem
is that our hearts used to be so big… And now (she holds
up a tiny rock) look how small they are. Here."

–*Marriage Italian Style* (1964), Vittorio De Sica.

2.
"The promised view and brightness rarely coincide with reality.
I'm convinced that separations, divorces, domestic violence, the
excess of cable TV stations, the lack of communication, listless-
ness, apathy, depression, suicide, neuroses, panic attacks, obesity,
tenseness, insecurity, hypochondria, stress, and a sedentary lifestyle,
are attributable to architects and builders."

–*Medianeras (Sidewalls)* (2011), Gustavo Taretto.

In Rome last winter, so in love with the place, so at peace and at home in it, I played around with the name of the city and realized that the anagram for Rome is "more." That seemed perfect, as I couldn't get enough. The week before, I'd been in Venice. I'd always dreamed of going there in winter after seeing *Don't Look Now* years ago.

• **NICOLAS ROEG**
Don't Look Now (1973)
LINK: http://youtu.be/Ooi8sU8ub_4

I spent my first few hours in Venice this time looking for the church that John Baxter restories in the film. It took me hours to find. Half a day. All the way across the city, I walked. Over bridges, which tie the whole city together. I constantly took the wrong turn or was sent the wrong way. No one knew what the hell I was talking about. There were churches everywhere and it was getting dark. By the time I finally found the church of San Nicolo—located in the remote Dorsoduro district—it was dark outside,

• **PINO DONAGGIO**
Don't Look Now - Movie Theme (1973)
LINK: http://youtu.be/9fEqYbMDCKk

and the church, one of the oldest in Venice, was empty, so I had it to myself.

It was late enough that it could have been closed, but it wasn't. Inside, I sat on a wooden pew for a long time, looked around at everything to see if it looked familiar, like the movie, and also so that the next time I saw *Don't Look Now*, I would recognize the church in a different way—from the inside out. From real to reel, instead of reel to real.

The next day I looked for the palace where John Baxter is murdered. I looked all day, but when I found it, the building—a museum—was locked. So I circled it for a while, imagining how the palace looked inside. Replaying John's death in the film.

In his BFI book on *Don't Look Now*, Mark Sanderson writes: "*Don't Look Now* is an exploration of grief, but it is also a film about a film. [Roeg] uses light to illuminate life."

In *Don't Look Now*, Christine, a little girl, drowns in a pond at her home in England. After Christine's death, the Baxters, her parents, go to the city of water—Venice—to grieve, to work, to drown (in) their sorrows.

That's what my voyage to Italy, to use Rossellini's film title, was like last winter. I went there because of grief (my break-up with W.). Because I was in it, because I needed to come out of it, because it is my favorite country, because I had dreams of it in winter, because of *Don't Look Now*, one of my favorite films, and because of Fellini's *Roma*. I also wanted to find the church of Saint Nicholas (Nicolo) because Saint Nicholas is the patron saint of scholars and children. Now, inspired by Avital Ronell's chapter, "The Unrelenting Creepiness of Childhood: Lyotard, Kid Tested" from her book *Loser Sons*, I am writing a long essay about the uncanniness of childhood and childhood

cinema. The way childhood always haunts adulthood. The way it is always creeping into and up on adulthood. The way it never goes away. In all of Fellini's films, too, there is something uncanny, unnatural, and haunted about a voice. About time. About people speaking. About living. About breathing. In a Fellini movie, life is spooky, creepy, absurd.

▪ FEDERICO FELLINI
Roma - Trailer (1972)
LINK: http://youtu.be/V_LRGpBPICs

Like *Don't Look Now, Roma*, my favorite Fellini film, is also a film about a film, as well as a film about a city and the filming of a city. Fellini films Rome like the historical and architectural coil that it is. The way in one scene the camera and the motorcyclists go around and around the city; the Coliseum. Rome is mesmerizing because of its proportions; the spaces and interstices around and between things. The way in Rome buildings frame other buildings, instead of simply blocking them or covering them up. In *Roma*, Gore Vidal, who makes a cameo in the film, declares, "We're getting closer and closer to the end of the world… And Rome is the ideal city for waiting to see if it will really come to an end or not." That's how I felt when I was there: the world is ending anyway, so why not be here, where it partly began. Why not be in Rome for the end. In the end. Why not be close to time when we are out of time. When time is out of joint. I like things very old. I like them to feel like forever, especially when there is no forever. I am living in a place, in a country—America—that is never old enough for me. That gets rid of its time, wastes its time, time it never even had. In Rome, I realized how old I need a place to be. How battered. How time-laden, which makes me feel light. I am comfortable in ruins, remnants, cracks, dirt.

Rome is lit like *Barry Lyndon*.

I walked off the train in Rome like I'd been in the city all my life, when I'd only been there once before as a teenager. Rome is the kind of beautiful that takes your breath away. Palm trees and ruins. Its winter is warm like spring.

For the three nights I stayed in Rome, I was woken up by seagulls outside my hotel window. At times they sounded like witches cackling in a Dario Argento movie. Other times, orgasms.

Was it time I was feeling in Rome? Actual, non-digitized time? I think you need a certain amount of time (age) to fully appreciate what Rome is. I'm not sure if Rome can mean that much to a teenager, which is the last time I was here—though it did make a big impression, even then. Real time is what you feel in Rome and time is what you feel as you get older, so there's a way of being in sync, in time, there.

In Rome, two weeks into the new year, I asked myself if the year you start out with is the year you end up with? ▪

04 25 2012—WHO YOU REALLY ARE IS WHO YOU REALLY WANT

"The hero and heroine of the [1930s] screw-
ball comedy may decide to attempt a life with
a more conventional person (e.g., 'the rube'). It
can't work, and learning that—learning who
one really is and whom one really needs to be
with in order to fully realize that—is the arc of
the comedy."
—SUSAN BORDO, *The Male Body*

▪ **SCREEN**
The Lady Eve (1941), Preston Sturges.

04 27 2012—UNTITLED

"Sloppy thinking gets worse over time."
—JENNY HOLZER, *Truisms (1979-1983)*

In the only writing class I ever took, my teacher, a New York poet, assigned Kathy Acker's very short novella, *Florida*, for us to read. *Florida* is part of Acker's *Literal Madness* trilogy of novels. I was 19.

▪ **SCREEN**
Kathy Acker's *Literal Madness*.

I'd been reading Acker's books for years, but had never heard of *Florida*. I think it changed my life, or held the change that held my writing. That made it possible. That is, it somehow unearthed and summoned what I wanted to do with/in my writing in the form of cadence.

Based on the 1948 film noir *Key Largo*, starring Humphrey Bogart and Lauren Bacall, *Florida*, like the rest of the collection (the second novel in the trilogy is *My Death My Life by Pier Paolo Pasolini*; Pasolini would later become one of my favorite filmmakers), is about movies in many ways, and is written into, as, and from the interstice that lives between cinema and life, life and cinema, as well as the hybrid made by the two. An interstice that would eventually become all my work. The line in everything for me.

After reading *Florida**, I wrote a story for the class called "The Drive" that was an answer song. Everyone loved it, even the bankers who wanted to be writers. "The Drive" had the same rhythm, the same tone—a tone which is also straddling and transgressing a fine line, on a border. For me, everything that is remarkable about *Florida* has to do with cadence—the answers, the ideas, the form, the style, the sexual politic, the story—is in this cadence, and as Nietzsche pointed out, cadence is everything. Cadence makes a person.

Is the when and how. ▪

*
For an audio recording of *Florida* read by Masha Tupitsyn:
http://mashatupitsyn.tumblr.com/post/21959075058/florida-kathy-acker

1. "I make a fool of myself and they don't give a shit."
—SU FRIEDRICH

2. "All films about crime are about capitalism, because capitalism is about crime. I mean 'quote unquote,' morally speaking. At least that's what I used to think; now I'm convinced."
—ABRAHAM POLONSKY

3. "Have a nice day."
—REAL ESTATE DEVELOPER

▪ SU FRIEDRICH
Gut Renovation (2012)
TEXT: *On May 11,2005 the New York City Council approved the rezoning of Williamsburg, Brooklyn.*
LINK: http://vimeo.com/41107252

When everything is gentrified, and everything is, including the mind, as Sarah Schulman argues in her book *The Gentrification of the Mind: Witness to a Lost Imagination*, then a phrase like this, "I make a fool of myself and they don't give a shit"—an observation like this, a realization like this, about you in the world in relation to people of power, systems of power; buildings as systems, emotions as buildings, buildings as lives, windows as outlets (Su Friedrich is screaming out of hers because a window is also a window out onto the world); buildings being ripped out, knocked down, taken away, erected and paved over people and spaces—becomes a statement of personal and political mourning for our times. An edict of cultural despair.

In *The Gentrification of the Mind*, lesbian novelist and activist, Sarah Schulman, examines the historical relation between gentrification and AIDS, stating that "gentrification made us forget who we were," and has resulted in "a loss of vision" on all levels. Schulman draws parallels between socio-economic gentrification and mental (artistic) gentrification. In one passage, she writes: "Gentrification replaces most people's experiences with the perceptions of the privileged and calls that reality. In this way gentrification is dependent on telling us that things are better than they are."

You say something, you make a "fool of yourself" by *trying* to say something—to a lover, to a friend, to a neighbor, to an employer, to a landlord, to a real-estate developer, to a politician—in person, in writing, on camera—and they don't care. You make a fool of yourself, but no one gives a shit about what you say or how you feel: the energy you spend and expend, the tears you shed. The sense you're trying to make to and of people who don't understand anything or have any sense, and the dismissal of one's life, values, communities, labors, energies, needs, and rights. The way no one hears anything, even when you scream.

Even when you point a camera at them, the way Friedrich does, telling those developers, "I'm watching you. I see you. I won't let you get away with it, even though you don't care." Or chant, the way the OWS protestors chant at every police officer that assaults and violates their civil rights, that those violations have been caught on tape. Yes, the whole world is watching, only not in a way that makes us accountable or safe, for our watching has become part of the problem: how much we watch, how much we've seen, and how all this seeing and watching—witnessing—

is competing with so much footage. How much everything and everyone has been reduced to watching and footage. How watching makes us turn everything into a mere image; has made images—even powerful ones—quotidian and forgettable, turning everything and everyone into a spectacle of losses, victories, and empty threats. How "crimes pile up and become invisible" in the process, as Brecht noted, a line Schulman often quotes, and as I myself have argued using various theorists and quotes in my essay "Screen to Screen" (from my forthcoming book, *Screen to Screen*. An early version of this essay was published in the first issue of *Animal Shelter* (Semiotext(e)) and a long version in *Puerto del Sol*). How images pile up and become invisible.

"Screen to Screen" opens with three movie quotes:

"What does it matter what you say about people?" (*Touch of Evil*, 1958)

"The world's a hell. What does it matter what happens in it?" (*Shadow of a Doubt*, 1943)

"Everybody says everything. What's the difference?" (*Mikey and Nicky*, 1976)

And then in the concluding paragraphs, I write: "In an essay in *Bookforum* called 'Nikons and Icons,' David Levi Strauss writes: 'Robert Hariman and John Louis Lucaites rightly point to the larger problem identified by Peter Sloterdijk that modernity has entered into a terminal phase of 'enlightened self-consciousness' whereby all forms of power have been unmasked with no change in behavior.' This recalls Brecht's, 'As crimes pile up, they become invisible,' Jacques Derrida's, 'In this century, monstrous crimes ('unforgiveable' then) have not only been committed—which is perhaps itself not so new—but have become visible, known, recounted, named, archived by a 'universal conscience' better informed than ever,' and, *The Master and The Margarita's*, 'Maestro Woland is a great master of the technique of tricks, as we shall see from the most interesting part, namely, the exposure of this technique and since we are all unanimously both for technique and for its unmasking, we shall ask Mr. Woland.' To those unfamiliar with Mikhail Bulgakov's great Russian novel, Mr. Woland is the Devil and shows up in Moscow. In exchange for studying what each fraudulent cell looks like under a merciless commercial and commodified lens, viewers enable late-capitalism to run more smoothly by calling in with their votes, as is the case with Reality TV. From the inside, secrecy appears eradicated, as though secrets comprise the totality of injustice rather than just one part. Justice is reduced to a vantage point. To simply seeing or hearing something. We see and we see and we see ad infinitum."

Sarah Schulman: "Anything that humans construct, humans can transform. Other people can change you, why can't you change them? …The key to restoring buildings is to keep the original people inside."

And, Jane Jacobs: "Fix the buildings, but leave the people."

Sarah Schulman: "When we don't, we don't know who we are."

Su Friedrich yelling out her window at the gang of male developers (which includes one lone

woman trailing behind) walking below in *Gut Renovation* is a perfect example of the way we are gutted by a powerful elite who refuses to be impacted, transformed, or even affected in return. An elite that ruthlessly changes and defiles without asking anyone what that change and defilement will mean for their lives. Sarah Schulman once wrote that "marginal people know how they live and they know how the dominant culture lives. Dominant culture people only know how they live." These words have never left me. ▪

04 30 2012—EXILE

The summer I was seventeen, in Provincetown, next to ocean trees and ocean sand, my boyfriend had this song playing all the time, along with the Beastie Boys' *Check Your Head* and Liz Phair's first and only great album, *Exile in Guyville*. I think I was free in a way that I'm not anymore, or in a way that's been lost or taken away. Will I get it back? I don't know. That's the big question. Love sets you free. I still believe that. The rest is exile. It hurts to think about it. It hurts to not think about it. But sometimes a sad song is part of and accompanies a happy life.

▪ **BOB MARLEY**
Slave Driver (1973)
LINK: http://youtu.be/JITFBHHF3IQ

"The journal is where a writer is heroic himself. In it he exists solely as a perceiving, suffering, struggling being."
—SUSAN SONTAG, *Against Interpretation: And Other Essays*

05 23 2012—THE TIME IT TOOK/THE TIME IT TAKES

It used to take me longer to kiss someone I liked because I thought I had more time, which means I didn't really think about how long things took or whether I had the time for what something or someone was taking. I didn't know that people left, that they prefer leaving over staying, or that things end as easily as they do. That they end over and over. I could draw things (time with someone; a kiss) out and the days would add up and I never thought: *I am running out of time. I am running out of chances. This will not happen.* ▪

05 25 2012—TEENAGE HEART #4: *AUF DER ANDEREN SEITE*

▪ **SCREEN**
Auf der anderen Seite (2007), Fatih Akin.

05 26 2012—TIME-JUMP #15: AND LEAVE ALONE (GREEN SERIES)

"Love is the green in green.
Does this explain its pain?"
—FANNY HOWE, *Come and See*

Driving backwards and away
sometimes leads us forward.

▪ MASHA TUPITSYN
And Leave Alone (2012)
LINK: http://vimeo.com/42905291

05 28 2012—P.S., DEAR ELAINE (THE MOST INSANE IDEA IS TO LOVE)

"…she conceived of the most insane idea that
any woman can think of. Which is to love.

"She decided that since she was setting out on
the greatest adventure any person can take, that
of the Holy Grail, she ought to have a name
(identity). She had to name herself.

▪ ELAINE CASTILLO
Abfahrt/Departures, Munich Hauptbahnhof (2011)
LINK: http://vimeo.com/42617646

"'Either become normal, that is anonymous, or
die,' the handsome man told Don Quixote. 'I
can't be normal because I can't stop loving.'"
—KATHY ACKER, *Don Quixote*

Abfahrt/Departures, Munich Hauptbahnhof is Elaine's digital epistle about love, trains, and time-jumping. It is in response to my digital epistle ("And Leave Alone") to her about love, driving (away, which is also towards), and time-jumping.

Elaine and Kathy Acker are right. Love means being insane in today's world (the lack of it is also what makes the world insane), and it is what makes me intense. As a person, as a woman.

"You're too much," everyone always says, and there is nothing I can do to hide it. It always just shows.

The green still shows. Why didn't I rust or go dead like so many others? Let the color fade. Why didn't I learn to turn the volume down? Why did it only get louder? I am not camouflaging, I

am sticking out. I am see-through, like glass.

My father sometimes disparagingly calls me a "crystal ball." He tells me to hide things now. But he is also the one who taught me to show things.

A. would refer to this as "showing your hand."

▪ **SCREEN**
St. Mark's Bookshop (New York City, 1980s).

When I was a teenager I inhaled every single one of Acker's books, one after the other. My father gave me my first Acker novel when I was 14. He bought it at the old St. Mark's Bookshop in New York, where we used to browse for books together for hours. Me in the literature section, him in philosophy.

In the Spanish film *Máncora*, a man beaten and drowning, realizes this just before he sinks to the bottom of the ocean and nearly dies: "There are blows in life… so great… I don't know. Blows as if from the hatred of God. As if before them, the backlash of everything suffered were damn up to the soul. I don't know. They are few, but they are. I don't know. They open the dark furrows of the fiercest face and in the strongest side… there are blows in life so great. I don't know… Perhaps the problem has always been me. What has been of my dreams? …There are blows in life so hard. I don't know."

W., you are the greatest blow I ever received. Maybe because I thought with you the blows had ended. I don't know. Perhaps this is where the drive comes in, the train ride, the time-jump— Rousseau's destinal knock-down by the Great Dane in *Reveries of the Solitary Walker*. Rousseau had no idea what was coming, but it changed everything to be hit that way.

Acker's *Don Quixote*: "When she was finally crazy because she was about to have an abortion, she conceived of the most insane idea that any woman can think of. Which is to love. How can a woman love? By loving someone other than herself. She would love another person. By loving another person, she would right every manner of political, social, and individual wrong: she would put herself in those situations so perilous the glory of her name would resound… It's a hard thing for a woman to become a knight and have adventures and save this world. It's necessary to pass through trials sometimes so perilous, you become mad and even die. Such trials are necessary."

I don't know.

I am aching for a second chance of green. ▪

Driving at night always feels like the invisible road to destiny becoming visible. The female nighthood/knighthood Kathy Acker writes about in *Don Quixote*. Underneath the green, there is black. Underneath the black, there is green. Your valor: light in the dark. As fresh and eternal as a forest.

▪ **MASHA TUPITSYN**
Destiny Noir (2012)
LINK: http://vimeo.com/42950102

In *Don Quixote*, Acker writes: "The knight took such a night to be an omen. But of what? Nevertheless discounting the peril, she kept on… Slowly, life was returning, in the same way that light makes its way into a sky that has lasted through the night."

In "A Philosophy of Surrender," Robbie Dewhurst writes about David Rattaray's collection of essays and stories, *How I Became One of the Invisible*, a book about traveling—un(t)raveling.

"On its surface, of course, the text is a simple collection of carefully-written, intricately-detailed, first-person narratives, prose accounts of a single poet's multiple journeys into, within, and back out of different foreign territories: uncharted geographic, literary, and emotional spaces. But somehow travel narrative doesn't really feel right as a label here; David's stories always seem to go somewhere beyond that. Far beyond the aorist, beyond the what happened. Marc Thivolet's comments on Roger Gilbert-Lecomte, cited in here by Rattray, apply just as well at the late end of the century to Rattray's own stories, to these prose productions of this other strangest-of-poets. Like Gilbert-Lecomte's soberly unfinished verses, Rattray's stories are nothing less than 'road signs which are meaningful only to someone on the road.' Certainly, 'they are not for stationary reading.'" ▪

05 30 2012—SUMMER BLUES

Green world, cold water. Nowhere to be found. Sweat and misery in New York City. I want to be thrown into the bluest, deepest water, with Venus orbiting over me. A century rare.

"I have walked behind the sky.
For what are you seeking?
The fathomless blue of Bliss."

—*Blue* (1993), Derek Jarman.

1.
"You become a subject to the extent to which
you can respond to events."
—ALAIN BADIOU

• **SCREEN**
They Live (1988), John Carpenter.

2.
"I'm anonymous. I'm at this party just like I'm
watching a movie. No event touches me."
—KATHY ACKER, *Don Quixote*

06 01 2012——IN THOSE DAYS IT WAS REAL (MOVIE GREEN)

Talking to my publisher about what color the
cover of my new book should be. We both agree
on green, as green is everywhere in *Love Dog*,
and everywhere in love.

• **SCREEN**
Light Keeps Me Company (2000), Carl-Gustav Nykvist.
TEXT: *Here was blue, here was yellow, here was green.*

Tonight, it occurs to me that like *LACONIA*, my
last book, *Love Dog* (the third book of mine with
an L title) should be the kind of green you see in
70s cinema. That *Love Dog* should be 70s green
the way that *LACONIA* is 70s yellow and blue.

I want *Love Dog* to be the gray-green of *The Long Goodbye* and the blue-green of *Deliverance*. Both
films were lit by the cinematographer Vilmos Zsigmond. Both greens were made by him. There
is also the sun-filled, wide-open green that predates *The Long Goodbye* and *Deliverance*, which is the
green of *Easy Rider*, shot by László Kovács, who also lit *Say Anything*.

Color is also a memory. These greens aren't made anymore. It's a green that's gone like a cer-
tain time is gone. It's a green that has everything to do with time and the way the world doesn't
look anymore. The way photographs of the world used to look. The way books used to look.
The way people used to look. And feel. The world changed and the pictures changed. Or, as
Zsigmond put it about his cinematography in *McCabe & Mrs. Miller*, "it looked real at one time."

The book will be like this. •

06 02 2012—UNTITLED #2

The good news: People help you, even when they don't mean to.
The bad news: People hurt you, even when they don't mean to.

▪ SCREEN
Au hasard Balthazar (1966), Robert Bresson.

06 03 2012—TIME-JUMP #17: DESTINY BLANC (GREEN SERIES)

On time-jumps and desire, desire as time-jumps, and love disguised as a forest:
"…What's mainly not allowed? Time's the main non-allower… (Time is substance). Three thousand miles now between the events of you and me, or three hours. Absence to a child is death. This is death. Time's killing me. Time's proving you don't love me. I have to mold my passion for you out of time… Time is our love."

▪ MASHA TUPITSYN
Destiny Blanc (2012)
LINK: http://vimeo.com/43308738

On mad relations:
"Between you and me was a madness which's rare. Not just sexuality. Who're you kidding?… Maybe you're so young, you believe there're an infinite number of mad relations."
—KATHY ACKER, *Don Quixote*

"Catharsis is the way to deal with evil. She polished up her green paper... Lost in books and in nature."
—KATHY ACKER, *Don Quixote*

"I travel all day on trains and bring a lot of books—"
—ANNE CARSON, "The Glass Essay"

• **MASHA TUPITSYN**
Wave Goodbye: Acker's Green (2012)
LINK: http://vimeo.com/42938601

"The ideologues of Marxism (not counting adepts of 'concrete action') did not scorn utopia for the simple reason that, like a tree bursting out of its bark, it broadened the framework of the existing world order in its quest for new regimes of social experience."
—VICTOR TUPITSYN, "The Genealogy of Failure"

06 05 2012—TIME IS OF THE ESSENCE

Desire is sometimes an empty space. You in an empty space and an empty space in you. Growing full, growing empty. Trains pull in and out. Arrive and depart. Where and when do you get on? Where and when do you get off? I'm talking about timing. About knowing *when* and *not-when*, but also about going where you are supposed to go once you are going there. The ethics of timing is also the beginning of ethics. When Žižek came to teach Avital Ronell's class last fall, he stated that *Hamlet* is about the beginning of ethics. But if we relate being to time, and love to time, it's no longer just the Hamletian to be or not to be. But, when and not-when. Or when to and when not to, which according to Badiou is

• **PHOTO**
Elaine sends me pictures of empty train stations for our time-jump film.

also where subjecthood begins: "You become a subject to the extent to which you can respond to events." This includes the event that subjecthood—becoming—is, for, responding is answering, and the way we answer, and don't answer, has everything to do with who we are, as well as who we are deciding to become and not become. Every moment you are near and far. Every moment you are possible and impossible. There is always a bridge. There is never a bridge. It is too early and it is too late. I am talking about myself and you (X.). These two halves of meaning and being(s) going the distance. That going is love. Going away, coming back, it always just feels like I'm going one way: towards you. ▪

"What I wanted most was love. What I want most, even as I'm dying, is love…I would have this love which is neither control nor being controlled."
–KATHY ACKER, *Don Quixote*

06 07 2012—THE AESOP PARABLE THAT IS MY LIFE, A NOTE ABOUT DOG AND CRAB

From Elaine:

"Couldn't believe this graffiti I saw in our neighborhood, Kreuzberg. It has multiple meanings.

"First it just means:
Crab Dog (You are Love Dog and X. is a Cancer)
Which, already, !!!!
Also means: *Cancer Dog*

· PHOTO
Krebs Hund

"And cancer can mean both the sign and the illness. But *krebbs hund* could also be a way of saying like 'bloody cancer' so it's also likely to be someone fighting cancer who's cursing it. Could also be someone in love with a cancer and cursing that person. Multiple interpretations through mysterious wordplay… Crab, dog…"

In another message, minutes later, Elaine sends me a video of some wall graffiti at a park and writes this: "Hopefully this video is short enough to manage email sending; the graffiti says on one side: 'heartbreaker.'

"And on the other side in response it says 'yourself,' as in, 'no, you are.'" ·

06 08 2012—A REAL DOG (KNIGHT WOLF GLAD)

"You're not a real dog. As soon as you beat yourself up so much you suffer, vision'll take over this world... Finally Don Quixote understood her problem: she was both a woman therefore she couldn't feel love and a knight in search of Love. She had to become a knight, for she could solve this problem only by becoming partly male...This is the beginning of her desperation to find love in a world in which love isn't possible."
—KATHY ACKER, *Don Quixote*

▪ PHOTO
"Knight Wolf Glad" (New York City, 2012).

06 09 2012—FACES

Jeff Bridges was never just a blonde, especially at a time when he could have been just a blonde.

▪ SCREEN
Cutter's Way (1981), Ivan Passer.

06 10 2012—MY QUESTION TO YOU (X.)

"She wants to ask if he loves at all, but can't because such language isn't allowed."
—KATHY ACKER, *Don Quixote*

06 11 2012—LIGHT IS CALLING

"If you see it, it is there." (*Lancelot du lac*)

▪ **BILL MORRISON**
Light Is Calling (2004)
LINK: http://youtu.be/cf9ah8lUVgw

06 12 2012—CAMERA ONLY (ON "AMUSING OURSELVES TO DEATH")

Emotions are no longer from people, for people, between people. For real people or real life. For real period. You don't feel emotion: you look at emotion, you act emotion. You play emotion like another part. Emotions are now for the camera, on camera, between cameras. You don't need a camera to live on camera. You don't need to be an actor to be an actor. ▪

▪ **SCREEN**
Reality TV contestant: Real housewife of New Jersey, Danielle Staub.

06 12 2012—GIRLS, VISIONS, & EVERYTHING (BOYS, BLINDNESS, & NOTHING)

"It was another example of a typical American asshole who wouldn't know an emotion if it punched them in the eye."
—SARAH SCHULMAN

▪ **PHOTO**
Fuckuall: Sticker on parking sign. Photo by Margarita Tupitsyn (Munich, Germany; June 2012).

Elaine Castillo:
Masha and I are always in the forest. In some way it all started with a forest (as in a fairy tale; especially one with wolves in it, and red girls), with my film *Holy Forest*, which I wrote about in that first post about reviewing *LACONIA* in *Big Other*, before knowing how forests and green and grief and love would unfold in our love, our friendship. Astonishing, that, days before we even began writing each other (though in truth what we discovered was that we have always been writing each other, even before we knew it), I could have written:

• ELAINE CASTILLO
Time, Being Also A Color (Green):
Saved a Seat For You On The Train (2012)
LINK: http://vimeo.com/43682714

> I watched Naomi Kawase's *Mogari No Mori* (*The Mourning Forest*) again last night, instead of watching *Sharasoyju*, which I want to write about, but not yet.
>
> Thinking: I still fall in love with trees. There is a scene in which Machiko looks up at a tree that might be thousands of years old, with tears running down her face.
>
> In that scene I see and feel what I already know about the green of the forest, the green of wonder, the green of the sublime, the green of still-smarting pain, the green of recent death, the green of age, the green of duration, the green of grief and loss.

The green of the forest, the green of wonder, the green of the sublime, the green of still-smarting pain, the green of recent death, the green of age, the green of duration, the green of grief and loss. The green that we went into with each other. What Masha wrote recently, which our film also is: "on time-jumps and desire, desire as time-jumps, and love disguised as a forest." Green of love and the green of our film, which is a forest, and a train, a train into a forest. Time like a forest. The time you spend (not) lost in it, and the time you enter when you finally emerge from it. The two times are different (different without being separate). The same time jump you get when you emerge from a darkened theatre, into the world. Coming out of the world; going back into the world. Both being the world. Transtemporalities, transpatialities. One not being subordinate to the other. Incubation matters, has matter. In our film (in our letters) you get in a car in upstate New York, and get out on a train in Liverpool Street station. How everything between us has had to be sent, like a message in a bottle, in the hope of the soul who might give asylum at last; like a missive; like an "epistle," as Masha says[*], or like an envoi. We green-letter-writers. We incorrigible addressers and addressees. We fragile frangible senders. Writing always towards the you. Always, everything, everywhere – writing to you. For you.

Derrida, "Envois," from *The Post Card*: "What impels me to write you all the time? Before I can even turn around to look, from the unique destination, unique you understand me, unnameable and invisible, that bears your name and has no other face than your own, before I can even turn around for a question, at every moment the order to write you is given, no matter what, but to

[*] 5 28 2012—*P.S., Dear Elaine (The Most Insane Idea Is To Love)* (p 121)

write you, and I love, and this is how I recognize that I love…"

"Eros in the age of technical reproductibility. You know the old story of reproduction, with the dream of a ciphered language."

Forest language. That line of Barthes' I love, from *Barthes by Barthes*: "Toward writing. According to the Greeks, trees are alphabets. Of all the tree letters, the palm is the loveliest. And of writing, profuse and distinct as the burst of its fronds, it possess the major effect: falling back." Forest language. We write in its code and read the trees. Women are often charged with not seeing the forest for the trees, which is to say, of being myopic, of looking too closely and obsessively into detail, not seeing the big picture, the landscape, the map, the territory. We know that's a false dichotomy. Our heart-eye zooms in and zooms out. Is attentive to micro- and macro-connectiveness. See the forest for the trees and see the trees in the forest. Readers who are lovers, lovers who are readers: my beloved in details is my whole beloved. Love to bits.

In "Time Is of the Essence," Masha wrote: "But if we relate being to time, and love to time, it's no longer just the Hamletian to be or not to be. But, when and not when, or when to and when not to, which according to Badiou is where subjecthood begins: 'You become a subject to the extent to which you can respond to events.' This includes the event that subjecthood—becoming—is, for, responding is answering, and the way we answer and don't answer has everything to do with who we are and who we are deciding to become and not become. Every moment you are near and far. Every moment you are possible and impossible. There is always a bridge. There is never a bridge. It is too early and it is too late. I am talking about myself and you (X.). These two halves of meaning and being(s) going the distance. That going is love. Going away, coming back, it always just feels like I'm going one way: towards you."

The bridge that isn't and is there. We know that what we send may not arrive; even, especially, when what we send is ourselves. How do you know you've arrived? Maybe a Lacanian would say that the concept of arrival itself is reactionary, that arrival should be infinitely deferred, but frankly I don't care for infinite deferral, in lack fetishizing, in manufactured absence making the heart grow fonder, in treat 'em mean and keep 'em keen. No. I've lost people. We both have. I have to know how to mourn it without fetishizing it. To dare towards radical fulfillment, towards deep and deeply felt consummation. Important here to note that fulfillment and consummation are different from: closure, culmination, verdict; no phallocentric language of the law to be used when imagining revolutionary love utopias, I want to be full, not final; some will realize this conflicts with my much-documented-here affection for *Spectres of Marx* and communist/messianic opening, the promise; you'd be right, I'm conflicted, brown woman gets angry about being told by white men to wait for the justice-to-come, how come when minoritized groups start talking about rights, sophisticated and privileged white European intellectuals begin theorizing that human rights as a category doesn't actually exist—then patronizingly say but of course for pragmatic reasons we still retain the category, for pragmatic reasons you understand—and that the horizon of true justice is always-infinitely kept at a remove—which is to say: removed, excised, not ever for you—and isn't that's fucking convenient. Thinking about that graffiti on the Kunsthaus Tacheles artists' collective: how long is now. What I'm saying is: repletion is not impossible. Justice is not impossible.

I keep thinking about the romantic immigrant, her affective politics. Immigrants often being incorrigible utopians, too. Some of us have had no choice but to believe, to pray, that arrival would at last bring the Good Life. The heaven on earth. Some of us, many of us, have been wrong. Have been disillusioned. According to Fortress Europe, nearly 20,000 people at least have died since 1988, along the borders of Europe. What about the girl I'm writing, in *Postcard*, who throws herself on the shore of Europe. Who drowns, or doesn't drown. Time forks for her, too. The way time forked for my mother, my father. The way time has forked for me. Before Europe. After Europe (love). One life, and another. The fantasy doesn't foreclose the brutal practicality required in the attempt to make the fantasy come true. I have always liked this phrase: come, true. To come, and to come true. A little like: come correct. Who or what doesn't come true, come correct. Erotics of migration, of gendered and racialized subjecthood: still trying to come true—we the minoritized, have to invent ourselves; have to affirm that we do exist—and still trying to come correct. How funny that I thought of "come correct" when earlier I wrote that immigrants were "incorrigible utopians." Can't correct me because I'm already coming correct? There's a difference between "being corrected" and "coming correct." Difference being: authority. I don't want to be corrected; I do want to come correct.

So try as the xenophobes might to stop us (and they do try, and they have might, having monopolized and mobilized so much might)—still we come. Come and come. Difficult for me to imagine the orgasm of the xenophobe, who refuses the dissolution of borders? Coming, I'm coming, can't come, don't come, patience to come, make me come, multiple coming, have to have to, come, come for me. Dream of arrival: have you arrived, finally feel like I've arrived, after all this time still don't feel like I've arrived, when do you feel like you've arrived, let me know when you've arrived, feels like I'll never feel like I've arrived, I've arrived, I've just arrived, did you come, I came, I didn't come, I came, are you coming, I'm coming, I'm still coming.

Derrida, for M. and X.: "A tragedy, my love, of destination. Everything becomes a postcard one more, legible for the other, even if he understands nothing about it. And if he understands nothing, certain for the moment of the contrary, it might always arrive for you, for you too, to understand nothing, and therefore for me, and therefore not to arrive, I mean at its destination. I would like to arrive to you, to arrive right up to you, my unique destiny, and I run I run and I fall all the time, from one stride to the next, for there will have been, so early, well before us…"

In the video, at 2:00, I filmed the empty seats because it felt like I was saving a place for you, for us. In the film we could sit across from each other, look out the window together. And then as I was editing I noticed the letters ("M + [X.]") scratched into the window, on the lower left corner of the pane. Those letters exactly. Can you believe it? Magic inscription.

▪ **PHOTO**
M + X.

Back in September, in the middle of the night, I was in California visiting my family, one of the many times neither [Masha nor I] could sleep and we wrote each other desperately.

Fragments of what we wrote then, what is true now*:

> **FROM:** Elaine Castillo
> **TO:** masha tupitsyn
>
> Deleuze and Guattari, Becoming Animal:
> "If the writer is a sorcerer, it is because writing is a becoming, writing is traversed by strange becomings that are not becomings-writer, but becomings-rat, becomings-insect, becomings-wolf, etc."
>
> For the magic of letters, our letters. And for writer-dogs and writer-wolves. And for things to-come. To-become.
>
> Elaine

> **FROM:** masha tupitsyn
> **TO:** Elaine Castillo
>
> Yes. Yes. I know. I believe. I am believing, with you.
> We are seeing together, for each other. Seeing this: all this magic.
>
> 7:28 am
>
> Writers as sorcerers.
>
> Two powerful girls. Making magic together.

From Derek Jarman's "Green Fingers," in his book on color, *Chroma: A Book of Color*:
"My first memories are green memories."

"Lost in the woods of sweet chestnut I stared entranced at a pumpkin, with leaves as big as the fans that cooled the Egyptian pharaoh in a Hollywood epic. The cinema was born in a green wood."

"My second experience of the cinema was even more frightening—Walt Disney's *Bambi*, in which nature is consumed by a raging forest fire."

"The Jolly Green Giant and his friend the dragon are coming to the rescue. Why are dragons green? Why are some lucky and others unlucky?"

"Green is a colour which exists in narratives… it always returns." ▪

* See: 6 08 2012—*A Real Dog (Knight Wolf Glad)* (p 128)

"Everyone's existence, when tested by love, confronts a new way of experiencing time… It is the desire for an unknown duration."
—ALAIN BADIOU, *In Praise of Love*

• **SCREEN**
Gare de Lyon, Paris.

06 17 2012—OUTSIDE INSIDE

He wears red inside. She wears red outside.
On the outside he loves her and listens.
On the inside he drank and beat the shit out of her.
On the outside she is nobody's fool.
On the inside she was so young. Even younger than the girl she plays.
On the inside he was furious when she—not him—won an Oscar.
On the outside he smiled.
It is called acting.

• **SCREEN**
Children of a Lesser God (1986), Randa Haines.

In Sophia Coppola's *Somewhere*, celebrity goes with repetition. With drive. In fact, celebrity is the cult of repetition par excellence. If acting is a condition of life, then what role is most fulfilling and what roles are we (ful)filling most? The part of father that Johnny plays for a couple of weeks puts into crisis the role that makes him increasingly miserable: the actor-as-person, the person-as-actor, or the person as a result of fame (repetition, reproduction). It is a role that at

▪ SOPHIA COPPOLA
Somewhere (2010) - Trailer
LINK: http://youtu.be/C9n9hP_LtL8

the end of the movie causes Johnny to weep and admit, "I'm not even a person." *Somewhere* opens with an extreme long-shot, real-time exposition (an homage to Antonioni) of desert car racing. Johnny drives his sports car (sports life, game life, movie life, life movie) in circles. His life is a loop of this torsion. Is there anything or anyone to return to? Or is there only something and someone to circle; encircle? *Somewhere* closes with Johnny back in the desert, where he stops his car, gets out, and walks away (from it, from the life he's been living) in a straight line. This scene is shot in close-up and the curve is momentarily (permanently?) suspended.

On the YouTube (YouTube being an endless digital catalogue of tautology) page for the above clip, one user describes *Somewhere*'s opening driving sequence with, "Nowadays, people are like this." Yeah, nowadays, they are.

Despite being an unbearable quagmire of a book, Žižek's *The Parallax View* does make a useful distinction between drive and desire, desire being something we've lost:
"…Desire is grounded in its constitutive lack, while drive circulates around a hole, a gap, in the order of being. In other words, the movement of drive obeys the weird logic of the curved space in which the shortest distance between the two points is not a straight line, but a curve: drive 'knows' that the shortest way to attain its aim is to circulate around its goal-object. At the immediate level of addressing individuals, capitalism, of course, interpellates them as consumers, as subjects of desire, soliciting in them ever new perverse and excessive desires (for which it offers products to satisfy them); furthermore, it obviously also manipulates the 'desire to desire,' celebrating the very desire to desire ever new objects and modes of pleasure. However, even if it already manipulates desire in a way which takes into account the fact that the most elementary desire is the desire to reproduce itself as desire (and not to find satisfaction), at this level, we have not reached drive. Drive inheres to capitalism at a more fundamental, *systemic*, level: drive is that which propels the whole capitalist machinery, it is the impersonal compulsion to engage in the endless circular movement of expanded self-reproduction… the Freudian death drive has nothing whatsoever to do with the craving for self-annihilation, for the return to the inorganic absence of any life-tension, it is, on the contrary, the very opposite of dying—a name for the 'undead' eternal life itself, for the horrible fate of being caught in the endless repetitive cycle of wandering around in guilt and pain.

"This rotary movement, in which the linear progress of time is suspended in a repetitive loop, is *drive* at its most elementary… This is also how we read Lacan's thesis on the 'satisfaction of drives': a drive does not bring satisfaction because its object is a stand-in for the Thing, but

because drive, as it were, turns failure into triumph—in it, the very failure to reach its goal, the repetition of this failure, the endless circulation around the object, generates a satisfaction of its own. As Lacan put it, the true aim of a drive is not to reach its goal, but to circulate endlessly."

In *Praise of Love*, Badiou, who advocates love over sex, because while "love focuses on the very being of the other," "in sex you are really in a relationship with yourself via the mediation of the other," love over drive and deferral and lack, concludes:
"If we want to open ourselves up to difference and its implications, so the collective can become the whole world, then the defense of love becomes one point individuals have to practice. The identity cult of repetition must be challenged by love of what is different, is unique, is unrepeatable, unstable and foreign. In 1982 in *Theory of the Subject*, I wrote, 'Love what you will never see twice.'" ▪

06 19 2012—AGE OF CONSENT

On the bus to Ithaca, where I'm doing an artist's residency. Nursing a broken heart.
About everyone. About all of it.

Going away makes me feel better and worse.
Everything makes me feel better and worse.

New Order's "Age of Consent" comes on my headphones at one point.

▪ **NEW ORDER**
Age of Consent (1983)
LINK: http://youtu.be/8ahU-x-4Gxw

The words:
I've lost you I've lost you
I've lost you I've lost you
I've lost you I've lost you
I've lost you I've lost you
I've lost you I've lost you
I've lost you I've lost you
I've lost you I've lost you
I've lost you.

06 19 2012—HOT SEX VS. SUBJECTIVITY

With some men, most in fact, hot subjectivity makes hot sex difficult. It cools men right down, if it doesn't shut them right off. The older and more weary men get, the worse the subjectivity-sex relation seems to get. But for me, hot sex has always been the result of not just two hot subjectivities, but two subjectivities accepting and relishing each other's subjectivities, as they heat up and cool down, together and separately, which makes sex not just hot, but the hottest.

▪ PHOTO
A red light (Ithaca, New York; 2012).

As Susan Bordo puts it in her book *The Male Body*:
"Women in porn are hot, but in a crucial way their subjectivity is cool, undemanding, accepting, placid. They provide a fantasy of sexual encounter that does not put manhood at risk in any way."

Women of color have to contend with their own specific versions of racialized, and therefore hyper-eroticized and hyper-sexualized, subjectivity. Because women of color are oversexualized by the culture, their subjectivities get erased, warped, and stereotyped. There is a long vocabulary list, along with key phrases, of all the sexual and subjectivity-shaming women have to listen to. Like: "Take it easy," "Don't get so worked up," "Don't get all fired up," "Calm down," "Slow down," "Simmer down," "Relax," etc., etc. I've been told all of these. ▪

06 19 2012—FROM ELAINE, WHO KNOWS I WANT TO BE READABLE

Elaine Castillo:
Pictures for my girl. For Odysseus on her way to Ithaca. "Mail & female," the name I saw of a store I saw in Amsterdam, is like a great pun on what we do (how we do), what we live (how we live); it having always been about mail— as in mail, letters, sending, posting; but also mail, chain mail, knights and knight's armor, Lancelot, mesh, enmeshment—and females. Mail and female.

▪ ELAINE CASTILLO
"Heartbreaker" / "You Are" (Berlin) (2012)
LINK: http://vimeo.com/43907029

And the video that Masha mentioned in a recent post. What moves me in it are the faint, sudden trumpets you hear in the end. Why trumpets, from where? Like the beginning or end of a march, a joke, or an arrival. An announcement, or Annunciation.

As you move backwards from the love-angry words, staring at the Victory Column, where in *Der himmel über Berlin*, the angels gathered. ▪

Untitled, 1944

This is an optimistic portrait of a creature that has very few branches but has fantastic roots. So this is a child, an investment that you have to protect because it has fantastic potential. You could call this *The Loved One*.

A tree is a portrait. But usually not a self-portrait. A tree is something that you plant, that you watch, that you water, that you trim, that you really take care of. The tree is a metaphor for a child. And responsibility. But, you see the problem of responsibility disappears when you talk about love. When you love, you don't take care of something because you are supposed to. You take care of it because you want to, right?

Hold My Bones, 1994

This is my favorite drawing of all. It is a call for help. It means, "Keep me together, do not abandon me, hold my bones together." Speaking of the *toi* and *moi*! It should be called *Friendship, The Value of Friendship*. I made this for Nigel Finch, the filmmaker. He just passed away.

Insomnia, 1995

This, also, is a solution of continuity, but there is a melancholic and a little bit tired aspect to it. It is as if to say, "I count the hours." During the night I count the hours.

Le Cauchemar de Hayter, 1995

So this appears lately as a solution. It is a solution of continuity; that is to say, it is a symbol of something that is totally continuous and harmonious along the length of the day. With no up and no down and everything readable, clear. I want to be readable, you see.

▪ **PHOTO**
Mail & Female storefront in Amsterdam (2012), Images taken by Elaine of Louise Bourgeois' *The Insomnia Drawings* (1995).

Yesterday Elaine sent me this image of Derek Jarman's text on paradise. On green. Her shadow on the page, as she leaned over to take the photograph for me at a museum library in Cambridge, England, where she lives.

In October, a Tarot card reader told me this (read it like a page from a book, which also has shadows cast over it, darkened by something that started off as the most unexpected light. Light no one was ready for, it turns out. Light

▪ PHOTO
From Derek Jarman's *Chroma: A Book of Color* (1994).

we couldn't make light yet, or at all) about my question about him. Giving a voice to our story. Giving us voices to talk to each other with.

"We met. We were in the garden of love dreams. Could we have a happily ever after? We could. But then something happened that we couldn't. There's a sense of betrayal, the swords were stolen, something happened… between… in our logistics. And now we're in that space of silence."

Do I need to say that Elaine is also a green place, a garden? My deepest root blooming flowers when so much has died or not grown? Got started but never came through. I know this all sounds corny, and I've been criticized (if that's even the right word) for that recently. But I'd be knocked for doing something else too. For doing something different. Because it's different.

One big-boy critic on a big-boy website, *HTML Giant* (part of their series of posts on "The New Sincerity,"), accuses me of being too sincere because, as a critic, I still make distinctions between truth and falsehood when it comes to representation and subjecthood. Another bad-boy writer and former fan (maybe he still is, who knows. But doubtful, since he doesn't have any real feelings to appreciate anything) tells a writer friend, L., that I am writing kitsch now. But is there anything more kitsch than male misogyny? Than acting like a (*white*) male genius? For aren't white men the only ones who even really get to think of themselves as geniuses, as artists, as cultural taste-makers, and therefore have other people think of them this way? Aren't they the only ones who have access and rights to such terms? So even when a (white) woman claims to be a genius, she can only get away with it, or even be thought of as one, if she acts like a male genius. Does genius the way a *male* genius would do genius. And by being a white female-male genius, she gets to do to other women what a male genius gets to do to women: exclude them, alienate them, decide who is and who is not a genius like them, therefore allying herself with other white male geniuses.

When I was all covered up, in vines, in thorns, in ice; with the fire and green underneath (not on the surface in plain view) for only the right heart to thaw or weed (rip off, if necessary), I was called other names. My work has been called other names. So I can't win, and I don't want to. What's winning and who wants to win all these dead, cold hearts who don't even mean what they say or think? Who will think and mean something different tomorrow anyway. And who never asked, who make a point of not asking, so they never have to be responsible for anything or anyone; to anyone.

Besides, I couldn't win. Not in this world. Not given what winning entails. Not as a woman, not as feminist, not as a critic, not as someone who mourns things, not as a true lover. And no one like this can, really. Not anyone green or trying to stay awake ("During the night I count the hours").

With Elaine, the swords were not stolen. They were placed in our hands. The weight a gift and honor.

Louise Bourgeois: "When you love, you don't take care of something because you are supposed to. You take care of it because you want to, right?"

Paradise haunts gardens. Gardens haunt paradise. ▪

06 21 2012—PRECARIOUS LIFE

You could love it like this.

Or you could hurt it like this.

▪ SCREEN
Au hasard Balthazar (1966), Robert Bresson.

In an email about friendship (ours), about love (ours), Elaine writes to me about Odysseus, Penelope, and their like-mindedness, which is also a secret code between them. A password for one to get to (into) the other: "[Penelope] deflects [Telemachus'] criticism and replies that she still has to test [Odysseus]. She says: 'We two have secret signs, known to us both, but hidden from the world."

We two have secret signs, known to us both, but hidden from the world. That quote was my heart-quote, my soul-quote, for a long, long time. Looking for the one with whom I would recognize the secret signs, hidden from the world."

About his friendship with La Boétie—a prescription just for him, and which makes two people secret signs for each other—Montaigne wrote in his essay "On Friendship": "If you press me to tell why I love him, I feel that this cannot be expressed except by answering: Because it was he, because it was I."

And from a *Cabinet* interview with Angie Hobbs on the philosophical roots of friendship: "You always have this tension between friendship as the building block and the glue of the state, as Aristotle wants it to be, and then all these literary models where friendship can work against authority, against political stability, and can sometimes be an immensely disruptive force. It's partly this tension that later prompts the Greek philosopher Epicurus to separate friendship from politics and set up a community of friends in what was called the 'Garden'—a real garden, as it happens—outside the polis. In addition to abandoning the polis for the garden, the Epicurean tradition also has room for different kinds of relationships than one sees in the polis— women, for example, are more present in Epicurus's scheme than in Aristotle's.

"Women are allowed in the Epicurean setting in two ways. First, wives and children are welcome in the garden, you can bring your family—for Epicurus, friendship is not necessarily antithetical to the family unit. And also women are allowed in their own right. We have, for example, a follower of his called Leontion (a former prostitute, and it's often former prostitutes who become philosophically trained in ancient Greece, because they're the only women allowed out of their home and into male environments) who takes an active part in philosophizing. It doesn't appear that Aristotle envisaged such a scenario in either his theory or his practice, though Plato is interesting because of course he does allow women to be major players in his ideal State, which includes philosopher queens and women in the army—he's extremely radical in this respect. Another possible alternative tradition is that of Sappho on the island of Lesbos, and her group of close female friends who wrote poetry to each other; they may or may not have engaged in homoerotic affairs, but they were clearly very intimate friends. And the Greeks did revere Sappho's poetry—she was regarded as quasi-divine. So they knew about these other possibilities for friendship, though they didn't often make them very explicit."

The garden again. Not just the garden of love, but the garden of friendship. Of what can grow and thrive. The green that brings us close. The green that lets us let things in; be let in.

A few months back, I wrote "By Heart," an essay about someone I lost. Someone I left. *The* someone. I lost both the person and the secret signs of him. Or maybe it was the other way around;

W. stopped being able to read me. Stopped wanting to be in on our secret, part of our secret, the secret that was us. Of us, for us. Our secretness (sacredness) to each other. He slipped back into the rest of the world and hid himself from me.

I wrote: "Sometimes he would show up at my door to pick me up for our all-night dates agitated but soft for me. I think that's maybe my favorite combination. Agitated but soft. People who are like forbidden cities. People who only love people who have the key to them. People who unlock each other."

I end "By Heart" with a quote from Robert Bresson's *Notes on a Cinematographer*. A line that echoes the beginning of Elaine's letter to me about Odysseus and Penelope.

"Hide the ideas, but so that people find them. The most important will be the most hidden."

The most important people are like this, too. Hidden from the rest of the world, most of the world, but not hidden from you. I want to be hidden from everyone but you. I want you (whoever you are) to find me. ▪

06 22 2012—TIME-JUMP #20: DANCE IS RULED BY VENUS

So many times I've listened to this and imagined the dance floor. Of what will happen on the dance floor that comes at the end of a day (a year) of endless thinking and hoping. When everything starts to add up in this song, in my life; when the song can finally glide through its apex (at 4:00), something finally happens. Something that would—could—also happen when two people pull up to each other, at the same time, and reunite like trains at a train station. ▪

▪ **RADIOHEAD**
Lotus Flower (Jacques Greene RMX) (2011)
LINK: http://youtu.be/G4hljPQshAU

In *The Walk*, Robert Walser writes:
"As is well known, there are people who excel at concealing the crimes which they commit behind disarming, obliging behavior."

Conversely, one is accused of committing crimes one has not committed because of one's refusal to oblige to corrupt systems and corrupt people. That is, not obliging to obliging. And, of course, just for the very fact of calling something or someone corrupt in the first place. ▪

▪ SCREEN
Robert Walser, December 25, 1956.

06 24 2012—THIS IS MY TIME

Is there any anything? Is there anyone? What is left?

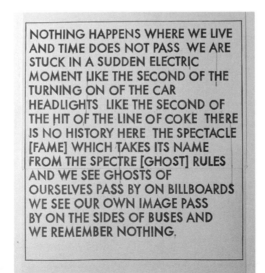

NOTHING HAPPENS WHERE WE LIVE AND TIME DOES NOT PASS WE ARE STUCK IN A SUDDEN ELECTRIC MOMENT LIKE THE SECOND OF THE TURNING ON OF THE CAR HEADLIGHTS LIKE THE SECOND OF THE HIT OF THE LINE OF COKE THERE IS NO HISTORY HERE THE SPECTACLE [FAME] WHICH TAKES ITS NAME FROM THE SPECTRE [GHOST] RULES AND WE SEE GHOSTS OF OURSELVES PASS BY ON BILLBOARDS WE SEE OUR OWN IMAGE PASS BY ON THE SIDES OF BUSES AND WE REMEMBER NOTHING.

▪ SCREEN
Robert Montgomery.

NOTABLE/QUOTABLE

"Miranda July Thinks 20-Something Women 'Already Just Love Themselves.' At author Sheila Heti's reading of her new novel *How Should A Person Be?* in Los Angeles last night, performance artist, writer and filmmaker Miranda July delivered her verdict on Me And You And Everyone in Bushwick *Girls*, sort of:"

Miranda July: "*Girls* is a great show. Sheila and I were talking about Lena Dunham's generation, whom we admire. These women are able to make art at a much younger age, without having to go through, like, a punky rebellion like us older feminists have. They already just love themselves. And that's great." [http://jezebel.com/notable%5cquotable/]

Nina Power, *One Dimensional Woman*:
"The political imagination of contemporary feminism is at a standstill. The perky, upbeat message of self-fulfillment and consumer emancipation masks a deep inability to come to terms with serious transformations in the nature of work and culture. For all its glee and excitement, the self-congratulatory feminism that celebrates individual identity above all else is a one-dimensional feminism… If feminism takes [the] opportunity to shake off its current imperialist and consumerist sheen it could once again place its vital transformative political demands center-stage, and shuffle off its current one-dimenionality for good."

Note: Miranda July acts as though feminism is some kind of default or preventative measure— you're a feminist because you have no other choice. You don't have power yet. You don't have access. Feminism is no longer a life-long struggle or commitment to social justice. It's something you have to be until you no longer have to be it. For the record, feminism is not just about "loving yourself;" loving ourselves in the way that loving our ourselves has come to be defined (*Sex in The City*, HBO's *Girls*, etc) and accepted is overrated, privileged, and self-indulgent. A lot of assholes love themselves, don't they? Or are at the very least self-satisfied and unconscionable. Usually it's the people who *shouldn't* love themselves who do. So what exactly does "loving oneself" entail and what kind of relationship does it have with feminism as a political movement for social justice? For that matter, what is "punky rebellion" (July uses the diminutive, cuter "punky" instead of the more threatening, politicized "punk")? Is rebellion simply a personal and temporary phase you learn to outgrow? Something adolescent. A general teenage rebellion that you get out of your system, as opposed to something you actively do and consciously are as a way to oppose a larger system of power and oppression. Me vs. everybody. Your system vs. the system(s).

bell hooks, from "Love As The Practice of Freedom" (*Outlaw Culture*):
"…Many of us are motivated to move against domination solely when we feel our self-interest directly threatened. Often, then, the longing is not for a collective transformation of society, an end to politics of domination, but rather simply for an end to what we feel is hurting us. This is why we desperately need an ethic of love to intervene in our self-centered longing for change."

As bell hooks points out, feminism is part of an *ecology* of love and social justice that is both individual and collective—political, personal, and social—and women aren't just feminists because

they have to be, or until they have to be, but because they want to be and should be—always and ongoing. Because it makes the world better for everyone (to quote bell hooks, "feminism is for everybody." See also Audre Lorde's "The Master's Tools Will Never Dismantle the Master's House" from the book, *Sister Outsider*, 1984), not just for "yourself" or "me."

July seems to think that feminism is only necessary when you are trying to make *your* way into the outside world of work and status, but that the minute you've "made" it (gotten your own HBO show, become a cult personality), you can stop being a feminist and hopefully, like Dunham's generation, don't have to be one in the first place. Though it's doubtful that July was ever anything as politically conscious or critically engaged as a feminist herself, since as Nina Power puts it in *One-Dimensional Woman*, the word "feminism" itself these days has been so bastarized—used for everything and by everybody—for the most cynical, self-serving, and often incompatible causes that both the word, and the struggle as a whole, have to be reimagined, redefined, radically repoliticized, and rescued from the miasma of consumer capitalism, as its come to mean everything and nothing—a promiscuous label that anyone can purchase with no real commitment or accountability. First the word "feminism" was shamed and demonized by the patriarchal media, so that no one would even use it, or associate with it anymore for fear of risking marginalization. Then consumer capitalism figured out a better way, as it has with everything else: corrupt and co-opt the word and the radical (transformative) potential of feminism so completely that, sure, you can use it, and even *be* it, but it won't have any disruptive or transgressive power anymore. As media critic Todd Gitlin puts it in *Media Unlimited*, "The media have been smuggling the habit of living with the media." In other words, things can be hollowed out and disabled not only by making them look abnormal, but by making them normal.

"I contend," writes Power, "that much of the rhetoric of both consumerism and feminism is a barrier to any genuine thinking of work, sex and politics that would break with the 'efficacy of the controls' that Marcuse identified. What looks like emancipation is nothing but a tightening of the shackles."

The shackles are further tightened when feminism becomes nothing more than an instrument and a politic of personal gain and emancipation; a form of social darwinism and upward mobility.

Power:
"It is clear, then, that what we are not only dealing with 'right' and 'left' feminism, but with a fundamental crisis in the meaning of the word. If 'feminism' can mean anything from behaving like a man (Jacques-Alain Miller), being pro-choice (Jessica Valenti), being pro-life (Sarah Palin), and being pro-war (the Republican administration), then we may simply need to abandon the term, or at the very least, restrict its usage to those situations in which we make quite certain we explain what we mean by it." ▪

"…Time is never linear. You always feel that everything happened just yesterday but also 100 years ago. I don't want to experience time in a line."
 —JEANETTE WINTERSON

▪ **WARREN BEATTY**
Reds (1981)
CLIP: "Reds - train station scene"
LINK: http://youtu.be/X5MtATxkyHM

06 27 2012—TIME-JUMP #21: DESTINY RED

What is coming sounds like this.

▪ **JOHN ADAMS**
The Chairman Dances (Foxtrot for Orchestra)
Music from the Motion Picture: *Io sono l'amore (I Am Love)* (2010).
LINK: http://youtu.be/BA4PRI319O8

"*Sleepless In Seattle* is about the dream that inevitability itself – fate, signs, all that – can produce happiness…This is a step into nonsense, and I mean that lovingly and etymologically. *Sleepless* is about love cut adrift from sense; it is about nonsense, and while wandering off with someone you've never met and know almost nothing about is in reality a great way to blow up your life, the desire to believe in this idea is a deeply human form of faith… [*Sleepless in Seattle*] is also about leaning on your friends: Meg Ryan and Rosie

▪ **SCREEN**
Sleepless in Seattle (1993), Nora Ephron.

O'Donnell have a quick phone call where, at the end of it, they say, 'I love you,' and 'I love you, too.' I was so struck by that, I remember—that in most movies, you're lucky if people say goodbye before they hang up, but this one knew that with your best friend, when it's important, you say, 'I love you,' and 'I love you, too.'"
–LINDA HOLMES

"*Sleepless in Seattle* is a very interesting movie about passion and love and fear. In both *Truly, Madly, Deeply* and *Sleepless in Seattle*, the fear is that you've lost a grand love and you'll never be able to experience it again. Passion and desire about love do have the potential to destroy people. It's like losing your sense of smell or taste. There is that intensity of passion in films like *Red Sorghum* and *Ju Dou*—that sense of being so deeply, spiritually, emotionally connected to another person. Tragically, there's so much weird focus on dependency in this culture—especially where women are concerned—that it has become very hard for women to articulate what it means to have that kind of life-transforming passion. I think that our culture doesn't recognize passion because real passion has the power to disrupt boundaries."
–bell hooks, *Outlaw Culture*

06 28 2012—TIME-JUMP #22: TIME-BEING

I see this kiss at a train station. This look of love. I hear: "I'm sorry. I couldn't. Because I wasn't ready." And my face is being held. And he is looking at me with such care and graveness. And I don't know whether I am seeing this or imagining it.

▪ **PHOTO**
M + [X.] scratched alongside a pair of empty train seats. Photo by Elaine Castillo (2012).

In a documentary I saw years ago about James Baldwin called *From Another Place*, Baldwin, a very important person and writer to me, said, "If you don't do your work, you really are useless." By work, he meant one's *life's work*. The work one is in the world to do. The work that changes the world because the work is also an effort to change it and because the call to do it is answered, like when the call to love is answered. Baldwin was living in Turkey when he said this, standing in one of his rooms, talking to the camera. The film is one long interview. Baldwin scholar Magdalena J. Zaborowska calls this Baldwin's "Turkish decade" in her book *James Baldwin's Turkish Decade: Erotics of Exile*. Baldwin went to Turkey as a refuge for writing, and, as Zaborowska notes, "his Turkish sojourns enabled him to re-imagine himself as a black queer writer and to revise his views of American identity and U.S. race relations as the 1960s drew to a close."

In Turkey, Baldwin was drinking and smoking and going to all-night parties, or hosting them. Yet despite his social lifestyle, he was still writing. Every day, all day, he said. Baldwin insisted that no matter how bad he felt, how hungover, exhausted or bereft, he still did his work. As a person who is committed to doing her work, who is haunted by doing her work and by the work she has to do, but who never feels she is doing her work well, or enough, or the way she is *supposed* to, and who also sometimes feels there is no room for the work she wants to do in this world of work-as-hyper-production, this struck me.

Life's work and work as capital are two different things in a world like this. A world like ours. I am constantly plagued by self-doubt; by whether I am in fact honoring the work I have to do; the work I haven't yet done but want to do, strive to do. That I waste my days. Waste my days. Which then throws me into a inner dialectic:

What is waste? What is not wasting? What is enough? What is not enough? What is important? What is not important? What should I want? What should I not want? What should I want? What do I want? What makes me a success? What makes me a failure? What is success? What is failure? (Remember that Deleuze said that life is not personal and that success and failure are culturally determined). Am I doing it right (life) or am I doing it wrong (life)? When are you useless and when are you useful? When is it important to be useless and when is it important to be useful? How much is too much? How much is not enough? What kind of uselessness leads to usefulness and what kind doesn't?

Sadly, what I tell others is not what I tell myself. Or, rather, what I believe is not always how I feel. I am harder on myself—meaner, obsessive, unforgiving. Sometimes I do not take, or even hear, my own advice. Writing either long things or very short things, I always make sure to make short work—an image, a film clip, or just a few laconic sentences—so that people can not only read the bare minimum as the bare maximum, but also so that they can read between the lines, between the posts. My lines, my posts. Around the lines that are there and the lines that are not there. To learn how to read not only what is written down, but what is not written down. That is, to read what is written—what a writer wants to say—by reading the space between what is written and not written. A minimalist at heart, I thrive on gaps, elisions, reverberation, noir, economy, quiet, concentration, discursiveness. Things whittled down. The dialectic between saying and not saying. I write for one, not all. An intimate, not a crowd. I never look at what I've done, achieved, only at what I haven't. I don't look at my books after I've written them. Only at how

slow, how long, how precarious, how impossible. Because it almost always feels like, *maybe never again*.

Baldwin, whom I love, and whose words always ring loudly in my ears, medicated himself in order to face things. In order to do his work. But I can't get to the work that way, to anything that way, and I don't want to. As Deleuze and Guattari put it, "art is never an end in itself; it is only a tool for blazing life lines, in other words, all those real becomings that are not produced only *in* art." I can't always face my work, but I always face my life. For most people it's the other way around.

I know that there is the work that I want to do and the work that I need to do. And there is a part of me that knows that and a part of me that doesn't. And the part of me that knows is able to do the work that I need to do, and the part of me that doesn't is not able to do the work I want to do.

The difference between production and work. What I said to Elaine recently, and to other writers, other people, about how the world doesn't need more work, it needs more of a *certain kind of work*. But even more than that, the world needs more love and justice—not more ideas—which is ultimately what the *practice* of love is.

bell hooks in "Love As the Practice of Freedom" (*Outlaw Culture*):
"In this society, there is no powerful discourse on love emerging either from politically progressive radicals or from the Left. The absence of a sustained focus on love in progressive circles arises from a collective failure to acknowledge the needs of the spirit and an overdetermined emphasis on material concerns. Without love, our efforts to liberate ourselves and our world community from oppression and exploitation are doomed. As long as we refuse to address fully the place of love in struggles for liberation we will not be able to create a culture of conversion where there is a mass turning away from an ethic of domination."

The big project, big scheme meta-narrative approach is not something I uphold or advocate, as I'm someone who argues and cheers for the small, the nano, the speck, the minor, the laconic every time. Especially now, when we can't afford to go big or grand anymore, not only because the world can't hold it, but because there isn't space or energy left for it—politically, psychically, ethically. There is simply no more room. No more time. But also, big things, big people, big names, big truths, big narratives, master narratives do not hold or account for the small, the fleck, the injured, the lost, the micro, the minor, the detail, the ruin, the fragment, the sliver, the holes, the slippages. Nor does it account for the smallest of injustices: the things that have happened. The people they have happened to. Especially the people they have happened to.

Because of course there is too much and not enough at the same time, and few people know the difference. As someone who is utterly affected and impacted by one person, one text, one film, one sentence, one line, one word, one look—just enough—just the right kind of thing is all I really need, and all I've ever wanted. For my work, for my life. These honed reductions. How when I was at Documenta 11 in 2002, wading through the overwhelming torrent of "art" everywhere, I walked into one room, where Alfredo Jaar's triptych of photographic texts (texts about

photographs) from "Lament of The Images" were hanging, and those three small pieces, with their laconic distillations about what happens to images in our world—the things that are kept from us, the things we'll never see—changed my life, and years later led to *LACONIA*. In that ocean of too much to bear, too much to even see, there was one artist who said something absolutely necessary. Who used a Kafkian speck, which is also an aesthetics of resistance, to say it all. As Flannery O'Connor puts it in her author's note to the second edition of *Wise Blood*, "Does one's integrity ever lie in what one is not able to do?" This might be the most important question we can ask ourselves in the 21st Century. ▪

▪ **IMAGES**
Alfredo Jaar, "Lament of the Images" (2002).
See: http://mashatupitsyn.tumblr.com/post/26097102855/enough-is-enough

I've decided to repost my Tweets about *An Affair To Remember*, one of my favorite films, as it inspired Nora Ephron's *Sleepless in Seattle*.

I am watching *An Affair to Remember* so that I can remember how people used to have affairs.
SEPT 17, 11:03 PM

"Now those were the days when people knew how to be in love. They knew it. Time, distance—nothing could separate them
SEPT 17, 11:04 PM

because they knew." Meg Ryan, *Sleepless in Seattle*
SEPT 17, 11:05 PM

Lyrics from "Love Affair" for *An Affair to Remember*: "Our love was born with our first embrace/And a page was torn out of time and space."
SEPT 17, 11:06 PM

In old screwball comedies, it's always about meeting your match. Love as your match and love as a match. Love as truly matching.
SEPT 17, 11:07 PM

In old screwball comedies, you never like what you see at first. Who you see at first. You don't like it because you've never liked anything or anyone
SEPT 17, 11:08 PM

so much.
SEPT 17, 11:09 PM

Words between lovers: "You saved my life. I was bored to death." Cary Grant
SEPT 17, 11:10 PM

"You will have confidence when you need it. That is your character." Deborah Kerr
SEPT 17, 11:11 PM

"We changed our course today." Cary Grant
SEPT 17, 11:12 PM

The other day, over Gchat, Elaine reminded me about how this remix clip of Martin and Debi from *Grosse Pointe Blank* was one of the first things I ever sent her when we first started writing to each other just over a year ago. It reminded me of a tweet I wrote back in September. In those early emails of ours, Elaine and I talked a lot about John Cusack, *Say Anything*—our love for Lloyd Dobler and his radical love ethic:

▪ **IMOGEN HEAP**
Just For Now (2004)
CLIP: "Martin and Debi" (*Grosse Pointe Blank*, 1997.)
LINK: http://youtu.be/BgpaT3mwgqg

"In real life, people can see something happen between two people and say, 'It's nothing.' In a movie that 'nothing' becomes an entire movie."

▪ Just for the record, I love a man who paces while trying to make a decision—the right decision—the way Martin paces outside of Debi's radio station. Deliberation. The ethics of when. Plus, who kisses like Cusack on screen? No one. It shocks me every time, the way he kisses. It's shameless. The reality, total surrender—desire—of his screen kisses. (00:55-1:00). The way he pulls away from a kiss, but wants in, still. Pulls towards again, rocks back and forth, adjusts his jaw to recover. The way he is with a woman's face, about a woman's face, Debi's. Looks at her mouth, looks at her face. Eyes always on a woman's face. He's all hers. This is what he once did best.

▪ Also, is there really so much red in this film? How did I not notice before? ▪

"The woman I love rode this way, carried off by horsemen. If I do not find her, I will never find myself. If I do not find her, I will die in this forest, water within water."
–JEANETTE WINTERSON, *The PowerBook*

• **MASHA TUPITSYN**
Premonitions (Ithaca, NY) (2012)
LINK: http://vimeo.com/44905849

"The novel has always been defined by the adventure of lost characters who no longer know their name, what they are looking for, or what they are doing, amnesiacs, ataxics, catatonics… *La Princesse de Clèves* is a novel precisely by virtue of what seemed paradoxical to the people of the time: the states of absence or 'rest,' the sleep that overtakes the characters… When the novel began, with Chrétien de Troyes, for example, the essential character that would accompany it over the entire course of its history was already there: The knight of the novel of courtly love spends his time forgetting his name, what he is doing, what people say to him, he doesn't know where he is going or to whom he is speaking, he is continually drawing a line of absolute deterritorialization but also losing his way, stopping, and falling into black holes. 'He awaits chivalry and adventure.' Open Chrétien de Troyes to any page and you will find a catatonic knight seated on his steed, leaning on his lance, waiting, seeing the face of his loved one in the landscape; you have to hit him to make him respond."
–DELEUZE & GUATTARI, "Year Zero: Faciality" (*A Thousand Plateaus*)

07 02 2012—WOMEN IN LOVE

Realizing that me and Elaine are also Meg Ryan and Rosie O'Donnell in *Sleepless in Seattle*.

"It's a sign."
"It's a sign."
"I love you."
"I love you."

• **NORA EPHRON**
Sleepless In Seattle (1993)
CLIP: "All I Could Say Was Hello"
TEXT1: *It's a sign.*
TEXT2: *It's a sign that I have watched this movie too many times.*
LINK: http://youtu.be/d9pY8EWE06o

The only thing missing from Christian Marclay's telephone montage is Lloyd Dobler on the payphone in *Say Anything*.

Or, for that matter, John Cusack on all his phones, in all his movies. ▪

▪ **CHRISTIAN MARCLAY**
Telephones (1995)
LINK: http://youtu.be/yH5HTPjPvyE

▪ **SCREEN**
John Cusack in *Say Anything* (1989),
and (bottom) *High Fidelity* (2000).

I Am Love features a beautiful homage to *Vertigo* and Kim Novak's famous hair chignon as portal of time and female erotics. The hair loop is the entrace to desire. Not just chronos (time, moment), but kairos (supreme moment, *the* moment). As Julia Copus puts it in her article about time, waiting, and love, "You Just Keep Me Hanging On, "In modern Greek, kairos means simply 'weather,' suggesting the possibility that time may be a quality rather than a quantity. We see our first snowfall, climb mountains and fall in love in kairos time."

I Am Love is also a rapturous women's liberation film. Emma doesn't even let narrative punishment (the death of her son) stop her. Nor her debt to wealth. *I Am Love* reverses and sheds *Vertigo*'s nercrophiliac weight and fetishistic doom. Emma follows Antonio, her young lover, instead of the other way around. Instead of Scottie following Madeline/Judy. Instead of the mysterious man in the museum that Kate Miller follows to her death in Brian De Palma's *Dressed to Kill*, Emma charges after love into life. After life, into love. Until *I Am Love*, that hair portal has always been entered, like her, rather than being the place *from* which and *in* which she lives. The supreme time at which she *begins* to live and the real quality of life begins. ▪

▪ **LUCA GUADAGNINO**
I Am Love (2010)
LINK: http://youtu.be/ZzUgfF-zkZ8

▪ **SCREEN**
Kim Novak in *Vertigo* (1958), Angie Dickinson in *Dressed to Kill* (1980), and Tilda Swinton in *I Am Love* (2010).

In *A Thousand Plateaus*, Deleuze and Guattari write: "The hands of a clock foreshadow something." Because of cinema, the home of the face, the clock and the face go together. The hands on the face of a clock, the clock on the hours of a face. The clock is a destiny in the same way that a face is. Both Bergman's and Fellini's films are one long clock. Fellini loves the sound of wind howling, which is time passing. Loves it the way Bergman loves a ticking clock. It's the time we're up against, and in, and out of. A camera is a hole that captures a face. "This is the face as seen from the front, by a subject who does not so much see as get snapped up by black holes. This is the figure of destiny… its only function is to have an anticipatory temporal value."

This could be one definition of the time-jump.

▪ CHRISTIAN MARCLAY
The Clock (2010)
LINK: http://youtu.be/xp4EUryS6ac

▪ ABBAS KIAROSTAMI
Shirin (2008)
LINK: http://youtu.be/rZ3iwCo7_qc

In this museum screening of Marclay's *The Clock*, faces are in front of faces and faces are behind faces (an outline of human heads creates a border of spectatorship at the bottom of the screen), so a binary unit is always formed. A pair on the inside, a pair on the outside. A pair on the inside of the pair, a pair on the outside of the pair. Like an inversion of Abbas Kiarostami's *Shirin*, which is an inversion, not only of the classical Western formulation of cinematic spectatorship, but the classical Western formulation of the privileging of white faces taking precedence on the white wall. In *Shirin* we watch non-Western faces watch non-Western faces that we cannot see, only hear. Cinema becomes our faces—reaction shots—in relation to cinema, which is also cinema. We cannot react without thinking about how we watch ourselves watching. ▪

I watched *House of Flying Daggers* tonight. A mixture of martial arts, melodrama, Chinese folklore, *Romeo and Juliet*, Arthurian legend, and screwball comedy, *House of Flying Tigers* is pure allegory and much of it is too much, bordering on kitsch. Which made me think about the whole idea of *too much* and why we need it, and why we're so sure these days that we don't need it. But what is too much? Who is too much? How much is too much?

▪ SCREEN
House of Flying Daggers (2004), Zhang Yimou.
TEXT: *because it's all about feeling*

And why have we become so emotionally resigned when it comes to our lives? When it comes to true love, which we can somehow only bear to watch in movies.

What is interesting about the hyperbolic fight sequences of Wuxia films is the way they slow things down, zoom into motion, expanding, lengthening, and freezing it. Forcing us to see what we cannot see. Making people move in ways they cannot move. Live in ways they cannot live, making Wuxia a subjunctive genre. Wuxia films give us the spatiality of emotion and the emotion of space. Heightening where we can bear to see things, bear to do things, bear to live.

In movies like *Crouching Tiger, Hidden Dragon*, *Hero*, and *House of Flying Daggers*, people see and feel each other regardless of proximity, that is, without actually having to be *near* each other. Characters can hear each other whisper from a hundred feet away. When people are far away, they are close. When they are close, they are far away. Far and close at the same time. Blades, daggers, and swords fly in the direction of emotional force, not in the direction they are thrown. Distances are reversed: far and close are close and far. Seasons are ubiquitous. Summer and winter happen at the same time. Forests slip into forests, creating layers of green. Green on green. Eyes are irrelevant, you see without them. Characters do what they can do and what they cannot do. Inner struggles and states are physically depicted through impossible action and movement. The body *can do anything*. Is everywhere at the same time. Lovers say goodbye, but then always return. Go one way, then turn back around. People are undone by each other's faces. Undone by each other. You can't forget. There isn't someone else. Distance is transgressed (traveled) by how far you are willing to go and how far you have gone. What you are *willing* to do—what you *will* yourself to do—makes you able to run across trees. And of course there is the impossible green everywhere. The everything, always, of green. ▪

07 07 2012—THE HANGED MAN, PART II

"Is it possible to tell, when the knight of the courtly novel is in his catatonic state, whether he is deep in his black hole or already astride the particles that will carry him out of it to begin a new journey? …Cannot the knight, at certain times and under certain conditions, push the movement further still, crossing the black hole, breaking through the white wall… even if the attempt may backfire."
—DELEUZE AND GUATTARI, "Year Zero: Faciality"

▪ **SCREEN**
A knight is woken up in the forest.

These tweets on creative anxiety and the performance of failure in the digital age were originally going to be in a sequel to *LACONIA: 1,200 Tweets on Film*. But in the end I decided not to do a second volume.

Writers only write about their failure—about being failures—when they're no longer failures. Otherwise, the narrative of failure wouldn't work.
OCT 5, 2:12 PM

I wonder how the internet has affected creative anxiety and self-doubt. I know artists have always been plagued by it,
OCT 10, 7:52 PM

but I think having to hear about what everyone is doing and saying and thinking every minute about what they are doing and making has made things infinitely worse.
OCT 10, 7:53 PM

We've lost the valuable feeling of being away from things. Of being removed. Of hermitage. Of waiting. Of keeping things in before you let them out.
OCT 10, 7:54 PM

Of when to and when not to. The anxiety of influence has become something new. Something public. With the hypervaluation
OCT 10, 7:55 PM

of the private, you are successful based on how public you manage to be. How public you are with your private.
OCT 10, 7:56 PM

On June 29, 2012, Elaine wrote:
"One more thing that I forgot to tell you, when I wrote you about Odysseus and Penelope. The first creature that truly recognizes Odysseus when he comes home, when he arrives in Ithaca is: his dog, Argos.

• **SCREEN**
Odysseus' dog, Argos welcomes him home.

"The dog that recognizes. Dog that loves. Has been loving and waiting and believing all this time. It's such a sad and beautiful scene, because after twenty years, Argos is very old, very tired, sick. But in that last instant he recognizes that his human has come home; he's happy. Odysseus isn't able to greet him as his master, because that would give away his identity, but he's moved by the scene, secretly cries. And when Odysseus leaves his side, the dog finally passes peacefully away."

And this, later that day, while I was reading in bed—Kafka on being a dog in "Investigations of a Dog": "How, indeed, without these breathing spells, could I have fought my way through the age that I enjoy at present; how could I have fought my way through to the serenity with which I contemplate the terrors of youth and endure the terrors of age; how could I have come to the point where I am able to draw the consequences of my admittedly unhappy, or, to put it more moderately, not very happy disposition, and live almost entirely in accordance with them? Solitary and withdrawn, with nothing to occupy me save my hopeless but, as far as I am concerned, indispensable little investigations, that is how I live; yet in my distant isolation I have not lost sight of my people, news often penetrates me, and now and then I even let news of myself reach them. The others treat me with respect but do not understand my way of life; yet they bear me no grudge, and even young dogs whom I sometimes see passing in the distance, a new generation of whose childhood I have only a vague memory, do not deny me a reverential greeting. For it must not be assumed that, for all my peculiarities, which lie open to the day, I am so very different from the rest of my species. Indeed when I reflect on it... I see that dogdom is in every way a marvelous institution." •

07 10 2012—ELECTRIC MOON

"If, however, far away,
he were watching the lingering moon
with a heart at all like mine,
surely this clear sky
would be filled with clouds."
—IZUMI SHIKIBU, "Untitled Poem"

• **NAM JUNE PAIK**
Electric Moon (1969)
LINK: http://youtu.be/3Kr4CoU3GO4

In "The Independent Woman," the second episode in the PBS documentary *America in Primetime*, American actresses (almost entirely white) like Mary Tyler Moore, Julia-Louis Dreyfus, Sarah Jessica Parker, and Felicity Huffman are interviewed about their famous TV roles. Every single one of them, except for Roseanne Barr, who politcizes her role on television, her desire to be on television, and her relationship to race, class, gender, and body image, insist:

▪ SCREEN
Mad Men (AMC), Matthew Weiner.

We weren't trying to be political. We weren't trying to be feminists. We weren't trying to be subversive. We weren't trying to stand on a soapbox. We weren't trying to pave the way for other women. We weren't trying to be strong. We weren't trying to change anything. Women can't do it all. Women can't have it all. Women don't want it all.

▪ SCREEN
Sex in the City (HBO), Darren Star.

Don't worry, these television icons assure us, we're not feminists and we never were. This is the very soothing message being communicated to America 60+ years after the inception of television. It is hard to imagine a group of male actors saying the same thing about men on TV:

Men can't have it all. Men can't do it all. Men don't want it all. We weren't trying to be men. We weren't trying to be strong. We weren't trying to be outspoken or independent.

What women want, the women writers, directors, producers, and actors in *America in Primetime*, explain, is the right to be "flawed" and "imperfect." To rebel against the sanitized representations of American womanhood in the 1950s. But when have women ever been treated as perfect in our society? Submissive and incompetent, yes. One-dimensional and marginal, yes. Perfect really means silent and secondary. It does not mean that women haven't been put down and degraded for centuries for their so-callled imperfections. That is to say, for the way they don't—as a sex, the lesser sex—measure up to men. Being put on a pedestal is simply less-than sublimated as higher-than. Has feminism being reduced to the right to be "just as fucked up" as men? Is feminism about accessing dominant power or eschewing it? Is it about the right to be different or the right to be exactly the same? Is role reversal the best we can do in the year 2012?

When it comes to men, the construction is reversed from the start: men are allowed to have it all to the degree that they have never been required to make the distinction or calculation between something, nothing, and everything—let alone justify the desire for, or the right to, the total and the whole. It is because men are permitted to be and have everything (I am talking about the straight white male norm here. The norm we see and hear represented) that they complain when they are actually expected to be accountable to that totality and wholeness. The desire is to signify power and entitlement, but cut corners when it actually comes to being accountable and involved in everything (the monetary, emotional, sexual, domestic, and spiritual).

And what is "having it all" or "doing it all" mean anyway? It seems that both the question and the answer have always been not just about the relation between genders, but the relation between the concept of gender and its relation to entitlement itself. Last spring, for example, a male Tarot card reader warned me that as a woman artist simply wanting anything other than a writing life was impossible and would lead to a lifetime of suffering. It wasn't enough that I told him that I don't want children, or even marriage necessarily, or that I "suffer" precisely from feeling like writing is all I am allowed to have. Being anything other than one thing as a woman (no male artist is told this, even though it is no secret that male artists have historically not been able to balance their art with their personal lives either. However, they continue to believe that they can have both, without actually having to attend to both, precisely because they are not expected to do both) is perceived as unrealistic and greedy—the source of all gender trouble. When I told the Tarot reader that in addition to my writing I also want true and lasting love, which is different from simply wanting a man or a relationship, he was dismissive. Real love as opposed to just being in a relationship means that no one gets to just be or have a man or just be or have a woman. Real love is about being radically opened up from the inside out, not enacting roles. If it were just about having a man, I would already have a man, as just having a man would reduce me to just being—playing—a woman.

When men work *and* have families is that considered having it all? Is it even a question that belongs to what it means to think of oneself as a man? If we apply this question to all men, it is the construct of masculinity that begins to crumble, and not whether men are allowed to have both a professional life and a personal life at the same time. At this point this is a given right for all men, regardless of race, class, and sexuality. Nor is it a problem (or it's largely a problem when it is men of color) when men aren't physically present as fathers and husbands. When male actors and rock stars are on the road 180 days out of the year, when they rarely see their kids, rarely see their wives, rarely participate in their domestic lives or responsibilities, does it make them feel guilty, the way women always lament that it makes them feel guilty when they go to work instead of staying home? The way that women always talk about how being working mothers goes hand in hand with shame and guilt. Do working husbands and fathers feel this much guilt? Do they work less? Do they stop being film stars and rock stars and businessmen? Are they pressured to choose between work and family? Between fame and family? Between artistic life and family life? Between their sexuality and their work? Do journalists and talk show hosts ask them these kinds of questions? Do they wonder if they should give up their work to stay at home? Do they tell themselves they can't have it all? That they have too much? Do they ask themselves if they give enough? Love enough? Are they made to wonder why most men are still allowed to be absent in some way—to merely signify presence?

Judging by conservative family-values Reality TV shows like *Super Nanny*, the majority of men, whether working class or upper class, white men, or men of color (although people of color are almost never featured on the show), are still only expected to be breadwinners. If men are asked to do more, they feel they are being put upon, stretched beyond their limits, feminized, sent "mixed signals"—required to be "everything"—by the castrating side-effects of the women's movement. It's no longer enough, men complain, to be a "Man" with a capital M. The very notion of having it all has only ever been applicable to women, for whom the public and the private, the personal and the political, the inner and the outer, are to this day still fundamentally

irreconcilable. In post-20th century America you can't even want everything, much less have everything. Women themselves are quick to point out that mixing both the professional and personal is an impossible ideal, one that they are giving up on. In *America in Primetime*, Shonda Rhimes, a black woman and the creator and writer of *Grey's Anatomy*, states that for female surgeons like Meredith Grey (white) and Cristina Yang (Korean), "love is elusive" and the "fairytale impossible." Yet is the source of Don Draper's anguish on *Mad Men* the fact that he has an ambitious career and a family? Or is the shame all his own; so self-oriented and lawless it gives him a constant out: to have, but not really want, everything. To possess everything, while also living with the option of having more of whatever and whomever else he wants, whenever he wants it. Is Draper's self-loathing and self-destructiveness simultaneously a foil and a vehicle for all of his transgressions and faults? That is, we need the faults for the transgressions and the transgressions for the faults. Is Draper's real torment and appeal having to answer for things men didn't have to answer for in the past? That is, the reality of the man who has to be accountable (in 2012) with the reality of the man who didn't have to (in the 1960s).

Of course Draper's retro-chauvinistic anguish (though with all those ridiculous and smug facial expressions Draper/Hamm makes, it is hard to imagine there is anything inside of him other than self-satisfaction), the glamor of having it all and the tragedy of fucking it up—a very old story— would have no cultural validity if it weren't coming from the current imagination and anxieties of contemporary American life, as it continues to lick its wounds from feminism and laments the loss of real American manhood, economic prosperity, and traditional family values. Mourning the men America has lost to feminism, immigration, and global capitalism—the men who have been wounded, crippled, displaced, and disoriented by social change—Don Draper is a man from the future (from today) sent back to the past. And, conversely, a man from the past sent to the future. The two men meet in the present—ours—in order to bond over their recontextualized, or more precisely, de-temporalized panic, and as an excuse to luxuriate in the nostalgic time-travel of a regressive gender and national politics.

In the retro-enthused (retro diners, retro cars) web series *Comedians in Cars Getting Coffee*, Jerry Seinfeld and Joel Hodgson ("A Taste of Hell from on High") confirm the deep-seated nostalgia for the unrestricted retro-masculinity that is at play in *Mad Men* while driving to a New Jersey diner in a 1963 Sea Blue VW Karmann-Ghia.

JOEL HODGSON: *Mad Men* is so great, still. I'm still in the middle of it.

JERRY SEINFELD: Yeah, I love it. We were on to that in the 80s.

JOEL HODGSON: That's all we wanted. That was *all* we wanted—to be advertising guys in the 60s.

JERRY SEINFELD: That's right.

JOEL HODGSON: We used to talk about that all the time (Hodgson and Seinfeld say "all

the time" at the exact same time. That's apparently how deep the *Mad Men* fantasy goes for men of all generations, but particularly Baby Boomers).

JOEL HODGSON: Drinkin' at lunch.

JERRY SEINFELD: Yup.

JOEL HODGSON: Having a bar in your office.

JERRY SEINFELD: Yup.

JOEL HODGSON: Is that like a shared dream of all guys our age? (Both Hodgson and Seinfeld are in their fifties.)

JERRY SEINFELD: Of course it is.

JOEL HODGSON: And the sexual revolution was all tied up in that.

JERRY SEINFELD: Yup. I mean, that's what the sports cars were all about. Women will give this to you (presumably "this" is sex?) if you have the right accessories.

Seinfeld and Hodgson arrive at a 1950s diner in New Jersey for coffee and breakfast.

JERRY SEINFELD: It's another 50s diner. Why are we looking back all the time? This diner is about looking backward, right? So why are we looking back?

Hodgson's admission that he's "still in the middle of *Mad Men*" is indicative of what is morally and ideologically at stake for these two comedians, which is not simply a favorite TV show, or entertainment, but a relationship to male authority, permissiveness, and an American past that precedes the social reforms of feminism. As young men coming up in the entertainment industry in the 1980s, Hodgson and Seinfeld—both white male Baby Boomers—longed to be mad men themselves: powerful, rich, and totally unrestricted.

For women the myth and rhetoric of everything isn't simply or specifically about being at home and being at work, but rather: and instead of either/or. Plurality vs. singularity. Even the binary itself is homogenized, as choosing work over and in addition to being a wife and mother is morally always the lesser choice. So while *The Good Wife* is about a working woman—a litigator played by Julianna Margulies—its title is haunted by the specter of the either/or binary and impossible female ideal. On TV men want to be free to be juvenile and ambivalent—partially absent, partially present, neither here nor there. However, when they are treated that way (*Everybody Loves Raymond*, *The Simpsons*, *Family Guy*, *Married With Children*, *The Honeymooners*, *The King of Queens*), they feel as though they have been emasculated and ball-busted by their castrating, ungrateful, disapproving, "macho" wives (see also the movie *Falling Down*, 1993). This of course becomes a vicious cycle, as this gives men comedic and dramatic license—"relief"—to act even

more juvenile, incompetent, and ambivalent. Since you treat me like a baby, I act like a baby. Instead of: because I act like a baby, you treat me like one, and can't rely on me as a human being, much less a husband or father.

On TV, men want to be authority figures without being in control, or to be in control without being responsible or accountable. To be men while acting like boys, to be in power without doing anything to command it, other than simply and emptily signifying it. The flip-side of "women having it all," the so-called mixed signals of feminism and 21st century life in general, is the burdensome and conflicting (rather than thinking of it as expansive and integrated, it is treated as contradictory) things that men "have" to be now as a result of those advancements— the "everything" (plurality) that men have to now live up to, which is what *Big Love* was actually about. On *Big Love*, the multiple wives were less about Mormonism or polygamy and more about the supposedly impossible demands and appetites of modern women. Polygamy was merely a cover for a much more reactionary sentiment: the varied pressures that women put on men in contemporary life.

Just as *Sex and the City*'s so-called smorgasbord of men was merely foil for the one man (Mr. Big. Can you get more Freudian?) Carrie Bradshaw not only wanted (a man who was such a Big Bad Daddy, silent-type throwback of a man, he wouldn't even tell Carrie his name), but who invalidated any of the supposed sexual liberation Carrie was indulging in, as well as the reformed modern men she was dating and having sex with (recall the show's Aidan vs. Mr. Big plotline). Mr. Big, it can be argued, was Carrie's narrative punishment—the shadow on her consumer-based, have-it-all freedom. He is, the show tells us, the man women really want, the man women truly deserve, the man women always go back to and leave the Nice Guy for. The man who will not be changed, who won't give you what you want, who will not bend to your or feminism's will—he's that strong—so you will have to change (back) for him. You will have to retro-reform.

While women are apparently still battling—in others and in themselves (as they've thoroughly internalized the binary. The broken record of everything rhetoric)—to acquire the permission to even imagine themselves as sexual beings, mothers, and working women (though as bell hooks has pointed out, women of color have historically always worked) all at the same time, let alone anything other than or alternative to a white heteronormative ideal, men cannot part with the split-legacy of signifying multi-dimensionality while actually only living and practicing one-dimensionality. While women have had to evolve not only their conceptions of themselves, but also their conceptions of men (men can be aggressive and sensitive, weak and strong, providers and caretakers), according to *America in Primetime*, the majority of American men are still lamenting the "good old days" of the 1950s and the paradigm of "father knows best" (the first series in the PBS documentary happens to be called "Man of the House"). One could make the argument that everything on TV, with the exception of some of the long-lost class, race, and gender consciousness of American TV in the 70s, has always been possessed by some specter of this supposed loss and ideal (see *Six Feet Under*. Despite being dead at the onset of the show, the father literally haunted the Fisher family as the ghost of the Father). If, as it is touted, television is now more in touch with real American life than ever, we are really in trouble. ▪

07 13 2012—TOO LATE TOO SOON (THE SOUND OF *HAMLET*)

Now I think quite a lot as I stare at my shoes
About all these things that I put myself through
Now there's nothing to say

▪ THE BEAT
Too Nice To Talk To (1980)
LINK: http://youtu.be/_bOWgk4HZlk

07 15 2012—SKELETON (MORE ON THE APHORISM AND WHY I WROTE *LACONIA*)

"He sometimes practiced with the vacuum cleaner on because that way, he
said, he could hear the skeleton of the music."
–LYDIA DAVIS, "Glenn Gould"

▪ NVCARTS
The Art of the Piano (Documentary, 1999)
CLIP: "Glenn Gould plays Bach"
LINK: http://youtu.be/qB76jxBq_gQ

I used to be so good at wearing my sadness on my sleeve. At being true to my anger. At not hiding anything. Not compromising. Saying exactly what I think. But how many times can you lose everything. Everyone. As a woman, in America, in the 21st century (I can really only talk about my own time and place), the risk of alienation and disapproval is near-constant. Because the line between being liked and accepted and being shunned and hated is so thin and precarious. It literally depends upon how fake and placating and "positive" you are required and willing to be. Because apparently having any kind of critical mind these days (and not just on paper, although on paper isn't exactly encouraged either), and expressing yourself, has somehow become synonomous with being a bad or difficult person. The front is so much more important than who you actually are. So you can be an asshole as long as you smile and have a good time while being an asshole. But you can't say what you think and feel *and* still be thought of as a good person. You are forced to choose between popularity and honesty. Integrity and approval. You aren't allowed to have both. To be both.

In this country, if you have anything to say, if you step out of line, if you complain or criticize or disagree with anything or anyone, you are immediately written off as difficult, a bitch, a drama queen, a threat. If you speak out against things, or even *for* them—passionately—it doesn't matter if you're a decent person. It doesn't matter what your other good qualities are. It only matters if you smile and get along, even if getting along is not real getting along. Most especially if getting along is not real getting along. Is not love, is not honesty, is not vulnerability, is not truth, is not understanding, is not open, is not intimacy, is not risk, is not work, is not change. There is no space for an incident-specific reaction. In an interview bell hooks once said that if your mind is decolonized in a colonized world then it becomes very difficult to live in the world.

Sara Ahmed, "Feminist Killjoys (and other willful subjects)":
"We can consider the relationship between the negativity of the figure of the feminist killjoy and how certain bodies are 'encountered' as being negative. Marilyn Frye argues that oppression involves the requirement that you show signs of being happy with the situation in which you find yourself. As she puts it, 'it is often a requirement upon oppressed people that we smile and be cheerful. If we comply, we signify our docility and our acquiescence in our situation.' To be oppressed requires that you show signs of happiness, as signs of being or having been adjusted. For Frye 'anything but the sunniest countenance exposes us to being perceived as mean, bitter, angry or dangerous."

Romans, 7:15:
"I do not understand what I do. For what I want to do I do not do, but what I hate I do." ▪

07 15 2012—MY MOTHER, PART I

My mother said the most amazing thing to me today as we talked on Skype and I complained about people. How fake and catatonic this culture has become.

She said: "Americans have been dead for a long time." ▪

07 16 2012—LOVE DOG

▪ **SCREEN**
A young Glenn Gould with his dog.

07 17 2012—THE JOY IS ALREADY KILLED

If love is also a politics of resistance, then certain kinds of anger go together with love. Today, in an email, L. writes about being a feminist killjoy, which is what I've been feeling like all the time lately and writing about, too. But I am also angry with myself for how quickly I let go of the feeling that I am loved. I need a love so deep and lasting that I can't forget. A love that lets me live with and bear my anger.

L: "Gotta get mad to make that shit stop. Gotta be a killjoy.

but… also gotta love somebody."

ME: "So true. And story of my life.

Getting/being mad

And wanting/needing to love somebody."

07 19 2012—THE DEATH OF REAL LIFE

In the documentary *America in Primetime*, which I wrote about last week, everyone happily reports that TV has come a long way from its 1950s origins, which were "fake," "unrealistic," and "out of touch" with the way things really are. Every program ended with some tidy conclusion, they say. Some epiphanal or redemptive moment. But today, every obedient, calculating, opportunistic, divisive, fame-hungry, media savvy Reality TV contestant sums up their so-called "meaningful" and "life-changing" experience on TV with: "I've learned so much and I am so much stronger because of this." It didn't take 50 years for TV to catch up with reality. It took 50 years for Americans to completely lose touch with reality. Before TV was not like real people, but now real people are not like real people. They are like TV. This is a much bigger problem. ▪

Samuel Beckett in a letter:
"One may just as well dare to be plain and say that not knowing is not only not knowing what one is, but also where one is, and what change to wait for, and how to get out of wherever one is, and how to know, when it seems as if something is moving, which apparently was not moving before, what it is that is moving, that was not moving before, and so on."

· LOS INDIOS TABAJARAS
Maria Elena (1962)
Music from the Motion Picture: *Days of Being Wild* (1990).
CLIP: "4: Days of Being Wild (Oh, How I miss Ye)" (Train Scene)
LINK: http://youtu.be/GBBRIAFbAQo

07 21 2012—SOMETHING YOU AIN'T DOING RIGHT IS HAUNTING YOU AT HOME
(AND EVERYONE WILL SAY YOU'VE MISSED YOUR CHANCE)

Sunday, July 15, 2012:
Walking home tonight, rain finally comes but the humidity still doesn't budge. It's hard to breathe, but I am happy to be home for a few days, even in this heat and with little time. I tell myself that if I get the big grant I applied for I can leave New York. I can leave America, too. But then I realize that I don't know where to go until I meet the person I can go with. Until I have love because love is the home I'm really

· THE WALKMEN
138th Street (2004)
LINK: http://youtu.be/lbPyoNiVoGU

looking for. The real reason to leave this time. I can't take off alone anymore because I'm not just waiting to leave, I'm waiting for someone to leave with. Someone to leave for. Someone to go to. Someone to stay with. This has not always been the case, as I've traveled my whole life, on long journeys, alone, and still go somewhere every year. Or maybe it has always been the case. But where before I left to find something/someone, now I need to find someone/something in order to leave. This time I am running to stop. I think I've ended up with a loneliness most people start off with. Eventually it catches up with everyone. An astrologer tells me: "You do everything backwards." I wonder what backwards is. I wonder what "everything" is. ·

Every time I travel abroad there is something that really surprises me. In some countries more than others. And it is this: even when young Americans are sweet (this is mostly a generational problem now), they are not authentically sweet because they have been spoiled and degraded by a cynical and pervasive (invasive) culture. They can't even help it at this point. It's just in them. Even sweet people are somehow ruined. Emptied out.

▪ PHOTO
Lunch at the Acropolis Museum in Athens, Greece (July 2012).

Drained of ideals and idealism. They say they want something, but they don't honor it with action. With the way they live. Here in Greece, it's somehow different. People are underpaid and depressed, living in a depressed economy, and yet a few key things are left in tact. Ways of being human remain human.

At the Acropolis Museum in Athens, while writing on my laptop and ordering food at the museum cafe, my waiter asks me where I'm from. I tell him New York. Of course this excites him, as it excites everyone abroad when I tell them this. New York is a world superstar. I want to dispel the myth and give him the reality, but I also don't want to kill his "dream." We chat about how it's his fantasy to live in New York one day.

When he brings me my food, he tells me it's on him. I refuse. He insists. I can't bear the idea that this guy, Nikos, probably makes no money all day and will use part of his pay to subsidize my meal. I say no over and over. He smiles and keeps insisting. "No," he says. "You are perfect. You are good." He emphasizes the word good. Of all the things to say. Of all the things to comment on. He smiles. He looks exhausted. Sad underneath his kindness. Then he brings me other things he wants me to try. Local dishes that are on him, he says.

He smiles and is chatty and open in a way that I am not used to, but love. Crave. My country's young are not like this. They are slick and aloof and guarded and cynical and opportunistic and savvy—used to everything. Worst of all, they are way too professional. Even when they don't want to be, which makes it even more heartbreaking. They are longing to connect but aren't built to connect. They throw words around but they can't handle what they mean. They never stick to their words and their words never stick to them. They want to feel, but mostly they can't. Mostly they play at feeling. Their feelings are from the outside in, not from the inside out. They love you one day and don't care the next. Nothing has a lifespan. They can take or leave anything and anyone. They want to be different, but can only be the way they are already. Maybe everyone everywhere is like this now.

By the ocean, I feel like maybe I have a chance to not lose my mind. I think of Derek Jarman's words: "Blue is love that lasts forever." ▪

07 23 2012—TIME-JUMP #25: LOVE ON A REAL TRAIN

One day I will be yours and you will be mine.

▪ **TANGERINE DREAM**
Love On a Real Train (1983)
LINK: http://youtu.be/rITT2mPA5BA

07 24 2012—TIME-JUMP #26: ON TRAINS (SWITZERLAND)

> Hazel Motes sat at a forward angle on the green plush train seat, looking one minute at the window as if he might want to jump out of it, and the next down the aisle at the other end of the car. The train was racing through tree tops that fell away at intervals and showed the sun standing, very red, on the edge of the farthest woods. Nearer, the

▪ **PHOTO**
From Flannery O'Connor's *Wise Blood*.

When people ask me what I like about you (X.), I'm not sure I know the answer. Or I'm not sure I can talk about it. Or I do know the answer, but they're not things I can explain, or that matter to other people. In my head I know it's partly because you are still wild. Meaning, you haven't been completely socialized or socially brainwashed yet. That doesn't mean you don't have other bad tapes running through your head. But you're not a fake, in the way that becoming (a) fake is like an American rite of passage these days. You still do and say the things you're not supposed to do and say. You still act the way people are not supposed to act. You still feel things that people have stopped feeling, and your feelings show—*they are all over your face*—even when you don't want them to. You are like a character in a movie and you make me feel like I am one too. You know—the kind of interesting, guarded, passionate chip-on-her shoulder misunderstood woman that people—men—only like in the movies. You don't ask me to change. You don't tell me what's wrong with me. You don't try to correct my behavior. You innately understood me. In other words, I think you knew me the moment you saw me. I think I knew you, too. Of course I could be wrong about all of this. ▪

1. A day in Athens, then the sea, so blue, you can see it with your eyes closed. See/sea. This is what Derek Jarmen was referring to in his film, his blue masterpiece by the same name. His masterpiece *Blue*. And Pierre Guyotat in *Coma*: "My eyes are full of that blue and the sweep of the shore seen from above." And: "So, in this late autumn, that color, which I do not see but whose fishing and trafficking

• PHOTO
My shadow in Athens, Greece (July 2012).

animates the coast over which I write, is already watchful, alive, in the increased darkening of my gaze. The resounding blue, a color of Antiquity, of *The Book*, of the perdition of History, of the horror of being alone in it."

2. It took two and a half days to get back to this blue. Still in New York, knowing that made me weary. Plane, plane, train, boat.

3. To go to my favorite beach on day two also required a small boat, on which I sat beside the bare feet of the young man who stood and drove it, who talked to me, smiled, asked questions, smoked a cigarette. I shut my eyes while swimming underneath the water, and the blue still struck through. Finally it was quiet and cold and free and I could sink down and plug up my ears with water. And then a empty little chapel at the top of a mountain, which I climbed and where I sat by myself, with a panorama of ocean to look at. The smell of wild sage. All blue. Everywhere blue. Everything blue. In this blue my blue feels tolerable. Slips into place. Lock and key. No voices. No people. Finally. Blue, water blue, is one way to get your energy back. To survive being alone.

4. Talking Heads, "Once in a Lifetime" (1984):
Letting the days go by / Let the water hold me down / Into the blue again.

5. My first summer in Provincetown, the tip of the Cape, in the open fist of the ocean: the first thing I did as soon as we pulled up in the car to the house we rented on 8 Law Street, after a six hour drive, was jump in the water. It was already getting dark. My mother and her friend, Charlotte, took me down to the bay across the street. I jumped in without even sussing the water out first. It was my favorite place for 14 years years straight. My mother spent every summer when I was still a child making sure I wasn't drowning. She isn't a swimmer, my father and I are the swimmers. She sat onshore with a nervous expression on her face. Hand over her eyes to see how far out I'd gone. But she also always let me swim. I had no idea how young she actually was, only 28, and I am her only child. Her girl. I did know. I knew how beautiful she was. How tender. Always kind to me. But I also didn't know. You can't until you are an age, or past it. I would swim in deep water, I would stay in all day. Until dark. I would go to the bottom and touch it. Alone, hours alone. I stayed in the water until I was blue in the face. My mother had to pull me out to eat dinner. I was blue, but not dead. In fact, the sea blue, sea blueness, is the only thing that makes me feel better, still. That heals all my wounds. That and love. At dinner, I would sit and eat with my bathing suit still on, begging for one more swim.

I fell in love for the first time in Provincetown, too, three years later. I was 10 and he was 12. We were both from the city, and we'd met once before at my friend's house. Then one day he was in Provincetown, standing in line at the movie theater. My mother said, "go talk to him." I am still shy about all this. Him. Saying hello to someone like that. Someone fated (in Chinese culture, there is a difference between destiny and fate. This difference is described by the untranslatable word, *Yuanfen*). This story is in "Diegesis (World of the Fiction)" from my first book *Beauty Talk & Monsters*. Five years after the book was published, last February, he sent me a private message on Facebook in the middle of the night, saying he'd been "somehow clicking around online and found my writing." One essay in particular. "Somehow." An hour before, I'd woken up from a recurring nightmare about him. I've been having it once a year or so for fifteen years. Unable to sleep after that, I decided to Google him, something I've only done once or twice. What's he up to, I wondered. Then his message at around the same time, which I found the next morning. In his note, he said he liked the piece he'd read, that it was "so on," and he "just wanted to say that." Much of the essay he read ("Prettier in Pink"*) is about our shared New York childhood. But the unspoken message of his email is that in that essay, only a few lines in, I write about him being the first boy I ever loved. Something he'd never known outrightly, something I think he's always needed to hear and which I regret not telling him, even though I had my reasons, so my admitting it, my putting it in writing where he could read it, was healing for him, I think. And him writing to me, finally, him reading it, was healing for me. I wrote "Diegesis" partly with that truce in mind for us. I wanted my own writing to be a witness to what had happened between us, because without putting it in writing we ran the risk, as every love story does, of "nothing had happened, generally, so it had been measureless" (*Do Androids Dream of Electric Sheep?*). A couple of emails in, we made a plan to meet, he suggested a coffee, I suggested a coffee or a drink, told him I'd be away for five months at artist residencies, then school. But ultimately we never did meet because he never responded after that. I don't know why. He's married now and has a little girl. But I think it might have been good for us. I think it would have given us some kind of peace. First loves need that, I think. I'd always hoped he'd find my (our) story one day. This is one of the powerful privileges of being a writer—you are building bridges. Roads between times. When I went back to the essay he'd read and contacted me about, I remembered my confession about loving him and winced, still embarrassed after all these years. In one of his emails he said he was "still haunted by the past, our past." Said he wanted to understand it.

6. The blue of bliss, the bliss of blue. The red of sun, when I close my eyes. The fire of sun as it gets cooler. The fire of people. My fire as I get cooler. Older. Maybe I used to need it more? But I don't know my own fire the way others do, who have always thought I'm hotter than I am. Can I feel my own heat? No, but I feel my blue. I do my best to regulate it. Both the heat and the chill. Maybe I underestimated the cool down that happens over time. The shade. Mistaking it for complacency and never ever wanting to be complacent even though I need a lot of solitude. Or an away-ness from certain people and ways of living. Being alone, or not quite immersed in the world as it is, or at all, is one way to be in the shade. Rousseau going to an island in Switzerland in *Reveries of the Solitary Walker* to breed rabbits and study flowers. The sun hit him that hard.

7. Saudade: "A deep emotional state of nostalgic longing for an absent something or someone

* http://www.ryeberg.com/curated-videos/prettier-in-pink/

that one loves. It often carries a repressed knowledge that the object of longing might never return. It's related to the feelings of longing, yearning. Saudade has been described as a vague and constant desire for something that does not and probably cannot exist... a turning towards the past or towards the future... A stronger form of saudade may be felt towards people and things whose whereabouts are unknown, such as a lost lover, or a family member who has gone missing. It may also be translated as a deep longing or yearning for something that does not exist or is unattainable."

8. What is true friendship, true love, I ask myself as I climb out of the water on my third day here. New beach, a rocky cove.

I think I heard Susan Sarandon say this once in some interview about a silly Jennifer Lopez/ Richard Gere dance movie she was in, and I thought she was right: true friendship and true love is about witnessing and being witnessed. Being a witness to someone's beingness. Taking note of how another—your other—lives. What it means for them to live. How one lives with another, for another, in another. I think watching all of that carefully is what love is.

9. If, as an astrologer told me just before I left New York for my trip abroad, I "do everything backwards," "opposite," (because I don't want children, because I got married to M., as a kid, instead of now, as an adult, etc) then this explains why almost everyone I meet, everyone I've had any romantic involvement with for the past two years, is younger. All these super young men. The older ones are so closed up and jaded, the young ones, too, but for cultural rather than chronological reasons. The world's cynicism, rather than any particular person or disappoint-ment in their life, afflicts them, wears them down, ages them. For the longest time I couldn't un-derstand why I went from being a person who always gravitated towards older people—friends and lovers—and then suddenly everyone around me was younger. It's because I started off old—older—extremely careful, rooted. Passionate, but cautious. All or nothing. And now I am working my way back to real love by going in reverse. Getting younger, unsettled, less rooted. Maybe not less, but reticent and careful in a different way, about different things. Levity is not always in numbers. Sometimes its direction. Progression. "The further one goes, the less one knows."*

10. Sea of faith. Faith in sea.

11. "Blue stretches. Is awake."†

12. On the beach. Staring at nothing all day. Staring at everything all day.

13. "Blue an open door to soul."‡

14. On the immoral moral (my term), which is almost everyone. Which is here, too, the other night (Night #2). Even though I am trying my best to live my life in a just way, to be just towards others, to do what's just, I am often told I don't know how to "behave." The disgusting tell me

*†‡ From Derek Jarmen's *Blue* (1993).

I don't know how to behave. The liars tell me I don't know how to behave. The chauvinists and womanizers tell me I don't know how to behave. The women who hate women tell me I don't know how to behave. The selfish tell me I don't know how to behave. The cynical and uncritical tell me I don't know how to behave. The people who don't know a fucking thing about love or how to treat people tell me I don't know how to behave. On my second night here (and I have since not gone out at night. I'm waiting for Elaine to come and rescue me), I go out to dinner with a guy, M., a hotel owner on the island who rents me my room, and from whom I rented last summer, too. We were good friends and spent a lot of time together. But this summer things are different. Numerous people end up crashing our dinner, including his yoga teacher, and this aging, alcoholic Norwegian womanizer and sociopath, T., who spent last summer trying to seduce me in the most bizarre and psychotic ways. Long story short: I said no way, go-to-hell (he needed and deserved the go-to-hell part), and he said and did a number of outrageous things to me in return, one of which was to tell everyone on the island (including his young teenage daughters with whom I spent some time) that I was a crazy slut and had tried to seduce *him*. He also told this to a woman neighbor in Norway that he ended up having a 3 day sexual tryst with once fucking me proved impossible. A woman he paid no attention to whatsoever when he was still hunting for me. Hunting being the operative word.

The yoga instructor, who teaches on Amorgos during the summer, is "renowned all over the world" apparently. I end up fighting with her. It's bad enough T. came to dinner uninvited despite the way he treated me last summer. I can't help running into him on this small island, but at the very least I should be able to decide if I want to have dinner with him. M. could have asked, as I've told him numerous times that I never want to see T. again. I was already upset that he'd sent T. to pick me up at the ferry the night I arrived to the island on the boat. It was 2 am and I saw T. standing in the shadows. I thought he was there to pick up someone else, but I still ducked and went the other way. The next morning M. told me that he had asked T. to help me with my luggage. Of all the fucking people to send to my aid, especially when I never asked for help. I was a pool of sweat by the time I dragged my suitcase up the hill to my room, but I would have rather died than accept anything from T.

At one point the yoga instructor snaps (she'd been snapping at me all night about everything I said, and I'd never even met her before): "Yoga is not about showing off. Yoga is about the spirit." She'd been correcting me all night. This holy woman, with her silicone face and glistening lips the size of I don't know what, and whose every word is a fucking New Age platitude, calls herself "Soul." Yoga is not for showing off (I never said it was. I could care less about the way the West has appropriated yoga, except that it pisses me off that it has), but a face and breasts are for slicing open and injecting? I guess she gets to decide what is and what is not for showing off. What is and is not spiritual. For me, the body and face are spiritual, too. I tell her she's been talking to me all night like she is my mother, except my mother has never talked to me like that. She explodes. "You are so aggressive. Go take a bath. Chill out," she barks. Her face is in my face, and she is pointing her forefinger at me when she says this.

The night turns into Reality TV. This Yogi is primed for a fight. She's been waiting to have one with me all night. I say, "And you're not aggressive? Aggressive people always accuse other people of being aggressive. Is this how yoga instructors talk to people? Go get some more plastic

surgery." She is up in arms about the last thing I say, not because she hasn't gotten tons of work done on her face, but because she has and I have called her face on it. The frozen expressions she's been making all night, the grotesque pouts, while she condescendingly lectures everyone— mostly me—about being evolved. It wasn't my proudest moment, no, but I meant it. I'd been thinking it. Was in disbelief over her face. The content vs. the form. What she was saying vs. the way she looked. I am after all a person to whom faces are everything. I still believe in the value of faces (not the commercial *value*), now more than ever, as real faces are dying all around us. Why can't I say that a certain kind of face bothers me, especially when I am being attacked? You think I am aggressive? I think your face is aggressive. There are different ways to be affronted. There are different ways to be full of shit. In The Smiths' song, "You've Got Everything Now," Morrissey sings, "And did I ever tell you, by the way, I never did like your face?" Well, I told her. Morrissey sings about hating a face the way some people hate someone's guts.

Soul had been an asshole to me all night, had some beef with me from the start, and even when she told me to "take a bath" (I think she meant take a swim? The bar we were at was on the beach), I tried to avoid the argument. When T. heard me tell Soul to go get more plastic surgery, he jumped in for his big moment. "Did you *hear* what she said to *you*!?" he asked incredulously. This sick fuck suddenly has morals and boundaries. M. slinks away from the table, drink in hand, straw in mouth, like a child. I respond to T. with, "Do you remember what you did to me last summer? The things you said? How dare you say anything to me?" T., like a true sociopath, who doesn't have his own moral compass needs other people to "witness" his crimes and transgressions in order for them to exist, smirks, "Prove it. There are no witnesses." Of course there were witnesses. M. was a witness, even confronting T. at one point last summer, and screaming at him in the middle of a bar about being a liar when T. accused me of chasing *him* and feeling scorned due to his rejection of *me*. T.'s daughters were witnesses, too. T., who crashed my dinner with M. has the gall to tell me "You are not wanted at this table." I tell him that if he says another fucking word to me, I will punch him in the face. He looks pleased and scared at the same time. This is his victorious moment. He consoles Soul, who is still up in arms. After all, he might get to fuck her, so why not. "Why did you tell my to go get plastic surgery?" Soul keeps asking. Why do you think? I want to say, but don't. Another older French woman in her 50s, A., an islander, defends T. Says he is a good man and a good friend, and then accuses me of trying to seduce M. all night. WHAT???? "We've been talking about it all night," she hisses. "This is not the way women behave in Greece. You don't know how to *behave*." At this point, even M. is in disbelief. "What are you talking about, A.?" He asks, dumbstruck. But A. keeps insisting. Do they realize they are practically talking to a monk, who has spent her whole life staying out of things? Looking for true love. What is all of this fury really about?

First of all, what A. says about me and M. is just nonsense. These men are old enough to be my father, I have no interest in either T. or M., I rarely have any interest in anyone, and I was just talking to M. that night, like I was talking to everyone else. Lastly, what business is it of anyone's even if I was? M. isn't married, and in fact he was interested in me last summer, but unlike T., had the decency to know it wasn't reciprocated and respected that. T. lashes out, "You are educated but you don't know how to behave. This is what you are like. You are a loser." If behaving is not telling the truth, then fine, I don't know how to behave. Especially with people like T. and Soul. And why am *I* the loser, but this 50+ year old lying lowlife scumbag isn't? What followed

was much worse and involved everyone ganging up on me for insane reasons. Some random guys at the bar defended me, telling me not to "fall with the rotten fruit." To "be strong because you are better. These people have cabin fever. They have nothing better to do on this island and they're drunk." Other drunk male assholes called me an "angry woman." I left the bar alone. Better stick to nature. I didn't come here to get eaten alive. But, I wonder, have always wondered: why are the so-called "spiritualists," the Souls of the world, always the biggest assholes? Why do the most "evolved" people defend the worst people? Why do women always defend misogynists? Why do so many women gang up on women (I know the answer to this, but it still shocks me). Why is a strong young woman, traveling alone, still so suspect? Why does it bring out the village mob in people? The immoral moral.

15. "What a terrible mess I've made of my life" (The Smiths).

16. "In the pandemonium of image, I present you with the universal Blue" (*Blue*).

17. Auden: "Words are for those with promises to keep." This digital age hasn't got a clue about what it means to say things to people. I used to ask people (lovers) to tell me things, but I don't do that anymore. Warning: no one should say anything to me that they don't mean. Good or bad. I get attached to and hung up on words. Words are actions. Don't say you miss me. Don't say you can't live without me. Don't say you need me. Don't say you love me unless you mean it and want me to believe you. Unless you want me to carry it around with me for the rest of my life. I am married to everything and I can't help but remember. Can't help but care. And just the way words kill me, words save me. So don't say something unless you know what it means to mean something.

18. "Use your time just to work things out" (Maximo Park).

19. The road to blue. "One can know the whole world without stirring abroad" (*Blue*). One can know nothing despite stirring abroad. ▪

07 29 2012—WELTSCHMERZ (LET IT BURN)

"All along he had believed, instinctually, that his broken heart had something to do with the collapse of the culture."
–SARAH SCHULMAN, *Empathy*

"So I put despair on my schedule for twice a month; I think that's a reasonable amount of time to feel hopeless about everything, about staying here on Earth."
–PHILIP K. DICK, *Do Androids Dream of Electric Sheep?*

PART II
(LOSS)

▪ IMAGE
je, tu, il, elle (1974), Chantal Ackerman.

08 01 2012—TIME-JUMP #27: SECOND CHANCES

"Thinking this, he wondered if Mozart had had any intuition that the future did not exist, that he had already used up his little time. Maybe I have, too, Rick thought as he watched the rehearsal move along. This rehearsal will end, the performance will end, the singers will die, eventually the last score of the music will be destroyed in one way or another; finally the name 'Mozart' will vanish, the dust will have won. If not on this planet then another."
–PHILIP K. DICK, *Do Androids Dream of Electric Sheep?*

08 03 2012—SIGNS (FOR A BROKEN HEART)

At school in Switzerland. Arrived yesterday after 3 days on the road with no sleep. My heart feels broken. Love seems impossible. I come home for a break before the next class session today. My key won't open the lock. I fiddle with it for a few minutes. Finally, I ring the doorbell for Elaine, who is my roommate at school, to open the door. She has accidentally left her key in the lock. I live on the third floor of a building called

▪ **PHOTO**
Love!: My apartment door in Saas-Fee, Switzerland (August 2012).

Everest, in a town called Saas-fee, in apartment "L." The letter is white and the door is dark wood. I look up at the letter and suddenly, while I wait for Elaine to let me in, I see what I haven't seen before. And even though I don't know what to think, what to make of this little inscribed detail on the door to my temporary home, my heart melts. Because whoever wrote this is right: it's not just "Love," it's "Love!" It's love this way. It's only ever been love this way for me. ▪

08 03 2012—MOURNING AND MELANCHOLIA

Žižek always talks about the loss of loss. Yesterday in class he said it again. Yesterday I did something I shouldn't have and the reaction I had to the person I did what I should not have done with made no difference to the person I was reacting to. And I thought: we have also lost the ability to feel rejected because people don't really care whether they are wanted or unwanted anymore. At least not in any genuine way. Wanted and unwanted are one and the same now. You have and then you don't have. Either way is fine. No one is invested enough in anything or anyone to feel something as gripping and arresting as loss. To feel like I lost: myself, you, him, her, that, a chance. ▪

A year ago, at the start of it all, Elaine emailed me the song, "Make Love" by Daft Punk. It was August and it was my first summer at school, a few days in. I listened to it in bed after a night out at the bar. It was very late and I was drunk and barely awake. Elaine sent it to soothe my heart. My heart, which X. had unexpectedly shook up. This person appeared and crept up on me, the way this song creeps up, revealing its destinal sound. "Make Love" has a mezzo

• **DAFT PUNK**
Make Love (2005)
LINK: http://youtu.be/aWpHRrXa9c8

beginning, which means it comes from the middle, from something that is already-there. It sounds like something between two people, something that's between them from the start. The volume of "Make Love" gradually increases and becomes audible. The volume simply reveals itself. The song arrives unexpectedly, like a person, into your world, like the Event that Badiou talks about. The way subjectivity, as he explains, happens when we respond to an event. You decide to answer a call. But maybe it was only ever my subjectivity that was at stake all along. The way I responded to the call, not whether he did or would or could. Maybe what was playing in the song and between us all along was me and my story. Me and my quest. Me and my search. Me and my question. Seeing through him. Seeing what is possible in the impossible. What was possible in an impossible person, him. What is still possible in me. What is possible even in the most ruined people. And what turned out to be totally impossible by his own doing. He made this decision and suddenly I was free because I made mine. Even with a broken heart, which is both more and less broken now, which gives up and and never gives up, I saw this. ▪

08 15 2012—TIME-JUMP #29: BEING THERE

"All is in time. Being is time. The philosophy of life is also the philosophy of time."
—BADIOU

▪ **PHOTO**
The European Graduate School (August, 2012).

08 16 2012—THE DIALECTICS OF ANXIETY: CLASS WITH BADIOU

"Anxiety is when we must know something we do not know. There is no creation without anxiety. There is always anxiety. Anxiety is the sign of the new Real. Too much Real. A Real which is an excess of Real. Courage is the effect which gives human animals the means to go beyond anxiety. There is a dialectical relationship between courage and anxiety. Anxiety indicates that there is really something new for the subject."
—BADIOU

08 17 2012—DOUBLE PLEASURE (THE LOSS OF LOSS)

The object of love is a double. The lover doubles the lover. The double doubles over. You (X.), want me and you don't. Everything that can happen doesn't and everything that doesn't does. Because you want me you don't want me. This kind of ambivalence is a male chauvinist's wet dream. Your rejection of me has always been a double of your desire for me.

First you tried, then you blocked every effort, which was also an effort. You affirm, you negate. You follow and you leave. You stay and you go. What you say and what you don't say. You circle and encircle. You cut off. You hover. You look away. You use the word "never." You scan the room for me. You stand next to me. You position your body next to mine, even when you don't. Especially when you "don't." You look and never look. Your desire is always expressed as a pathological proximity. You are never not near me or around. I never wanted this, but was struck, then caught, in this Evental phenomenon and the truth it had to offer me, which I dropped into all the way. Down the rabbit hole.

At the bar, drunk—all of us drunk—I collided with the scene like some return of the repressed, barging through the door and back into a room I'd already left for somewhere else. After completely denying it the night before, you announced in front of everyone that I am the "object of your desire" while making a toast. Yet you also insisted that you didn't miss me all year. In front of everyone, you admitted to wanting me. Alone, you denied it. You are open about your lies and secretive about your truths ("...the ceremonious tone in private. The intimate tone in front of everyone." Rousseau in *La Nouvelle Héloïse: Julie, or the New Eloise: Letters of Two Lovers, Inhabitants of a Small Town at the Foot of the Alps*).

You are two people. You shock me. You shock yourself. You go against your own grain. The logic of how you claimed to *not* feel about me. In your mind this is how you get to keep me and lose me. Have and never have me. Have and never have anything. This is how you get to live with what you don't want and without what you do want. And this is why I am now free. This is why this story is now over. ▪

08 18 2012—AUFGABE

"A gift might arrive years later. In your unconscious."
—AVITAL RONELL
The European Graduate School lecture, August 2012

08 18 2012—ON KAIROS, PART II (FOR H.)

"The possibility of conversion, of creation as such, as it may arise from the exploration of the self, is another name for the kairos. For that event of a pure presence which takes place only and does not begin again; whose very pleasure lies in not ceasing to want to begin again; in being in the repetition of the same gesture, the same ritual, the same school of words lodged in the place of desire where they encounter terror, and surmount it, every time imperceptibly. The other name for the kairos is that precise moment when desire ceases to be desire, and comes undone as it becomes embodied, and in this intimate struggle between madness and thought that makes creation possible, dread is overcome. But it wins in secret. It takes refuge in folded papers, twisted words, dreams, stammering and emanating from the memory of the dead. It is a childhood language that suddenly reappears. Whether in that wild language of madness, or in the childhood language of some of our terrors, or even in the so-called foolishness of certain everyday words, we recognize an inner truth that will make its own way in us. When we welcome it, we let it traverse us while we whisper its name and it passes. And if we take care to not frighten it, then perhaps we are breaking through the primitive dread in a way that allows us a new kind of freedom. Perhaps we are allowing the possibility of utteration of otherness to inhabit us, at least for a moment. But it also might raise the question of sacredness, if I can dare to put it that way, to overcome the primitive dread of the traumatic, whether the denial is individual or collective, is to be confronted by the horror, and in a certain way by the sacred. Maybe our conversion is an answer to this trauma, calling for an invention that will move us beyond the lost world where we think we belong. The pairing of horror and the sacred has structured the West ever since language and writing was constituted in our imaginary as the root of all experience. It is the West's secret architecture, its spider-like qualifications and links stretch as far as one can read them. The sacred-horror duality is a relation to the limits that institute secular space as a space that humans can grasp, and in which they can question and grow, while before them, like the shadows they carry with them, stands the immense story of horrors and sacrifices. And here also are the territories of the clown, the trickster, and the innocent, and consequently, of every human act. If philosophy is not the key to Bluebeard's 7th door, it at least opens up a little skylight in the chambers of horror."

—ANNE DUFOURMANTELLE
The European Graduate School night lecture, August 2012

The nights never end here. Everything is mystery and surprise.

▪ GEORGE STEVENS
A Place in the Sun (1951)
CLIP: "A place in the Sun"
LINK: http://youtu.be/wEuFNnJSIw8

08 21 2012—KAIROS, PART III

"From this perspective, what I call kairos is an exemplary temporal point, because Being is an opening up in time; and at each instant that it opens up it must be invented—it must invent itself. Kairos is just this: the moment when the arrow of Being is shot, the moment of opening, the invention of Being, on the edge of time. We live at each instant on this margin of Being that is endlessly being constructed. The instant that creates is the instant where Being creates, but it can be blocked by our inability to accept this opening. What I am trying to describe through the idea of kairos is not Bergon's idea of Élan vital: positing a temporal continuum doesn't suffice to describe the process of the creation of Being… Kairos is the way in which one sees the world, a point of view—one that is also a view of the past. The past is reconstructed on the basis of kairos, but it is not the past that constructs kairos. And to the extent that it is kairos that reconstructs the past, no access to a pure past can be had. One must nonetheless be careful, because when one says there is no pure past there is a risk of falling into a sort of total historical relativism. In reality, however, once a thing has been said; and once a thing has been done, I cannot undo it: it has been done. Kairos confirms that to us, puts it into circulation. Hospitality is not only a matter of opening one's arms and saying, 'Come.' It is also taking the other's arm and saying, 'Let's walk together.' It is this circulation, this sharing, that is terrific, wonderful. The classic Spinozist idea of friendship involves constructing ever more complex and stronger levels of Being through the encounter with different kairos. Every time an encounter takes place there is a construction of Being."

—ANTONIO NEGRI, *Negri on Negri: Antonio Negri in Conversation with Anne Dufourmantelle*

08 22 2012— BLUE BUT NOT DEAD

"Memory means: what is past becomes something that can happen again."
—GIORGIO AGAMBEN, on Walter Benjamin's definition of memory

• KRZYSZTOF KIESLOWSKI
Three Colors: Blue (1993)
CLIP: "Three colours: Blue - film Blu"
LINK: http://youtu.be/jJetkmTWxQc

08 23 2012—I AM LOVE: IN KAIROS TIME, PART IV

"The new philosophy bases itself on the truth of love, on the truth of feeling. In love, in feeling in general, every human being confesses to the truth of the new philosophy… Where there is no love there is also no truth. And only he who loves something is also something—to be nothing and to love nothing is one and the same thing."
—LUDWIG FEUERBACH, *Principles of the Philosophy of the Future* (1843)

08 24 2012—LAST NIGHT (AT SCHOOL)

Someone tells me:
"People fall in love with you."

Someone tells me:
"You want to know what you already know. You want proof."

Someone tells me:
"You are a singular being."

Someone tells me:
"You put all your fragility out there. You don't hide it."

"Even when the mouth lies, the way it looks still tells the truth."
–NIETZSCHE, *Beyond Good and Evil*

In an interview in *Index Magazine*, Kathleen Hanna of the feminist band Le Tigre talks to the writer Laurie Weeks about the female face(s) of music. Specifically, the facade of the female face when it sings. The face a voice has to put on to sing in the world:

▪ HAROLD ARLEN & YIP HARBURG
Over the Rainbow (Reprise) (1939)
TITLE: "Cut 'Oz' Scene: Over the Rainbow"
LINK: http://youtu.be/pAI4oMd7Wfk

Kathleen Hanna:
"I'm also really interested in women's voices on old records, like Leslie Gore, or the Shirelles or whatever. They're singing all these songs about following men to the depths of the earth, like 'You can drag me down a flight of stairs and I'll still love you,' but the quality of the voice always says something totally different. It reminds me of this Judy Garland special where she was doing the most fucked-up things — probably because she was on so many drugs. But every time she sang a happy song, she looked like she was going to cry and when she sang a sad song, she looked really elated. It was really bizarre to have her facial expressions contradicting what she was singing. And Connie Frances got raped and couldn't even talk for several years. So I got really into what it would be like to be a woman with way more constraints than we have now, singing these really fucked-up insipid heterosexual love songs. How do you get your actual voice through that? It's through the quality and the tone. Like, there's sneaky stuff going on in the way they're singing the lyrics."

Like Hanna, I am fascinated by the image of the voice—not just the image of the image—and what's behind Judy Garland's. What is the song (story) of the female face and what does it have to sing through? Live through? What does a song cover-up and what does it expose?

In my first book, *Beauty Talk & Monsters*, I wrote a story called "Kleptomania" that blended real and imagined Hollywood. Partly a ghost story, "Kleptomania" summons the Hollywood repressed, a battleground of misogyny. In the first section, "Judy," three intergenerational female movie icons meet for cocktails at a bar. As actors, as characters—it's all mixed up.

I wrote about Judy Garland and Marnie while living in California. I moved there to live with W. It was in California, as an adult, that I read Garland's biographies and watched all of her movies back to back. It was as a child, in New York, that I became obsessed with Dorothy's "Somewhere Over The Rainbow" and the double lyric of the song.

In a deleted take from *The Wizard of Oz* posted on YouTube, Judy/Dorothy breaks down during her iconic song. She doesn't sing "Somewhere Over The Rainbow," she weeps it. Did they want her to cry like this? Did they push her too hard, for too many years? Or did her crying overtake her and "ruin" the take? The director's response (at least on camera) is positive. In the YouTube clip, a wide-eyed, sepia-colored film still of Garland from *The Wizard of Oz* conceals the animate face that sings when the stakes are the highest. We can't see Garland cry when she is singing,

and when we do see her sing this song onscreen, she isn't crying. The crying is left out of the scene. Image and sound split apart. Either the face is hidden, as in the case of the clip, or the face masks, as in the case of the visible performance.

What did Judy look like in this outtake? What we can hear is precisely what we can't see and aren't shown. My feeling is that Judy/Dorothy was supposed to cry during this scene, only not like this. Not this much and not this hard. Doro-

· MASHA TUPITSYN
TITLE: "Masha Tupitsyn, 'Kleptomania, from BEAUTY TALK AND MONSTERS / KQED, The Writer's Block."
LINK: http://youtu.be/g7WaS-hywFQ

thy is finally going home, after all. She is sad about leaving Oz, but what's calling her back is supposed to be stronger than the intimate bonds she's forged on her odyssey. But the line between emotion and real pain—between the emotion you are asked to tread, to supply and to invent; to bring to a scene, and the real pain that shows up and intervenes; causing a breach in the fiction and a break in the breach (all the breaches that are enacted and received in a lifetime)—are devastatingly blurred. It's too much for Judy, not Dorothy. It was often too much for her. These are Judy's tears, not Dorothy's, and they are not the result of the fiction of movies, but of the reality of having lived them and made them.

In "Kleptomania" I describe Garland's voice as "a blue bird hitting the windshield of a car."

During the edits for *Beauty Talk*, my publisher asked me to rewrite the sentence from passive voice to active voice, as if it were merely a simple case (and to their mind, error) of grammar.

But where in the active is devastation and toil reflected, I wondered, and how would it express what had happened to Judy? What was happening to her voice as well as all the happenings that her voice had always imbibed and tracked. That showed up in her face, which aged in a way that had nothing to do with straight chronology. It wouldn't. So in the end I decided not to make the change.

It's not just the act that's an act. It's the voice and the face, and the face of the voice. It's the song, leaving us with so much to wade through, especially in the era of extra-features and culture as tell-all. An era where everything resurfaces, returns, doubles up—comes back. Language, along with the face, is a cover-up. It shows and it doesn't show. It doesn't show what it shows or it shows what isn't really there. The face doing something at the moment it isn't supposed to do it. The active covering up what's passive. What's vulnerable, at risk—at stake. What receives blows and cuts. If I'd adopted the edit, I would have been just another male producer/director/biographer inserting and enforcing the active when the passive (the patient, not just the performer) is the truth. As if being a star automatically makes one a winner and an active agent; setting up a voice's relation to voice that is exclusively active and in control.

A voice in this case—in Garland's case—is grammatical, literal, and figurative. The English passive is periphrastic and derived from the Ancient Greek *períphrasis* "roundabout speech," which comes from *perí* "around" and phrásis "expression." The passive tells us how long it

takes to get somewhere. It stammers, slips up—goes back and forth. Vacillates. The way isn't straight. The voice cracks. The active voice is often the official story. The take that is used as opposed to discarded. Unlike the passive, which takes the long and hard way, and which doesn't grammatically edit, photoshop, or sidestep, using the active voice in my story about Garland would have resulted in yet another cover-up and evasion. Another performance, another strain. More makeup, more star—not a feminist intervention.

There is a lot of face in our culture today. Now more than ever. There is a lot a face is expected to do. But I can never keep a straight face when I watch Judy Garland sing. I'm not a singer or an actress, after all, so it's not my job to. Yet regardless of vocation, a woman is still expected to perform, and is a natural performer—dissimulator—according to Nietzsche and others. If it's not her talent, it's her job. Yet, as a heterosexual, seemingly femme woman, I've been known to break and queer most of the codes when it comes to physiognomy alone, which according to so many men seems to defy convention based on the expressions I make or refuse to make. In graduate school last summer, a male professor and Palestinian filmmaker referred to me as the "girl who frowns when she sits in class." When really, I was simply listening (which includes thinking) to what he was saying. The process—the seams of thinking and feeling—that my face shows, *showed*.

"Why couldn't the world *that concerns us*—be a fiction?" Nietzsche asks, for whom truth also takes the form of the "apparent world"; the world we not only see, but that is shown to us (shown is passive. We receive it). In other words, assembled for display. While the fiction consists of whatever we do not see, and are not permitted to, it is also what we are given in *place* of truth, for fiction is organized and mediated by the truth that is not only concealed or falsified, but tampered with and embellished. Of course Nietzsche is right in the sense that appearances cannot be taken at face value. Mere surfaces never display just mere surfaces, but rather all kinds of concealed, fashioned, and prescribed depths. What is hidden is shown, or, what is *not* shown is hidden and inscribed in what *is*. Simply showing oneself is not bearing a truth, as "Talking much about oneself can also be a means to conceal oneself" (Nietzsche, *Beyond Good and Evil*).

Truth, like fiction, is a question of style and invention. Nietzsche inverts the relation between fiction and authorship as well, so it is not only the fiction that belongs to the author who writes it, but the author who belongs to the fiction that writes them (*being* a writer is equally a fictional production). Moreover the belonging is a link—a fictional device; the fiction of the fiction—that weaves truth and fiction into dialectic rather than a binary. However, it is not the concern with fiction and artifice—"mere appearance"—that becomes, or has become, the problem, as Nietzsche claims. It is making fiction and mere appearance the solution to *all* problems. The look of all reality and the source of every truth.

What truth are our faces allowed to tell/show today? If Hollywood and mass media are any indication, nothing is faked and enacted more these days than a face, especially a woman's. A woman's face is something she has to fake almost all of the time—from the wearing of make-up to the surgical enhancement and modification of facial features, to the lightening of eyes and skin, to the concealment of age, to the facial expressions we make or don't make. Faking is not only the modality par excellence of late modernity, the fake/r (not the real or original, as

Abbas Kiarostami's *Certified Copy* demonstrates) is the thing to imitate and strive for. Based on the 21st century fiction and artifice of celebrity consumer culture, there is no greater truth than a successful lie. Than a lie that functions and succeeds in public, even if and especially when it inevitably performs its disclosure-as-lie and breakdown-of-truth as just another show (Reality TV).

• **GEORGE CUKOR**
A Star Is Born (1954)
TITLE: "Judy sings The man that got away"
LINK: http://youtu.be/Z-HY8KiBYus

The lie, or the secret of ideology, is no longer something to conceal, for, in the era of cynicism and instant commodification, dissemblance is the only truth worth telling (living). Truth, along with reality, is a performance, and performance is reality.

Before we believed that a lie was the truth, we believed that what we were seeing was real, which means we believed what we were told. The fiction was not meant to be interpreted purely as fantasy or pure-fantasy, but as the ultimate-real. However, now that we know that the fiction is a lie, that the truth is a lie, we have learned to approach it as such. We live in the name of truth, even though, and because we know, the name of truth is fiction. We tell ourselves that it's not that we have a more dishonest or corrupt relationship to truth, it's that we have a different kind of relationship with the lie. That is, with the staging of truth.

In Kiarostami's *Certified Copy*, time is an object of multiple use, to use the Surrealist's phrase. Multiple versions make reproductions out of everything and everyone, even if everyone is the same person. The film exists and operates entirely in the subjunctive. The subjunctive is the form of wishes, conditions, desires, and fantasies—rewrites and retakes. In *Certified Copy* a would-be marriage between Binoche and Shimell becomes a conditional real. In Kiarostami's earlier film, *Shirin*, a character declares, "Back then it was an act. Today I am being truthful." In this statement, time forks, splits and doubles. But the fork in the road/relationship also concerns the binary/double of reality/appearance, where "husband" asserts that the copy or apocrypha has the same value (value being the key issue in the film) as original/truth. "Wife," however, believes the opposite, making the two disjointed approaches to real and copy, reality and appearance, a gender divide and a sexual politic. This rift in perception is unveiled when Binoche takes Shimell to see the original painting his work on copy refers to. Perhaps Binoche is the original/real thing and Shimell is a copy that lives in a world of copies.

When I watched Garland's performance of "The Man That Got Away" from *A Star Is Born* for this essay, I broke down in tears almost immediately. Garland's heartbreak is my heartbreak. A heartbreak of women watching women. Women being women. It is my invisible (off-camera) face coming undone as it bears witness to the brave face another woman puts on for the whole world. Garland is giving us her heartbreak so that we can survive and better understand our own. Songs and movies are records of the breakdowns that have already happened and that we can now, in the era of deleted scenes, outtakes, and DVD commentaries, watch over and over, both to our benefit and detriment. The heartbreaks we've survived and the ones we haven't are

inscribed in the breakdown of notes that are sung for all of us to hear, and by being sung both shore up and keep at bay just enough to make it tolerable for the rest of us to show and not show. Maybe it is because I can see and hear how much Garland tried to keep it together for the movies. In order to make movies. How she could do it, and how she couldn't. How much fell and falls apart as she performs, still. And how her voice splits and spites and faced all those cameras for all those years. ▪

08 28 2012—NO WAY OUT

Someone gives too much or someone doesn't give enough. Someone started off with a lot to give and then someone lost their way and stopped trying. Someone cared and then someone stopped caring. Someone cares about the wrong person or someone doesn't care about the right person. Someone is open and then someone is closed. Someone is ready and then someone isn't ready. Someone believed and then someone stopped believing. Someone started off one way and then ended up another way. Someone starts off with hope and then someone loses hope. Someone didn't fight hard

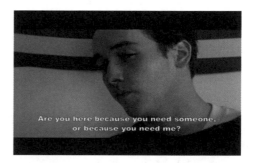

▪ **SCREEN**
Are you here because you need someone, or because you need me? (Say Anything, 1989.)

enough to hold on. Someone meets someone that could change their life but someone passes up on the chance to be changed. Someone could say more—everything—but someone says less—nothing. Someone wants love but someone doesn't recognize love when love shows up. When it is happening to them. Someone chooses place over person. Someone moves away instead of to. Someone chooses isolation over closeness. Alienation over communion. Someone says they want when they don't want and don't want when they do want. Someone can't tell what's what or who's who. Someone waits too long or not long enough. Someone says what they don't mean or doesn't say what they do mean. Someone stays and then someone goes. Someone doesn't try hard enough. Someone doesn't answer a call. Someone forgets. Someone forgets who they are. Who they were. Who someone else is. Someone turns their back. Someone runs away. Someone does the bare minimum. Someone gives up. Someone disappears. The world is this divide. ▪

Kierkegaard: "With regard to something in which the individual person has only himself to deal with, the most one person can do for another is to unsettle him."

And the following below, as I just spent a month up in the mountains of Switzerland, studying philosophy: not sleeping, drinking, smoking, dancing, in class all day, mind fried, body somnambulistic. Up all night. Heart awake. Life ready. Is it a coincidence that philosophy and insomnia came together this summer in such a tangible (literal) way? In such a lived way. In such a total way.

Anne Dufourmantelle, *Blind Date: Sex and Philosophy*:
"Anxiety is one of the fine names for philosophy as a practice of insomnia, when it stays up late at night, its forehead pressed against the window, keeping watch over the living and the dead, hoping that the dawn will not come and wipe out every trace of memory. Philosophy is a practice of insomnia. All of us, as living human beings destined to die, are looking for consolation. But the anxiety that inhabits us is not appeased by words. It keeps watch in the face of the greater mystery of what it is to 'be in the world.' Why? Why are we here? To what ends? Why is there pain? Why mourning? Why the succession of births and days? We suffer nonconsolation. And from the depths of time we have been speaking of the depths of 'night.' What other word is there to signify that which escapes, which slips away, which withholds knowledge of another time, knowledge of myth and mysteries, and keeps us in the dark? Philosophy was born with anxiety, with questioning, with insomnia. It takes upon itself the ills of the world, and thus it cannot sleep. The wound does not heal. Philosophical thought keeps watch at the hour of sleep and dreams. It has to answer for the Other: who? you, him, all of you, everyone, here, now, at once—before any possible acquittal, says Levinas. Insomnia means not being able to give oneself over to the certainty of love, to the self-evidence of words, to the presence of the world. It means being haunted. 'There is a part of the night when I say, Here is where time stops!' Nietzsche exclaims. He takes up the same theme in *Thus Spake Zarathustra*:

> From a deep dream I woke and swear:
> The world is deep,
> Deeper than the day had been aware.
> Deep is its woe;
> Joy—deeper yet than agony:
> Woe implores: Go!
> But all joy wants eternity—
> Wants deep, wants deep eternity."

M,

"Kairos is something that has interested me for a long time, its opposite maybe. It is something that always comes back, or is always coming back. The more one understands it, whatever that may mean, the more it never leaves, circles back around. It is in fact an awareness of what lies before you, and that at each moment there is always something worth seizing.

"I would have liked to have seen [Anne Dufourmantelle] lecture. I have only read a little of one of her books, I think it was her dissertation, on the prophetic in philosophy. The subject of the book drew me to it, but even more strongly was the book itself. Around the edges a pale blue-green, white in the middle with her name in black, the title in red and then below what really grabbed me, written in black, forming a circle—*Je dors mais mon coeur veille*. Roughly—*I sleep, but my heart is awake.*

"Veiller, is not so easy to translate. It means many things and for me is essentially linked to Kairos. *Veiller*, the verb, can be a wakefulness at a time which is ordinarily consecrated to sleep. It can be a vigilance or watching over someone or something, keeping guard. *La veille* is a vigil, but also can have the connotation of something which is directly preceeding something else. It is watchful and at the same time anticipatory. *Une veilleuse* is a night light, illuminating the darkness of the night.

"Kairos, I think, requires this same spirit of anticipation and watchfulness. Even when one is asleep, or especially when one is asleep, in however literal a sense, there is a light in the dark which must be cared for, or which one must be, for the self or another. Kairos is the surest sign that the heart is awake."

H., August 20, 2012

"Maybe they did just what we're doing," Roy Baty said. "Confided in, trusted in, one given human being who they believed was different."
—PHILIP K. DICK, *Do Androids Dream of Electric Sheep?*

• **ANTONY AND THE JOHNSONS**
Crazy Love (2009)
LINK: http://youtu.be/QP4hoz-Knac

08 30 2012—STRENGTH CARD VIII (CARTOMANCY)

Walking around Lucca, Italy and looking, I made my own strength card. So what do I do now?

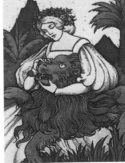

• **PHOTO/SCREEN**
In pieces.
Lion (top), Venus (bottom).
Strength Card (right),
Rider-Waite Tarot.

08 31 2012—RIP

"To be worshiped is not freedom."
—SHULAMITH FIRESTONE

09 01 2012—DAYTIME MOON

The problem (one of the problems) is in the dialectic of when to sleep and when to stay awake.

When to stay and when to go.
When to open and when to close.

Some people's difference is described as being so different from others, to others—even to them-selves—that it's "night and day." The difference in someone—one same person—is often night and day. The way they were with you, the way they stopped being. They were like this and now they're like this. Someone else entirely. Someone so untraceable, unrecognizable, you can hardly keep track. Why is it like this? Like this almost all of the time? I'm trying, still trying, to find the line between what was and what is. Who was and who is. Who someone could be—with me—and how I could be with someone. Where is the dawn, where is the dusk? How can we get into the interstice to change how the day turns out (with someone), how the night unfolds (with someone)? To make the two of one piece. Not a trauma or violent break. How we treat each other in between. Between the day and night. Yesterday and tomorrow. What we did with someone, what we do with someone. How it stops all the time—ceases to be—and becomes something that passes so quickly.

At school, I joked with classmates about overdoing it during the day by staging a kind of feigned intimacy, suggesting that we greet each other in the mornings and afternoons hyperbolically with hugs and kisses, since night (and drink) was what usually brought us together. Broke down the walls we had up during the day. In the mornings we went back to "normal."

Anne Dufourmantelle in *Blind Date: Sex and Philosophy*:
"Emotion makes you think. Emotion feeds thought, which in turn represses it. But philosophy hates emotion. Has it come to hate what makes us think?"

Rilke, "I Am Too Alone":

> *I want to be with those who know secret things*
> *or else alone*
>
> *I want to unfold.*
> *I don't want to stay folded anywhere,*
> *because where I am folded, there I am a lie.*

How to love. It's not that it's so difficult, per say. It's that people don't know how to want what they want, if in fact they really still do want. Mostly it's a diffuse—*why not?*—desire. How to love people who don't want to be loved even when they do and want to love even when they don't. How to not just want love in theory, but to do (give/receive) love in practice. Or are we now too fucked up? Too used to being alone. This modality of isolation total, inside and out. The writer Sarah Schulman once wrote (in *After Delores*, I think) that it takes a long time to break down someone's isolation.

In *Blind Date*, Dufourmantelle writes that the wound never closes. I think that's potentially a good thing. A way in. The worst is the wound that is there but won't let anything—anyone—through. A barricaded wound. There, but not there. Open but closed. Wound as chimera. Wound as excuse. I can't because I am wounded. I won't because I am wounded. Once, so not again. Once, but not again.

Freud says we do not know how to renounce anything. And yet we are always performing renunciations. To prove what? To prove that we don't need anything and are at peace with being failed and failing. Maybe we finally are. But fuck this. Fuck it. Fuck it. I want to fight my way out of it, for the one(s) who are worth fighting for. This is potentially everything and everyone. "I can't stand the way you androids give up," Rick Deckard tells Rachael Rosen, his android lover in *Do Androids Dream of Electric Sheep?* after they make love for the first time. But he also tells Rachael: "I understand now why Phil Resch said what he said [about retiring androids]. He wasn't being cynical; he has just learned too much. Going through this—I can't blame him. It warped him."

Then there is this—John Isidore reflecting on his android friends:
"You have to be with other people, he thought. In order to live at all. I mean, before they came here I could stand it, being alone in the building. But now it's changed. You can't go back, he thought. You can't go from people to nonpeople. In panic he thought, I'm dependent on them. Thank god they stayed."

Would it better if we could openly mourn? If we didn't all say we weren't mourning when we clearly are. Only the mourning we do have is a gimmick and does nothing for us, takes us nowhere new. Keeps us where we are. Keeps us from others. Those sanctioned, alienating, encapsulating mournings and rehearsals of pain that keep us ensnared in clichés and chains. That give us a script, zap us of life, and offer us a sustainable isolation, but make none of us better. Bring none of us closer.

Dufourmantelle:
"There is no real thought without emotion—no sex, either. Emotion is the signature of alterity. It is a sign, precisely, that there is otherness, and that the other in question is reaching us…Under the sway of emotion, you are another: even your memory, even your capacity for distancing yourself are affected… Emotion is a cursor indicating that something has taken place. Emotion is pure event. It relies on what we do not know about ourselves when the world approaches. When the world arrives, when it breaks the skin, breaks through the fragile abstraction that we are in order to make us experience the pain of being separated. Separated from what is. Light, wind, sand, astonishment, daylight, you."

This is the only thing that makes us feel better. This is the only thing that makes us feel worse.

Dufourmantelle:
 "To be hungry (for the other).
 To be astonished (that the world exists).
 Sex, cannibalism, philosophy, silence.

 "To desire, to think, to love.
 This won't make a common world, but a language, yes, perhaps, so that we can
 be in that hunger, that astonishment, that love."

09 02 2012—ALL OR NOTHING

Too many "in love" (everyone feeling it about everyone) or too few in love (no one feeling it about anyone).

09 02 2012—SOMEBODY THAT YOU USED TO KNOW (FOR EDWARD)

Told myself that you were right for me
but felt so lonely in your company.

• **GOTYE**
Somebody That I Used To Know (2011)
TEXT: (Male version, left) & (Female version, right)
LINK: http://youtu.be/DqRC5tquyUo

09 03 2012—THERE IS NO WAY OF KNOWING, THERE IS ONLY TRYING

People can say everything and mean nothing.
People can say nothing and mean everything.
People can say what you have with them will last, and it won't last.
People can what say what you have with them will end, and it won't end.

09 04 2012—SMART LIES (ON THE DEFENSE MECHANISMS OF PHILOSOPHY)

To think with, instead of without. How thinking must help us be with others, not alone.

"No, I owe you nothing, my thinking does not start with you or coincide with you, I function alone in the enchanted circle of pure idealities. Contemplation is my only passion, says the philosopher... In these territories of the mind, deserted by all afflictions, philosophy would be impersonal. And yet thought is nourished solely by what alters it so profoundly that it has to imagine another heaven, another form, another passage allowing it to cross over and see."
—ANNE DUFOURMANTELLE, *Blind Date: Sex and Philosophy*

09 04 2012—THESE BROKEN HEARTS
(I FEEL LIKE A GHOST EVER SINCE I LOST MY BABY)

On bleeding hearts, honor codes, fidelity, the life of contemplation, near-deaths, love dogs (who are also ghost dogs, *revenant*; who are both human and canine), and little girls who read. The little girl who reads voraciously in Jim Jarmusch's *Ghost Dog: The Way of The Samurai*.

For the record, I just saw *Ghost* again and realized Patrick Swayze isn't the ghost, Demi Moore is.

▪ When I lived in London, I painted my hallway the orange of Ocean's Lincoln town car in "Swim Good" because I wanted a bright tunnel of color to walk through every day. It was the color of this little orange building in Lucca, which I saw the other night, as I walked the park inside the 16th century wall (a ghost of defense) that rings the old city.

▪ **PHOTO**
This orange. This building.

▪ **FRANK OCEAN**
Swim Good (2011)
LINK: http://vimeo.com/29087560

09 05 2012—SONIC HEART (GENEALOGY IN SONG)

I cannot lie. I love 80s Madonna, mainly because that period of her music scores my childhood. It's the only Madonna I like.

When I was a little girl I acted and looked like a little boy. It was the first way I knew how to feel about boys, especially the ones I liked. Recently, I rediscovered Madonna's "Can't Stop" on YouTube—a euphoric, syrupy song from the movie-album *Who's That Girl?*, and a full-on

▪ **MADONNA**
Can't Stop (1987)
LINK: http://youtu.be/ykqSEqeet9w

obsession for me as a child summering in Provincetown. In "Can't Stop" I find lyrics that hold the key (another Madonna lyric from another 80s Madonna song—"Open Your Heart") not just to my heart—romantic biography—but to who I would become because, it turns out, I was this girl right from the start.

Madonna: *I've tried and tried / To get next to you. / My friends say I am blind, / I'll never break through. / But I don't give in so easily / Cause I know, you just wait and see. / I know that you're afraid that I might / conceal your heart away in the night.*

These bossy, romantic, female-obsessive lyrics go hand in hand with a boy that I not only fell

in love with the summer I was listening to these songs, and which I listened to in part because I was in love, but the singular fantasies I concocted about him, as I rode my 10-speed bike around town for hours. The album *Who's That Girl?* was the official score I gave those fantasies precisely because of the obsessive lyrics. I was a boy obsessing about a girl. Or, I was being the kind of boy I wanted boys to be with me.

• **JAMES FOLEY**
Who's That Girl - Trailer (1987)
LINK: http://youtu.be/yNuuxTTG-iM

Madonna ("Can't Stop"): *So shut me out, I'll never let go / 'Cause I can work a spell on your soul.*

Madonna ("Pretender"): *I'll make him dance with me / I'll make him tell me why.*

I would prove to him, not he would prove to me. I would seduce and rescue him—his weary heart—he wouldn't seduce and rescue me.

Madonna: *I know about your secret side.*

When it comes to love, I've always been the one with the courage. With the lover's heart and vision of the future. And the boys have always been the maidens who needed convincing and waking up. Who lacked faith in themselves, faith in the world, but had faith in me. This doesn't mean I wasn't also pursued, or loved. It means I am the one who always believed, who went the distance. Who didn't give up until it was time to give up (though that's been my hardest lesson in life, knowing when to give up: *Oh baby I can't clear you out*). Who sounded the call and imagined what was possible in love.

Madonna: *Cause baby I'm too strong.*

In the 80s, Madonna (her songs, especially in the 80s, have always been so lyrically and sonically immature. In fact, it's her arrested development that appealed to my gender-bending infantilism at the time) was always doing the boy-part—the chasing and wooing—with boys. But in the 90s, Madonna's pop-gallantry and playful gender-bending became phallocentric, a dominant power move on her part, and that is when I lost interest.

In the 1987 movie *Who's That Girl?*, an homage to old Hollywood screwball comedies, Madonna seduces and rescues Griffin Dunne. But while the uptight, stuffy, and passive attorney, Dunne, loves the rakish, heart-of-gold thug—Madonna—it is the impish and scruffy girl who opens the floodgates of love, passion, and desire.

Madonna: *I was born to love you / I've got nothing to hide.*

Unrelated to *Who's That Girl?*, or related in a tangential, lyrical (as in song lyrics) way, "Spotlight": *I'll hear you when you call / And I'll be here by your side.* Another favorite of mine.

Madonna's notions about love have always been closely tied to stardom. For her the "spotlight" that makes one "special" as an individual, and that is the source of the erotic exchange (exchange being the operative word), is also the same stardust that leads to fame. Fundamentally tied to drive and capital, love and desire for Madonna are an extension of and prelude to power and celebrity. If you're charming enough to seduce and beguile one person, Madonna sings over and over, you're charming enough to seduce everyone. Love is rehearsal for fame, and sex is the performance that keeps your audience your enthralled, subordinate lover. Love is thus a power move, and this period of Madonna's career is her memo to the industry as *she* becomes industry—a white diamond of ambition crystallizing and hardening into the shape of capital. This is also when Madonna's body starts to get chiseled (disciplined), when her hair turns peroxide (old Hollywood) white. That is, when everything becomes Blonde ambition. Intense ambition (famously ruthless ambition, Madonna is maybe the most ambitious woman we've ever seen) masquerades as dance-pop/party girl (sometimes ditsy) joie de vivre.

▪ **MADONNA**
Physical Attraction (You Can Dance) (1987)
LINK: http://youtu.be/FH2aTWWLSiQ

Of course I know this about her now, not then.

Madonna: *Now you have the power / Baby love is on your side.*

But it's "Physical Attraction," which at the time *sounded* like sex to me; the kind you have and imagine by yourself; the kind you watch; the kind that's in your head and in the future—the *desire for desire*—is the song I was most obsessed with early on, which makes sense because at that age everything was mostly in my head and in the future. Someone was on the other end of Madonna's lyrics for me. Those lyrics were for and about someone. Yet, more than a someone, it was the loneliness and thrill of being and imagining what being would one day be like. Would being get better or worse? Music is an interstitial medium, or more precisely, a medium that works *on* and *in* the interstices; the gap between the body and events. During childhood, music is the affect that gives you the experience you don't have—that you want and long for—and then later, as we become adults, music is the after-effect that gives voice and sound to the experiences you have had.

Madonna: *Even though you're not for real / It could be such a fantasy.*

Fantasy: from phantazesthai "picture to oneself," from phantos "visible," from phainesthai "appear," in late Greek "to imagine, have visions," related to phaos, phos "light," phainein "to show, to bring to light" (see phantasm). Sense of "whimsical notion, illusion" is pre-1400, followed by that of "imagination," which is first attested 1530s. Sense of "day-dream based on desires" is from 1926.*

* Source: etymology.com

"*Not for real*" is key here, along with to "*picture oneself.*" Not real for the dreamer, and not real for the one who is dreamed about. This is the way we dream in late modernity—without, it seems, even wanting our dreams to come true, and without wanting anyone to really be there or show up. Without fulfillment, desire is a narcissistic and private experience that fetishes lack, and in the digital age it seems that we prefer it that way. As Enrique Lima put it in "Why Pop Songs Are Not Novels": "We like monological music because we want to be alone with songs and we want them to be alone with us."

• **MADONNA**
Lucky Star (1983)
LINK: http://youtu.be/paggTs4wP5s

• **MADONNA**
Angel (1985)
LINK: http://youtu.be/APO9ZKtiy1c

"It could be such a fantasy," (not a reality) Madonna sings, and it is, as the conditional falls away, turns into pure image and solipsism, and loses all ties with actual fulfillment, engagement, and real love. In childhood, fantasies still have the possibility of becoming real. We aspire for things to come true. And why should we know any better without the trial and error and deduction of time, which whittles down possibilities, shows us loss, and has us growing more lost and at a loss the more we lose.

Spotlight, Starlight, Starbright, Lucky Star.
Angel.

In her book *Blind Date: Sex and Philosophy*, Anne Dufourmantelle writes, "We make pictures and live with them… images of desire we have fabricated ourselves." As a little girl listening to early Madonna, sex was largely a manufactured silhouette that I filled in with the found objects of representation and with a fantasy of gender that was free from gender constructs. I did this with adult material that I'd never actually lived, but nevertheless felt, as Anne Dufourmantelle points out, was my own life. But that's what being an 80s kid was all about. Being raised on a diet of images, fantasies, and consumer metaphysics, popular culture produces an excess; a third element that becomes a third parent. •

09 07 2012—I'VE BEEN THINKING ABOUT FOREVER
(THE RIGHT WORDS CAN BRING ANYONE BACK TO LIFE)

It will never get old.

That's why it's forever.

▪ FRANK OCEAN
Thinking About You (2011)
LINK: http://youtu.be/F15ljgyHd60

09 08 2012—IN KAIROS TIME, PART VII (ALL-KNOWING)

"[Kairos] is among the most important, and most delicate, objectives in the art of making use of pleasures. Plato reminds us of this, again in Laws: happy is he who knows what must be done when it must be done and the extent to which it must be done."
—ANNE DUFOURMANTELLE, *Blind Date: Sex and Philosophy*

09 07 2012—THE PROBLEMS OF CYNICAL HAIR: ON THE POLITICS
 AND PHENOMENOLOGY OF HAIR, OLD PHONES, THE VOICE,
 80S MOVIES, AND THE SOUNDS WE'VE LOST

The following is an excerpt from a Facebook thread about my "80s hair" Tumblr post, which was in reference to my video-essay on 80s Madonna, "Sonic Heart." It is between me and a fellow European Graduate School classmate, Sasha Reid Ross.

SASHA REID ROSS: thank you for taking this photo. Yesterday at 12:25pm

MASHA TUPITSYN: My pleasure. I am not far off from looking like a muppet either and self-deprecation is key. Yesterday at 12:31pm

SASHA REID ROSS: it's true, but there's a limit to self-deprecation—this is art. i wonder if in the 1920s, before there was such a thing as the 80s, people woke up with 80s hair, and if they did, what did they think? Yesterday at 12:41pm

MASHA TUPITSYN: I often wonder something similar. As in how did one correct something—their appearance—when and if one woke up looking bad? Or did you have to just live with it pre-hair brush, regular trips to a hair salon, and/or blowdryer? In my defense, this is me upon rising and no makeup. Not that I wear much makeup anyway. Yesterday at 12:44pm

SASHA REID ROSS: i know! i wonder…. did people in the 80s, moving from madonna concerts to family ties episodes to john hughes movies, ever not wake up with 80s hair? cindy lauper showed us that one never really had to fix anything, but then we are also left with videos of mike ness or motley crue spending hours in front of their mirrors teasing their hair and putting on makeup. curious. Yesterday at 12:50pm

MASHA TUPITSYN: i can promise you this is not a motley crue job/affect. this is more of a cyndi lauper moment. love lauper. i don't spend much time fixing things, hence this pic. but i did do a little combing before i left the house today. james spader would have killed for these kinds of feathered flips in pretty in pink. Yesterday at 12:53pm

MASHA TUPITSYN: http://www.youtube.com/watch?v=35tfXSINbCQ Pretty in Pink — "The Steff Edit" "…James Spader's devilish yuppie Steff in 80s teen flick Pretty in Pink is one of …" Yesterday at 12:56pm

SASHA REID ROSS: which brings us back to the hard question, does phenomenology affect your hair, and if so, can you travel back in time and try to have a philosophical intervention with james spader? Yesterday at 12:57pm

MASHA TUPITSYN: okay, here's my answer: i think your hair is also your anima. so for example, without going into too many details, i came to a morning class at EGS one day and my good friend knew exactly what I'd been up to all night just by my hair alone. so hair is not only a cultural signifier, but an individual ontology. so be true to your hair. it looks like you've had some good hair yourself. can you travel back in time and correct hair? don't we do this everyday when

it comes to aesthetics (fashion, style), which are always in part a correction of past aesthetics. in other words, "look how far we've come." look at the sins of our old hair, old bodies, old clothes. and forgive us. Yesterday at 1:03pm

SASHA REID ROSS: the personality similarities btwn spader's character and craig kilbourne, whose talk shows were so prominent in the late-1990s and 2000s, seems to echo the decline of 80s idealism, and with it, a respective hardening of hair styles. Yesterday at 1:05pm

SASHA REID ROSS: liberate future hair today Yesterday at 1:07pm

MASHA TUPITSYN: totally. miss the new-wave romanticism and softness of the 80s. it's definitely the start of hardness (ruthless polish and reflexivity) and the end of softness. Yesterday at 1:08pm

MASHA TUPITSYN: Can we run a hair campaign together? Yesterday at 1:09pm

SASHA REID ROSS: minimalism, also. the web had begun to decline the phone book and the land-line, two crucial crutches for lauperian fashion and style—there was such a humor and excitement in the masculine-feminine interplay of the bulky old phone book that knew everything and the feminine telephone set that had the chord you could twist in your fingers. with the internet and easy availability, identity was hit by a tremendous shock: chat room anonymity and the stark cerebral textuality of it all. Yesterday at 1:13pm

SASHA REID ROSS: i think we have to! Yesterday at 1:14pm

MASHA TUPITSYN: oh, my god, we evidently have the same cultural obsessions and beefs, as i've written a lot of posts lamenting the pathos of the phone—christian marclay's cinematic homage to phones and the beauty and romanticism of lloyd dobler (and john cusack in general) on his phones, making his high-stakes calls, as avital ronell would say. here's one example: http://mashatupitsyn.tumblr.com/post/26397905811/a-man-after-my-own-heart "A Man After My Own Heart" …"The only thing missing from Christian Marclay's telephone montage is Lloyd Dobler…" Yesterday at 1:19pm

SASHA REID ROSS: phone as conveyer of involuntary passion of the voice, conversation/conversion experience; internet as genetic modification machine. today the telephone doesn't even rings, destroying one of the best stage directions ever (beat / the telephone rings). the telephone vibrates just doesn't have the same ring to it, you know? Yesterday at 1:24pm

MASHA TUPITSYN: i know…sigh. what about the old alarm clock, the church bell, the clock tower, the siren, the boom box that lloyd holds in the air in say anything—the weight of it—in his arms and heart. i'm living in the wrong time. Yesterday at 1:26pm

SASHA REID ROSS: loving this montage. remembering when i used to pick up the dead phone (sometimes unplugged) and act out scenes where we would "get the terrible news." pausing for

extended periods of time.. dropping the receiver while holding the chord, so it would dangle in air. the camera focuses on the receiver, and you can see the person's clothes shudder. sobs are only implied... Yesterday at 1:27pm

MASHA TUPITSYN: yes. i even have an old phone (that doesn't work) from the 40s next to my bed at home to remind me of bygones days. the weight of the receiver, the cord tangled around lloyd's hand, as he makes the difficult call to diane for the first time. the artful and resonant way he wraps the telephone cord around his arm to signify the importance of such a call to his life. Yesterday at 1:29pm

SASHA REID ROSS: ugh and remember how the enormous bulky cell phones first appeared in the limousines of mobsters, corrupt politicians, and businessmen in films like the pelican brief. they sometimes had backpacks that looked like they should have been futuristic jetpacks. sad reminders that we would never have jetpacks, and that cell phones were attacking our personal space. Yesterday at 1:32pm

MASHA TUPITSYN: yes. makes me think of oliver stone's wall street, too. the foreshadowing of capital ruin, corruption, and cronyism. we should publish this discussion. can i post it on my blog? Yesterday at 1:35pm

SASHA REID ROSS: that'd be so cool :) Yesterday at 1:36pm

MASHA TUPITSYN: okay. done. tomorrow. Yesterday at 1:36pm

SASHA REID ROSS: in some ways, we have to blame environmentalists in part for depressing our hair. sure, on the one hand, we had charlie and martin sheen, but on the other hand, we had eddie vedder and chris cornell. the grunge scene was a punk evolution that sneered at the old punk aesthetics, but in so doing, didn't it kind of help advance the problems of cynical hair? Yesterday at 1:39pm

MASHA TUPITSYN: Can you take a screen capture of this thread though and email it to me? I don't have the program to do it on my computer and I am a luddite. That way I can just paste to my blog. Yesterday at 1:39pm

MASHA TUPITSYN: The problems of cynical hair. Brilliant. That will be the title of my blog post. Yesterday at 1:40pm

SASHA REID ROSS: makes me reflect on foucault's later seminars about the hermeneutics of the cynical self. foucault didn't really have hair issues. he was 'just a happy positivist'. Yesterday at 1:40pm

MASHA TUPITSYN: and bald. Yesterday at 2:00pm

SASHA REID ROSS: but there are so many ways of being bald. look at deleuze. his baldness was marked by a rebellious and half-hearted comb over. Yesterday at 2:10pm

MASHA TUPITSYN: my father is bald, too. shaves his head, after many years of a comb-over. but he's been liberated for 20 years now. he always says he lost his hair after swimming in chernobyl and claims that I have his hair color. my mother almost had a shaved head in the era of dynasty and 80s big hair. she used to come pick me up from school dressed in comme de garcon and yohji yamamoto before anyone wore those clothes. the next day kids beat the crap out of me. they called my mom a boy. Yesterday at 2:16pm

SASHA REID ROSS: i can't say i ever almost got beaten up over hair, but i did cry when i came back from colorado one year to find that my mother had cut her long hair into a strict, hillary clinton-style '90s business cut. what can i say, 27 was a hard year... Yesterday at 2:26pm

MASHA TUPITSYN: You cried at 27? Shame on you. You should have been gender enlightened by then. I was 6 and I didn't cry. In my heart, I knew my mom was a pioneer for women everywhere. Yesterday at 2:28pm

SASHA REID ROSS: i might have been 20 years off, i don't recall. what i felt was that my mother was being forced into this role of hard, cynical hair by an era that had given up on the dreams of judi bari, and conformed itself to a failing system that presented itself as victorious over the soviet union. today, i'm considering growing my beard, which is a signifier of enlightened counter-pathos Yesterday at 2:32pm

MASHA TUPITSYN: oh, i misunderstood. i thought you were lamenting and presiding over your mother's so-called femininity. Everyone who knows me knows that I have developed a near-pathological obsession with beards over the past few years. In fact, I don't even know if I can find a man attractive without one anymore. It's a problem. Moustaches, too. Yesterday at 2:37pm

SASHA REID ROSS: i'm thinking in particular of a marxian beard. one that suggests talmudic interpretations of noah's flood and the sinful nature of dimples. Moses parting the dead sea along the cleft of the chin. if dali could say 'i will defy nietzsche in all things, not least of which, his mustache,' perhaps marx could have said the same thing about the beard of plato - it was too straight-down, lugubrious, heavy. we need today beards with fluff, expanding outwards and in all directions, not severe and straight down to a point. Yesterday at 2:42pm

SASHA REID ROSS: there is no point! Yesterday at 2:42pm

MASHA TUPITSYN: Avital Ronell always disses beards. She thinks it's such a macho-philosopher throwback. My father always had a moustache, and if I could have one too, I would. Yesterday at 2:46pm

SASHA REID ROSS: i think beards are interesting. my friend Adam and i came up with an idea for a cartoon series featuring a disembodied beard who is trying to shut down a laser hair removal factory Yesterday at 5:06pm

MASHA TUPITSYN: Amazing. Yesterday at 5:20pm ▪

Last walk around Lucca's wall before I go home to New York. Watched the sun set, laid down in the grass and smoked a cigarette at dusk, and saw this in this order.

09 09 2012—DO YOUR BEST (SOMEONE'S ALONE, SOMEONE'S ALONE)

You can move. But to what and to whom?

▪ JOHN MAUS
Do Your Best (2007)
LINK: http://youtu.be/HDOMk_pGacA

09 09 2012—LOVE ON A REAL TRAIN (MILAN TO ZURICH)

Sometimes love is the way you sleep with someone.

▪ PHOTO
A couple on the train (September, 2012).

09 10 2012—HOME (ON YOUR OWN TIME)

"Love is never any better than the lover."
—TONI MORRISON, *The Bluest Eye*

09 11 2012—IT'S A SIN THIS NOT BEING READY. THIS NOT BEING UP FOR IT.

"I think she died of unhappiness. I really do. And what's so sad is her way out of that was me. No question. But she couldn't take it."
—JEANETTE WINTERSON, on her mother

09 12 2012—BACKGROUND STORY

Discussing his homage to New York City in *Manhattan*, Woody Allen declared in the late 80s that "One day people will look at my films and the only thing they'll see in them is the background scenery."* It turns out this was a self-fulfilling prophecy because Allen now makes the films he feared people would reduce his films to. Only he performs the reduction himself. Woody Allen ruins Barcelona and turns it

▪ **SCREEN**
Manhattan (1979), Woody Allen.

into scenery. Woody Allen ruins Paris and turns it into scenery. Woody Allen ruins Rome and turns into scenery. Woody Allen turns people and life into scenery under the guise of auteurism. Allen's first loss was Gordon Willis' ("Prince of Darkness") cinematography. This was the moment when Allen lost all interest in visual style and formal experimentation.

But Allen's real gift as a filmmaker was his ontological absurdism. At his most inventive and inspired, he was important not for what he had to say about men, women, relationships, place (though *Radio Days*, a film about the Brooklyn of his childhood, is one of his richest, much more so than his homages to an upper-class and WASPy Manhattan), or even himself (though his being in his own films is the *key* to his films, for, ironically, without that solipsistic thread he loses all ties

* *Woody Allen: A Documentary*. Dir. Robert B. Weide. American Masters, 2011.

with reality. His narcissism and myopia depend on his actual presence; on his actual *being* there). Rather, Allen's contribution to cinema lies in what he had to say about the history of cinema itself. About form, about diegetic space, about screen space, about genre, about spectatorship, about auteurism, about artistic influence, about what and who the history of cinema excludes and includes, gives us and takes from us. About the relationship between life and cinema and cinema and cinema. About history and contemporaneity. About the role cinema has played in the construction of human desire (*male* desire), vision, and perception. About its beauty paradigms, gender paradigms, and class paradigms.

Allen literally perforated and performed the screen: his characters walked into the screen space (*Play it Again, Sam*, *The Purple Rose of Cairo*, *Stardust Memories*, *Zelig*) and out of the screen space. He interrupted it, entered it, paused it, peeled it back, putting new things in, all the while using himself—the most unlikely screen star—to do it. ▪

09 13 2012—TEENAGE HEART #5: *SAY ANYTHING*

▪ **SCREEN**
Lloyd Dobler
Say Anything (1989), Cameron Crowe.

"One has to get rid of the bad taste of wanting to be in agreement with many (*mit Vielen uber-einstimmen zu wollen*). 'Good' is no longer good when your neighbor takes it into his mouth. And how would there exist a 'common good' (*'Gemeingut'*)! The expression is a self-contradiction: what can be common has ever but little value. In the end it must be as it is and has always been: great things are for the great, abysses for the profound, shudders (Schuder, also shivers or quivers or thrills) and delicacies (*Zartheiten, also fragilities and weaknesses*, etc.) for the refined (*Feinen*, the delicate, the subtle, the weak also, the vulnerable, for the aristocracy of this truth of election is both that of force and weakness, *a certain manner of being able to be hurt*), and, in sum, (*im ganzin und kurzen*), all rare things for the rare."
—NIETZSCHE, *Beyond Good and Evil*

09 14 2012—TEENAGE HEART #6: *GEGEN DIE WAND*

▪ **SCREEN**
Gegen die wand (2004), Fatih Akin.

Love is what you already know and don't know yet.

Derrida in *The Politics of Friendship*:
"The *arrivant* will arrive *perhaps*, for one must never be sure when it comes to *arrivance*, but the *arrivant* could also be the *perhaps* itself, the unheard-of, totally new experience of the *perhaps*. Unheard-of, totally new, that very experience which no metaphysician might yet have dared to think. Now, the thought of the 'perhaps' perhaps engages the only possible thought of the event—of friendship to come and friendship for the future. For to love friendship, it is not enough to know how to bear the other in mourning: one must love the future. And there is no more just category for the future than that of the 'perhaps'. Such a thought conjoins friendship, the future, and the *perhaps* to open on to the coming of what comes—that is to say, necessarily in the regime of a possible whose possibilization must prevail over the impossible. For a possible that would only be possible (non-impossible), a possible surely and certainly possible, accessible in advance, would be a poor possible, a futureless possible, a possible already *set aside*, so to speak, life-assured. This would be a programme or a causality, a development, a process without an event... What would a future be if the decision were able to be programmed, and if the risk (l'aléa), the uncertainty, the unstable certainty, the inassurance of the 'perhaps', were not suspended on it *at the opening of what comes*, flush with the event, within it and with an open heart" (my emphasis). ▪

▪ PHOTO
Stavros loves Craig '05.

09 15 2012—"REALITY IS A TIRELESS EXCHANGE"

"A lover may become a monster. I need a way to think about that… Love and hate coexist; they coexist in time, they coexist in other people, they coexist in me. I accept this but still I panic. It feels insane."†
—ANNE CARSON

09 16 2012—TIME-JUMP #31: UNTITLED #4

Lived in a dream world and my world became a dream. What came of it. A new life, I thought.

"Once your life has jumped track," Anne Carson asks, "where is the way home?"*

†* Carson, Anne. "Untitled (Flannery)." *Unsaid Magazine* (Issue 4), 2009. Web.

09 16 2012—HOPE IS A CHEAP THING (YOUR FUTURE'S AT STAKE)

- **DAVID BOWIE**
Sweet Thing (1974)
LINK: http://youtu.be/vrfc8c6VkTA

09 17 2012—FACES #2: A FACE NEEDS A SCORE

A face, especially a face like Anton Senna's, a face that was like a world (Maria Falconetti in Dreyer's *The Passion of Joan of Arc* had a face like that too), needs a score.

- **ANTONIO PINTO**
Senna's Face
Music from the Motion Picture: *Senna* (2010).
LINK: http://youtu.be/csO1nC_zixc

09 17 2012—UNTITLED #5

"Love saves us only if we want to be saved."
—bell hooks, *All About Love: New Visions*

09 18 2012—UNTIL

Maybe everyone has bad relationships until they have a good one.
Maybe no one feels loved until they finally are.

09 18 2012—LOVE ACTS

"You must know *how it can be more worthwhile* to love 'lovence.' Aristotle recalls not only that it is more worthwhile to *love*, but that you had better love *in this way*, and *not in that way*, and that hence *it is more worthwhile to love than to be loved*. From then on, a singular *preference* destabilizes and renders dissymmetrical the equilibrium of all difference: an *it is more worthwhile* gives precedence to the act over potentiality. An activity carries it away, it prevails over passivity… Consequence, implication, [friendship] is therefore an act before being a situation; rather, the act of loving, before being the state of being loved. An action before a passion… someone must love in order to know what loving means; then, and only then, can one know what being loved means. Friendship, the being-friend—what is that anyway? Well, it is to love *before* being loved. Before even thinking about what *loving, love, lovence* mean, one must know that the only way to find out is by questioning first of all the act of and the experience of loving rather than the state or situation of being loved. Why is that? What is its reason? Can we know? Well, precisely by reason of *knowledge*—which is accorded or allied here to the act. And here we have the obscure but invincible force of tautology. The argument seems, in fact, simple: it is possible to be loved (passive voice) *without knowing it*, but it is impossible to love (active voice) *without knowing it*."
—DERRIDA, *The Politics of Friendship*

"What I discovered was the difficulty of separating disciplines and also forms and levels of language. Everyone was asking, for instance, why *Proletarian Nights* was made essentially of narratives. And of course it was a scandal because people were looking at this shocked, and it was a big book, four hundred pages, and of course people were really angry, asking, 'where is the theory?' And, in the end, there was no theory, only narratives. Why? Because what was important for me was not to impose a new theory onto the old theories, but instead to try to change the very *look* of the material of theory itself. It was important for me to go back to this point where it is impossible to make an exact distinction between what is a narrative and what is an argument. What is philosophy and what is literature, and so on. So basically my attitude towards philosophy in this case was the same as my attitude towards disciplines. Of course I don't want to say that there should be no disciplines. But at the same time, I think there are a lot of problems with disciplines, especially when you don't know exactly what a discipline is because when you know what a discipline is it also means that you know where people are, you know how to identify them and their lot."

—JACQUES RANCIÈRE, on *Proletarian Nights* and the reluctance to define a discipline
The Kitchen, New York City (September 18, 2012)

09 20 2012—THE CHRONOLOGY OF SADNESS

Freud said that it takes two years to mourn. And he was right, as that is how long it took me this time around with W. Except of course there is the mourning you do for a time, for a time-being, and the mourning you do all the time. For all your time. The mourning you have to do every day in order to live every day. Derrida: "One does not survive without mourning." ▪

09 20 2012—THE BRIDGES THAT WILL BURN (I COULD NEVER SEE TOMORROW)

▪ **AL GREEN**
How Can You Mend A Broken Heart (1972)
LINK: http://youtu.be/UgAFcvlw8J4

09 20 2012—BAD TIMING

Two summers ago a man told me:
"You are running to stop."

This summer a man told me:
"Running away is the story of my life."

1. Everyone likes what everyone likes. Consensus. Consensual. As in you need permission to like something. You need to see other people liking it first.

2. Most artists today are not artists, they are politicos. Deal makers.

3. "When there is no censorship the writer has no importance. So it's not so simple to be against censorship." (SUSAN SONTAG, 12/7/77)

4. Philosophy sometimes feels like a tower of babel.

5. The new generation of philosophers are more jargonistic than the philosophers they've been raised on. The philosophers they study with. That became abundantly clear to me this summer at school, as I listened to my classmates sound incomprehensible when asking Alain Badiou, Slavoj Žižek, Avital Ronell, Bracha Ettinger, and Georgio Agamben questions during seminars. While I could understand what Badiou and the rest were saying, I could not understand what their students were saying. It's not even philosophy anymore. It's accounting or idea-crunching. It's philosophy-as-industry and pure verbiage.

6. "I'm now writing out of rage—and I feel a kind of Nietzschean elation. It's tonic. I roar with laughter. I want to denounce everybody, tell everybody off. I go to my typewriter as I might go to my machine gun. But I'm safe. I don't have to face the consequences of 'real' aggressivity. I'm sending out colis piégés ['booby-trapped packages'] to the world." (SUSAN SONTAG, 7/31/73)

7. I want to tip everything over with just a nudge. A line. Shatter someone with one word. I want three days to be enough for three more.

8. The Politics of Friendship: You surprise yourself by loving the people you once hated and hating the people you once loved. Blake: "Do be my Enemy for Friendship's sake." The mixmatched alchemy and slippage of the two registers—friendship and enmity; love and hate. Suddenly nothing is clear. Suddenly no one is clear. How people end up in you—impregnating you—like a drink. I always let everything inside, but this summer I swelled with the things going in me. It is wonderful, it is awful. Thank god you changed your mind, thank god you didn't. You can't believe how much less you know every day. How ambiguous everything and everyone gets with age.

9. I was never more present or clear than when I was drunk this summer every night at school. Keeping everything by letting it out. "The stomach became the tomb. At one point Baudelaire seems to ask: whom are you preserving in alcohol? This logic called for a resurrectionist memory, the supreme lucidity of intoxication, which arises when you have something in you that must be encrypted." (AVITAL RONELL, *Crack Wars*)

10. What am I doing and who will I do it with?

11. "What you desire is what creates quality. You are not made by yourself, but by the thing you desire." (FANNY HOWE, *The Wedding Dress*)

12. Jeanette Winterson, in at least 3 different novels: "What you risk reveals what you value."

"We had everything in harmony. We come to the point where everything was turning into music for us and you go upstairs and smash all the instruments."
—*The Music of Chance* (1993)

Emmanuel Lévinas wrote in "Peace and Proximity":
"The face as the extreme precariousness of the other…"

The other day my mother tries to console me by telling me this about love:
"You know the face of love and you will get it."

In *Love's Work*, Gillian Rose writes, "The embrace of face by face is the true carnival of sex beyond gender." Faces (as my mother and everyone knows) are my big thing, my life (love) story, my dissertation. So was it ridiculous, or absolutely in line with who and how I am, when M. pointed H. out to me early on at school and I reacted like some maniac with, "I don't like his face." What a strange thing to say, what a viscerally negative reaction to have to someone else's desire and potential crush. I could have been nonchalant, could have shrugged, said he's not my type, said he's cute, said *go for it*, whatever. But, *I don't like his face?* Why such dismissal and hostility when I had never even noticed him until M. singled him out. Why such repudiation when nothing in reality was wrong with his face (apart from the fact that I initially found it too impassive), and when I ended up finding it beautiful later on. It was the same way with X., but inverse. X.'s face floored me, nailed me, turned me upside down ("I look at him. How his whole face talks." *An Arab Melancholia*), but I lashed out at everything else about him. *I don't like <u>him</u>*, I declared right away. Two waves, we came crashing into each other that first summer at school, and I was determined not to let X. anywhere near me precisely because he was already in. In with the very first look. Prima facie. With X., as Gloria Swanson puts it in *Sunset Boulevard*, "We didn't need words, we had faces."

I don't want to imagine anything about what any boy is, might, or could be, anymore. You are or you aren't. You want to know or you don't. You can or you can't. You will or you won't. I want proof, not hypothesis. Presence not absence. Or absence only in presence, not presence in absence. I've had too much of the latter. I am a lover of things possible and future—unseen even; of things that have not happened yet and things that are coming (Nietzsche in *Beyond Good and Evil* produces a future by going into the future: "Alas! If only you knew how soon, how very soon, things will be—different!" And in *A Thousand Plateaus*, Deleuze and Guattari on the life we listen to rather than speak, "Language is not life; it gives life orders. Life does not speak; it listens and waits.") and could come *if…* But I have now (after two-plus years) also exhausted that love of, that sight for. That will to bear. Now I want the possible to shape-shift into something and someone

actual. To arrive and to stay. I know that the possible is everything, but it is also not everything.

My mother and I always talk about the difference between younger (young) men vs. older men. My father is twelve years older than my mother and they have been happily married for almost 40 years. But their love story is an exception in so many ways, and I become more and more aware of those impossible exceptions the older I get. I've always rejected much older men because of the exploitation, sexualization, and fetishization of younger women in our culture. I've therefore always been suspicious of much older men and their interest in me. But there is also the apathy that often comes with age and aging. That happens to people both young and old. And that never happens to some people, but happens to most people. There are different kinds of age. They are people who were never open and people who will always be open. There are some people (and these are the kinds I tend to like) who always remain committed to what is possible. Like Nietzsche, I never want to be contemporary or with a time. This time. But I've always wanted to be in time, in the sync of time, the joint, joining, union of time, *with* someone. That is, I want to age, to go *through time* (since time, like everything else, is something we go through and endure; both have and don't have. Never have and never had) with someone. To age together at the *same* time, instead of being young while they are not young. Here while they are there. Young with someone who is no longer young and has already learned what it means to be something, someone, while I am *still* learning.

Abbas Kiarostami on his new film *Like Someone in Love:*[*]
"I am not giving any advice, but it sounds natural to me. Older men are better. I think when you are young you are more emotional. It doesn't mean that older people are emotionless but they can control their feelings, hence are more concentrated on knowing *the other person*. It would be awful if it was the reverse: if it were the old man who hit the girl, and the boy was the one who was taking care of her. The good thing about the professor is that *he is already all there*. That is the good thing about aging; you face your own truth. There are no more ideals left about who you are" (my emphasis).

> **BADIOU:** "I shall extract something else from what was mere chance." (*In Praise of Love*)

> **MALLARMÉ:** "Chance is at last curbed."

> **BADIOU:** "To make a declaration of love is to move on from the event-encounter to embark on a construction of truth. The chance nature of the encounter morphs into the assumption of a beginning." (*In Praise of Love*)

> **BADIOU:** "The declaration of love marks the transition from chance to destiny, and that's why it is so perilous and so burdened with a kind of horrifying stage-fright." (*In Praise of Love*)

[*] "Cannes 2012: Abbas Kiarostami's *Like Someone in Love* - A Light Surprise." *Huffington Post*, 5/22/12. Web.

BADIOU: "How can something that was basically unpredictable and seemed tied to the unpredictable vagaries of existence nevertheless become the entire meaning of two lives that have met, paired off, that will engage in the extended experience of the constant (re)-birth of the world via the mediation of the difference in their gazes? How do you move from a mere encounter to the paradox of a single world where it is revealed that we are two?" (*In Praise of Love*)

BADIOU: "A philosopher must ask why that happens. Why are there so many films, novels, and songs that are entirely given over to love stories?" (*In Praise of Love*)

BADIOU: "I believe that love is indeed… a 'truth procedure." (*In Praise of Love*)

What is important about films on love? Or, what is it that they give us, show us that we are not given or shown elsewhere? That we fail to see off-screen. Precisely what Badiou states above: "The (re)-birth of the world via the mediation of the difference in their gazes." We see what it is like for two people to see (recognize, encounter) one another. "In Sophocles and Homer, the *kairos* is the moment when the archer strikes the heart" (Anne Dufourmantelle, *Blind Date: Sex and Philosophy*). We are inside of the inside that we are normally outside of. Through film, we have access to something that outside of film is often solely restricted to and reserved for the two people having that experience and re-birth. ▪

09 24 2012—TO ACT IS TO CHANGE: CLASS WITH BADIOU #3

"The whole world is a structure for possibilities. Being itself is only a name for change."
—BADIOU

"Youth, for her, was not a transitional age—for this modern one, youth was the only time befitting a human being.[…] Her youth had no need of ideals, it was in and of itself an ideal."
—WITOLD GOMBROWICZ, *Fredydurke*

▪ **SCREEN**
Do you know who you are?

The above screenshot is from Andrew McCarthy's new book, *The Longest Way Home*. I've written a lot about the movie *Pretty in Pink*, so it was interesting to see McCarthy read from his memoir at McNally Jackson Books recently. Because of the way he acted, talked. That's the reason I went to the reading—to see. Because of what he said about fear (how acting and fame alleviate it and also create more of it) and being young on camera. What it means to be young on camera. What it meant for him to have been young on camera, something he understands and appreciates only in retrospect. What it means for the camera to see you young, to want you and love you young, to record you young, to show you to the world and the world to you—young— even after you no longer are, and precisely because you won't always be.

We waste time watching. Cinema incubates and eats time—it was made for this. Creating an always out of something transient, this is what cinema really does. Staying where you (actors) can never stay. Taking us (viewers) where we almost never go. Keeping you where you were. Allowing us to go back again, back again. Giving us a way to be before. The urgency and melancholy this creates, both for the viewer and the actor. Creating the problem it resolves.

The way the actor, with their face, helps us face, de-face, and re-face (re-map) our own faces in time through theirs. Even after you've changed, until what you see as an actor looking at yourself then—now—is precisely what you partly, if not entirely, lost by being on camera: by being in an industry that wants to exploit, cash in on, and preserve the very thing it extinguishes and painfully distances you from when it puts you on camera, and thus inside of things like subjective time as collective, and collective time as subjective. Because an actor onscreen is also a life onscreen. Time onscreen.

The things your face loses, the sparks and openness that fade, the naiveté about being a star— before you are one, on the way to becoming one—that you can't fake, says McCarthy ("I can see what was special about that kid now. I can see how open he was, how vulnerable. And I understand why people like him. I see it now."), and that moves him now for that very reason. How we (the viewer) miss these things when they are gone as much as the person who was and did those things (the actor) misses them. Mourns them. "The 'youth' that the Spectacle has granted the Young-Girl," wrote Tiqqun in *Theory of The Young-Girl* "is a very bitter gift, for this 'youth' is what is incessantly lost."

At McCarthy's reading there was woman in the audience (a writer) who asked a question that prompted this ramble. She said McCarthy had this look that he would give onscreen. Just a look, and she would know, she said. She would know the way the characters onscreen are supposed to know. Because viewers are characters, too. They are who the looks are for. They

are part of the fiction. And that look was what Hollywood wanted. It was the look, maybe, that brought him there. And that kept him there for a while. At that time. But it was also something he had in himself to give because that was who he was inside, McCarthy says. So the inside made an outside in the same way that an outside always makes an inside. Makes and breaks an inside. It was the look that he had at that time, before he started to age, to know things, he says. To close down. To lose it. Himself. It was a self that he didn't even really fully have, but that was taken in full by a medium that made him bigger than he was. That makes everyone bigger than they are. This "thing" (look) that is not a role, but beyond a role; something extra, something diegetic, something pro-filmic. In the eyes, and in the skin, which gets shed.

▪ **PHOTO**
Pretty in Pink poster.

▪ **HOWARD DEUTCH**
Pretty In Pink (1986)
CLIP: "Pretty In Pink - Computer Scene"
LINK: http://youtu.be/250AfhEZQb4

After McCarthy's reading it struck me: Hollywood pushes for and instigates in its stars and in its screen faces what it does not want to see happen and that it punishes for when it does: the loss of the very thing it wants to capture and capitalize on. The *a priori*, which it sacrifices, and which must be, and inevitably is, sacrificed for things like craft and experience. But also because one cannot maintain innocence and artlessness in the face of such attention, exposure, and affect. What McCarthy was talking about seeing in himself in movies like *Pretty in Pink* and *St. Elmo's Fire* was the (his) body/being/face prior to the screen. That is, the *a posteriori* of the *a priori* via fame. You can no longer be what you were once you became famous because being famous precludes one from it. It makes a "look"—giving it and having it—self-conscious and reflexive, and in most cases impossible to preserve as a result. Through fame, one begins to know, as others do, what one looks like and how to look like one looks. One sees it and one learns to make it visible to everyone. One produces and formulates the look rather than simply possessing or having it. That is the job of an actor. And yet at the same time, you are shown forever looking like you did when you were on the cusp, the threshold, of that cognitive shift. The before and after of being what you were *before*. ▪

09 25 2012—GIRL TROUBLE

Tiqqun's *Theory of The Young-Girl* is about the feminization of misogyny and Capital in order to perpetuate misogyny. Thus, not only turning everything into Capital, but all Capital into the generic form (face) of Girl. Everything and everyone becomes subjugated and subjugatable. Making it: Sexism is for Everybody (the inverse of bell hooks' *Feminism is for Everybody*) and Everybody is Sexist(ism). But *Young-Girl* is also very French in its chauvinistic deconstructive objectification of misogyny and Girlization. The feminine is always abject and pathetic, so the root of all degradation, abjection, and social crisis—even its *critique*—must necessarily take the figure of the Girl.

Tiqqun: "At the present hour, humanity, reformatted by the Spectacle and biopolitically neutralized, still thinks it's fooling someone by calling itself 'citizen.' Women's magazines breathe new life into a nearly-hundred-year-old wrong by finally offering their equivalent to males. All the old figures of patriarchal authority, from statesmen to bosses and cops, have become Young-Girlified, every last one of them, even the Pope." ▪

09 25 2012—CINEMATIC SUBJUNCTIVE

"The subject of the cinema prefers to verify that something else is still possible (a body, a friend, a world)."
–NICOLE BRENEZ, "The Ultimate Journey: Remarks on Contemporary Theory"

09 26 2012—I LOVE THIS WOMAN

"And I have to tell her."
–DUCKIE, talking about Andie in *Pretty In Pink* (1986)*

* Audio: http://mashatupitsyn.tumblr.com/post/32316929906/i-love-this-woman-and-i-have-to-tell-her

"Why does tragedy exist? Because you are full of rage. Why are you full of rage? Because you are full of grief. Ask a headhunter why he cuts off human heads. He'll say that rage impels him and rage is born of grief. The act of severing and tossing away the victim's head enables him to throw away all of his bereavements... Perhaps you think this does not apply to you. Yet you recall the day your wife, driving you to your mother's funeral, turned left instead of right at

- **SCREEN**
Lancelot du lac (1974), Robert Bresson.

the intersection and you had to scream at her so loud other drivers turned to look. When you tore off her head and threw it out the window they nodded, changed gears, drove away."
—ANNE CARSON, *Grief Lessons*

09 27 2012—OUT IN THE COLD (POVERTY IS IN THE AIR)

How to get inside the castle.

This:

- **SCREEN**
The Five of Pentacles (Rider-Waite Tarot).

Is also this:

- **SCREEN**
The Castle, Das Schloß (1997), Michael Haneke.

09 27 2012—UNTITLED #7: YOU ONCE TOLD ME

"You once told me that I had whole feelings and whole thoughts. You said it was important that such people be alive."
—*Hour of The Wolf*

▪ **SCREEN**
Hour of the Wolf (1968), Ingmar Bergman.

09 28 2012—MY HEART (MISSED ANOTHER BEAT FOR YOU)

I don't want to know that it doesn't matter. That it didn't matter. I would rather not know.

▪ **THE DANSE SOCIETY**
My Heart (1982)
LINK: http://youtu.be/xujCAEm9tYg

09 29 2012—MY MOTHER, PART II: HOW WRONG I'VE BEEN

On the phone with my mother I ask, "Why does everyone want shit and drama and the wrong people in their lives?" And my mother replies, "Because harmony is a burden. Don't you know that? People don't want happiness. Happiness requires the kind of work that apathy, misery, and destruction don't. Real happiness is radical."

10 02 2012—BLACK OR WHITE (I AM CATT)

"Terry was never afraid to end things with her lovers. Catt was unable to break up with anything."
—CHRIS KRAUS, *Summer of Hate*

10 02 2012—I'M RUNNING HEADLONG INTO NIGHT

Just to wipe you from my mind
Like waves do.

· THIEVES LIKE US
Headlong Into Night (2008)
LINK: http://youtu.be/MWsW4hS0sLc

I read the following quote by bell hooks years ago when I read *All About Love* and *Communion* back to back. But today, reading it again, it is even more relevant, as I walk around feeling heartbroken over this truth: that people—men and women—don't choose love. For women this means something endlessly devastating, divisive, and regressive. For men this means choosing to be with women that allow them to maintain gender stereotypes and sexist paradigms. For me it means that I have always chosen love, feminism, and friendship with women over male approval, and this has not led to lasting love.

"Women who learn to love represent the greatest threat to the patriarchal status quo. By failing to love, women make it clear that it is more vital to their existence to have the approval and support of men than it is to love."
—BELL HOOKS, *Communion*

10 03 2012—FOOLS RUSH IN

ABDELLAH TAÏA, *An Arab Melancholia*

up, how was I going to react? What should I tell [...] myself, about me right now, about my past? Did [...] sleep with me, was that it, did he only want to sleep with [...]

Was I in love with him?

Was he in love with me?

I dared to ask myself these last two questions [...] before we finished filming. I didn't know how to [...] The only thing I was aware of was my growing distress [...] sadness and happiness were fighting inside me.

I was only too familiar with my reactions inside the [...] of love. I rushed right in. I don't like waiting. I believe in love at first sight. I need to know everything, everything right away. I'm not afraid of heartache. I don't like playing the game of seduction for long. I always want to know exactly how somebody feels about me. I'm too curious not to ask. I never know how to pretend... I take things very seriously, unfortunately.

I want to be in love.

I wanted to be in love and I wanted to be loved back and that was the exact moment when Javier appeared in my life, showed up in my homeland, right there on the red earth that had been red forever.

It wasn't his fault.

I forgive him.

- **PHOTO**
2:47am

I couldn't stay like that, with Paris completely indifferent and me starting to feel an extraordinary, totally shattering emotion. I was no longer in control, not on the inside. I already felt the impatience that love brings on, showed all the carelessness caused by love. His, his, I was completely his. My brain would

- **PHOTO**
5:00pm

How to tell a story. My life in someone else's text. Our lives in other people's texts. Our texts in other people's lives. This whole book, *An Arab Melancholia*, is like this. Mine, Taïa's.

> Taïa: "…fill his name with meaning and importance, fill it with the both of us."

Little things, like someone's name, are everything.

> Taïa: "…the overwhelming intensity of desire and raw emotion, our silence, our distance, then our coming together, body against body."

> Taïa: "That night for the first time."

Abdellah Taïa, a romantic and obsessive, like me.

> Taïa: "I had read too many books, seen too many films."

> Taïa: "Inside my dark apartment, eyes wide open, on the verge of a panic attack, I kept telling myself that I had to take action, confront the issue head-on, find out what I meant to him, what I meant to both of us. A promise, a hint. A further connection. A sweet, straightforward smile."

Who is straightforward? Who is sweet? "Clear, trembling, honest."

> Taïa: "I wasn't dreaming. I was laboring under love's dictatorship. I was speeding things up. I didn't want to wait. I had to force him to tell me how he felt. There was no other solution."

> Taïa: "Move him to tenderness. I waited five days. Five days with a fever."

> Taïa: "A real nuisance. The kind of guy who becomes sentimental and thinks everything that happens means something."

Men who are like women and women who are like men. Is the trick to be the same? Like each other.

> Taïa: "Of course I wanted something more. I expected more, more from him and more from life."

Privation. Everyone is so careless and numb.

> Taïa: "I didn't want anybody looking at me, figuring out how unhappy I was."

> Taïa: "A mystic consumed by love."

> "I had nothing else to say."

Taïa: "It changed his destiny. That's how he'd start, he'd start with writing."

Taïa: "Yes, that was me, the me of the fiction, the me of reality."

Taïa: "How do you walk away from love?"

Taïa: "Work, work, work, from morning to night. Another tale of obsession."

Taïa: "What did I have left? Same as always, tombs, mausoleums, saints."

Taïa: "I didn't know whether I believed in anything anymore."

Taïa: "A place of eternal contemplation."

Taïa: "I was losing touch with reality."

Taïa: "Something to keep me in this life."

10 05 2012—UNTITLED #8

The Night of the Hunter:
"It's a hard world for little things."

Is love a little thing?
The little thing in between the hards things.

• **SCREEN**
The Night of the Hunter (1955), Charles Laughton.

10 06 2012—THIS IS ALSO MY STORY

"I believe in people. I am a small boy, no more than 5 years old, but I believe in people."
—JARETT KOBEK, *ATTA*

10 07 2012—DOUBT (EVERY ASSHOLE'S HEART)

How did I become the ordinary asshole in every ordinary asshole's heart?

10 08 2012—STAR CROSSED (NEVER THE TWAIN SHALL MEET)

"A woman with a past meets a man
with no future."
—JOHN TOTTENHAM, *Antiepithalamia & Other Poems of Regret and Resentment*

10 08 2012—WE'RE ALL ASSHOLES

I don't even know who the asshole is anymore. The heartbreaker. Is it me? Is it them? Did I fuck it up? Did they? I can't sleep thinking about what goes wrong. Thinking about what gets lost. How everyone gets used to things being this way.

Tom Hanks in *Cloud Atlas*:
"Yesterday I would never have done what I did today."

This admission perfectly articulates the principal difference between movies and real life.

Does it still bother you? Does it still matter? Why does it still bother you? Why does it still matter? The most important thing to do now is to forget. To surrender and encourage. You should support one another. You should support him. You should learn from your experience together, then move on and love again. You should both be friends. There is nothing better than being friends. One day you will be good friends. You loved each other at the time. You meant what you said at the time. He meant what he said at the time. You can love a few different people at a time. You can be in love with someone and still want other people. You can be happy and in love with someone and still be with other people. You can have a soul mate, a true love, and still desire other people. It is impossible to only love one person.

You should call him up and ask him things. You should let him know that nothing's wrong. That nothing's lost. You should tell him how much he's taught you. You should listen to him say you've taught him nothing. Love is a lesson. Love is for learning lessons. We each have many lessons. We each have many soul mates. There are no soul mates. Nothing lasts forever. But eventually it might.

There will always be other people. There are always other people. There are so many people in the world. You should go out and look for them. There are too many people in the world, you will never have enough time to find them. You can meet anyone. You could find nothing. You can expect everything. You can expect nothing.

You should date. Are you dating? Are you dating anyone? Who are you dating? Why aren't dating anyone? It's time to date someone. Everything is timing. Everyone is timing. You can time things. You can time someone. You can time your life. You should try it. You would like it. You could learn to.

Are you having sex? Are you having sex with anyone? Who are you having sex with? Why aren't you having sex with anyone? Are you over him? Have you gotten over him? When will you get over him? Aren't you over him? What are you waiting for? You can't wait all day. You can't wait all year. You can't wait forever.

There is no such thing as love. Love is really lust. Love is really temporary. Love is really loss. Love is oppressive. Passion is oppressive. Passion is destructive. Passion is fleeting. Passion is temporary.

Passion is only in the beginning. Passion is when you're cheating on someone. Passion is when you don't have permission. Passion is when you are young. Passion is when you were young. Passion is before you made decisions. Passion is the first time. Passion is before you got hurt. Love is only in the beginning. Love is before you know someone. Love is the opposite of desire. Love is unhealthy. Love makes you sick. Love makes you bleed. Love makes you too fat and too skinny, too comfortable and too nervous. Love is exhausting. Love is consuming. Love makes you exhausting to be around. Love is in your sick mind. Love makes you feel like shit. Love is old-fashioned. Love is impossible. Love is criteria. Love is demanding. Love makes you demanding. Love is several. Love happens all the time. Love is happening all around you. Love is happening now. Love is easy. Love is unrealistic. Love is impossible. Love ends. Love doesn't exist.

You blame love for everything. You do everything in the name of love. Love is why you stayed. Love is why you left. Love is why you're tired all the time. Love is why you're no longer fun to be around. Love is why you're always busy. Love makes you talk too much. Love is the reason you've stopped acting like a guy. Love is why you let him use you. How could you let yourself love him? How can you call that love?

Love means you call everything you have ever done love. Love means every time you hurt someone, you say that love is hurtful. Love is an excuse. Love is coexistence. Love is codependence. Love is the loss of your freedom. You're too young to love. You don't know what love means. You've never loved anyone in your life. You can't love now. You can love later. Now is not the time to love. You can love when you're ready. Love is freedom. Love is unconditional. Love means you can't want anything from the person you love. Love means you will gladly give away what you love. Love means you don't love, but you pretend you know how to. Love is something you give up on because someone gave up on you. Love means you don't even try. Love means after you've lost love once, you could lose again and you'd survive.

Love makes you jealous. Love makes you remember. Love makes you not care. Love makes you shit and have diarrhea and throw-up. Love makes you sleepless. Love makes you spleenless. Love makes you age prematurely. Love is why you eat so much. Love is why you've stopped eating. Love makes you pathetic. Love is disgusting. Love is inconvenient. Love makes you the same. Love means you can't see the difference. Love gets you nowhere. Love is a prison. Love is a waste of time. Love is precious. Love gets in your way. Love covers you with bruises and breaks your legs. Love breaks your heart and then love leaves you broken. Love is what everyone says. Love is what no one means. Love is what you can't say. Love is what no one knows how to do. Love is what you forgot. Love is what you lost. Love is what you thought you had. Love is the word that you won't say. Love is the word that everyone says. Love is the word that never gets you anywhere. Love is what you do when you fuck. Love is what you fucked up. Love is what no one means. Love is what you will spend your whole life looking for. Love is what you already have. Love is what you will spend your whole life trying to mean.

And when it is over you should forget. When it is over you should forget and move on. When love is over you should forget and fall in love again. Except never acknowledge what you are doing as forgetting. Forgive and forget. Forgive and forget. ▪

10 10 2012—IDÉE FIXE (LOVE'S YOUNG DREAM)

Do other people remember what I remember? As much as I remember? Me in a blanket on your balcony in the mountains this summer while you fed me a rolled cigarette at four in the morning on our last night together. Or the orange juice you drank straight from the container on our second, with me wrapped around you in the dark kitchen like we were a couple. In bed you never let go. When I complained about the size of the mattress, and the bedframe, which we broke having sex on the first night, you said, "In our future bed it will be different." And as we both started to fall asleep after we had sex the first time, I murmured, "Let's have sex at school tomorrow," and you sweetly mumbled back, "Okay." ▪

10 11 2012—I REMEMBER EVERY SINGLE DAY OF MY LIFE

Every day is just like the rest
The worst and the best.

▪ **MOLLY NILSSON**
8000 Days (2008)
LINK: http://youtu.be/S2OmGJVtPO8

10 10 2012—SEEING DOUBLE

· SCREEN
Film Socialisme (2010), Jean-Luc Gadard.

· SCREEN
Marnie (1964), Alfred Hitchcock.

10 11 2012—UNTITLED #9

"Talking like touching
Writing like punching somebody."
—SUSAN SONTAG, (8/14/73)

But also:
Talking like punching somebody
Writing like touching.

10 11 2012—EVERYONE IS A KILLER, NOT A LOVER

And I am like Janet Leigh at the bottom of the tub.

• **SCREEN**
Psycho (1960), Alfred Hitchcock.

10 12 2012—ALL OF IT: ON THE OLD WAY OF MAKING MUSIC

This is the way *Love Dog* is composed:
"When you make a record, you make a concept record. You sequence your records, so that even if somebody doesn't like the third song, they're probably going to listen to it anyway because it comes out of the second song, and goes into the fourth song. So they're not going to superficially go over there and take the third song out. They might not like everything on your album, but they're going to like some of it, so they're going to listen to all of it. And maybe they might fall in love with the whole thing. And that's what you hope."
—STEVIE NICKS, in conversation with Mike Albo

• **CONVERSATION WITH... STEVIE NICKS**
Hampton's International Film Festival (2012)
LINK: http://vimeo.com/50972516

"Here is the time of the sayable: here is its home."
–RILKE

• **SCREEN**
The Accidental Tourist (1988), Lawrence Kasdan.

Sometimes you watch a movie and it grieves beside you, or with you, and you grieve beside or with it. The pain you feel takes solace from and residence in the pain onscreen. You go to the screen just for that. For a space that is interested in the space of pain. For years I watched movies for this reason. Going into the places, alone, where I stopped feeling alone while also feeling my solitude and isolation more keenly. Amplifying and saturating my sadness in and with movies, every significant period of loss, solitude, and contemplation in my life has been accompanied and allayed by watching films for months—sometimes years—at a time. I've gone into movies and through movies to get to some other side.

For the past three days, I've been watching *The Accidental Tourist*. Little bits of it here and there. In doses. Sometimes it just plays while I zone out and think about other things, like William Hurt's half-dead, grief-stricken man, Macon. Watching, not watching. Here, not here. Hurt hurt. I like young William Hurt. Late 70s, very early 80s Hurt. So screwed up in real life. Such a jerk. Beautiful for only a handful of years. He was always so uncanny onscreen. Like some alien man (a man he played in *Altered States*) with alien intensity.

I think I am watching this movie, dragging it out, because I need some warrior alien like Muriel (Geena Davis) to walk into my life, the way she walks into Macon's, or he walks into hers. To take my alien hand, pull me into her home, and put me to bed. Not take no for an answer when I push them away. To understand why I'm pushing and to do it anyway. To go right through me. To do it because of that. But fearless people—lovers—like Muriel only exist in the movies. Love only shows up like a person, like an alien, in the movies.

John Williams wrote the score for *The Accidental Tourist*. Williams' weird, familiar, ongoing score shows up in every one of his soundtracks. *Accidental Tourist*, a movie about grief and loss, has many of the same notes as *Jaws* and *E.T.*, and *Superman*, making it sound like both water and outer space. Real and imaginary. Down below always sounds like up above in a Williams' scores and vice versa. Between worlds, and between worlds is what Macon is. Between two worlds, two women. Life and death. The death of Macon's son keeping him in limbo, out of the world, and then—through pain—directing him to love. Back into the world.

Macon tells Muriel, who is all life, about losing his twelve-year old son:
"Now I'm far from everyone."

Last weekend a friend joked that I was three centuries far:
"We don't live in the 17th Century, Masha. And this is not a Thomas Hardy novel."

I was drunk, so I just laughed. I've been told similar things before. I pictured the tragic Tess of

the d'Urbervilles.

My friends, who want to walk away from me at times because I am too close. Who like things far.

No one can find the right proximity with one another. That's really the problem.

I don't know where I am, but everything—then and now—is real. No matter where you say things. No matter where you hear them. We have designated certain places for reality, but nothing is that clear anymore.

"Life isn't a romantic comedy."

Everyone is always telling me what life is not like. What isn't like it was, as if people have nothing to do with how things are. At school this summer, H. told me that he thought love was an "improbability," which is something you also hear people say in the movies. "What are the chances?" he kept asking, disheartened. But he was a bad actor. He was just saying his lines, trying to commit them to memory. He didn't actually believe it. He just wanted me to tell him it wasn't true.

If we'd been onscreen, everyone in the audience would know what was coming. They'd say, "Those two are falling in love. He doesn't mean what he is saying." What happened to us did not look like a Thomas Hardy novel, but it did look and feel like an Ingmar Bergman film. I thought that the minute I stepped into his apartment, a cabin in the middle of nowhere. The past in the present. The present in the past. Everything as it's always been. We were in our time and not in our time. The absolute quiet around the two people that we were. Our memorable faces with so much room. The wide-angle spaces all around us. The dream of life.

Where and when do things happen? Like Tarkovsky's indeterminate and interstitial Zone in *Stalker*, what happened to me was so real, so bound to a specific moment and place in time—to a kind of zone—it wasn't real at all, as in it was detached from the cynical (unreal) "reality" of everyday life, where what passes for real is never true. In his book on *Stalker*—*Zona*—Geoff Dyer writes "…even when we see clearly, we are not sure what we are seeing." The Zone is a place where one's deepest wishes come true. Where wish (desire) turns into place. "Here we are…" the Stalker says, "home at last." Home from home.

In Derek Jarman's *Jubilee*, John Dee (based on Shakespeare's Ariel in *The Tempest*) tells Queen Elizabeth I, "In you is the beginning and the end and the forgetfulness beyond… Every deed you accomplish accompanies you throughout time."

In the movies people deny in order to affirm. Denial sets things in motion. In the movies the dialectic of affirmation-negation is everything. You have to say you don't want something to get what you want. Lying is one of the ways to instigate truth.

Kafka said that we need books, and in this case movies, too, "that affect us like a disaster, that grieve us deeply, like the death of someone we loved more than ourselves, like being banished into forests far from everyone, like a suicide. A book must be the axe for the frozen sea within us."

What and where should a person be for another person?

Macon is frozen and Muriel takes an axe to him.

In the movies, someone calls you. Someone comes to pull you out. Out of the distance, the death, the isolation, the other time you're in. The frozen sea. Someone sees what's on your face. What's in your body. Someone wakes you up. Someone wants to be awakened. In the Zone in *Stalker*, Geoff Dyer writes that "everything is reciprocated." No one leaves empty-handed.

If you push through someone, if you take their no for a yes, do you become their ghost and do they become yours? When Macon walks into Muriel's house for the first time, everything is red and green, and pulsing. Life comes back to life. Life comes back to people. Muriel's red and green house is what is still left. What is still alive. Muriel lays Macon down to die in her bed because he is dead and needs to be resurrected. Macon tells Muriel he doesn't want to be seduced, he just wants to sleep. But then he tells her to take off her clothes when she lies down next to him. He wants her to be naked like him. With him. Muriel says she's too bashful. Then quickly resolves this problem by climbing on top of Macon and making love to him. ▪

10 13 2012—UNTITLED #10

I can't remember the last time I felt like I didn't imagine something. Invented someone who was not that someone. How do we know anything? How do we know anyone?

10 14 2012—LAISSEZ-ALLER

Walking home I think: It's possible that we both let our past experiences get in the way.

10 15 2012—UNTITLED #11

Do lovers who don't love each other sleep like they do?

10 16 2012—STATE OF AFFAIRS (ON EMOTIONAL SIMULACRA)

"You could have had her. But you adhered to a policy of destructive ambiguity, resulting in a broken window of opportunity. You didn't pounce, she fled, leaving you alone with the unseized moment. But that's all right: you can go home and masturbate about her instead."
–JOHN TOTTENHAM, *Antiepithalamia & Other Poems of Regret and Resentment*

10 16 2012—LOVE IS ALWAYS AN EVENT

"Event is the traumatic encounter which destabilizes your symbolic coordinates. Your universe."
–ŽIŽEK

10 17 2012—A PIECE IS ALWAYS MISSING

▪ PHOTO
Graffiti heart, NYC (2012).

10 18 2012—THIRD PERSON

Two people fall in love onscreen even though they often don't really know each other. But it works. It lasts. Over and over again in the history of fairytale cinema. Yet, without real knowledge or information, how and why does it work? How and why can it last? It's not simply because a movie is a fairytale and life isn't. It's because *we* know the people onscreen, we have information about who they are and what they want. So it is through and for us that love works. It is through our knowledge of the characters and their story that love becomes possible. The love is for us. Because of us.

10 18 2012—IT IS TOO LATE (MORE ON *HAMLET* AS THE BEGINNING OF ETHICS)

"*The problems of those who are waiting.*—It requires strokes of luck and much that is incalculable if a higher person in whom the solution of a problem lies dormant is to get around to action in time—to 'eruption,' one might say. In the average case it does *not* happen, and in nooks all over the earth sit people who are waiting, scarcely knowing in what say they are waiting, much less that they are waiting in vain. Occasionally the call that awakens—that accident which gives 'permission' to act—comes too late, when the best youth and strength for action has already been used by sitting still; and many have found to their horror when they 'leaped' that their limbs had gone to sleep and their spirit had become too heavy. 'It is too late,' they said to themselves, having lost their faith in themselves and henceforth forever useless. Could it be that in the realm of the spirit 'Raphael without hands,' taking this phrase in the widest sense, is perhaps not the exception to the rule? Genius is perhaps not so rare after all—but the five hundred *hands* it requires to tyrannize the kairos, 'the right time,' seizing chance by its forelock."
—NIETZSCHE, *Beyond Good and Evil* (Part Nine, Paragraph #274, "What is Noble")

10 18 2012—COME CUT ME OPEN (OF BLUE AND RED)

"Undisturbed,
my garden fills
with summer growth—
how I wish for one
who could push the deep grass aside."
—IZUMI SHIKIBU

▪ **ST. VINCENT**
Surgeon (2011)
LINK: http://youtu.be/Hw7UeOxTGuM

10 19 2012—FIRST THE PERSON

"I have a wider range as a human being than as a writer. (With some writers, it's the opposite.) Only a fraction of me is available to be turned into art."
—SUSAN SONTAG, (8/8/64)

10 20 2012—UNTITLED #12 (ONE GREW OLDER AND THE DREAM VANISHED)

"What in us really wants 'truth'?"
—NIETZSCHE, *Beyond Good and Evil* (Part One, Paragraph #1, "The Prejudices of Philosophers")

10 20 2012—ALL THE FIGURES OF GRIEF

"I would be there for 12, 14 hours at a time, completely lost in thought. Deb had left in this extraordinarily abrupt way. I have always coped with rejection really badly—I take it personally. I was in a rage and I wanted to discharge really unbearable feelings… I thought of suicide. I rang up friends saying, 'I think I need to kill myself.' I saw myself between two dark spaces. One dark space was suicide. The other was pretending to myself there was nothing wrong and carrying on my life without confronting that darkness. I had to be in that space where suicide was really an option for overcoming unbearable mental pain… A lot of people don't do that. They sidestep the pain, by taking pills or moving on or whatever. But I didn't think any of that would work. The pain would come back again and again if I didn't live in the grief. And the thought of it coming back was awful, unbearable. I'd rather have died… At college, I was told there were four great women novelists in the 19th century—Jane Austen, George Eliot, Charlotte and Emily Brontë. Not one of them led an enviable life—all of them had to sacrifice ludicrously in order to be writers. I wasn't prepared to do that. You could become ill so that you could retreat to the bedroom, avoid your domestic responsibilities and write like Emily Dickinson and Christina Rossetti. You had to forget about writing if you weren't prepared to sacrifice any other things you might want from life, like kids or lovers. It's not like that now."
—JEANETTE WINTERSON

10 21 2012—THE FUTURE IS NOT OURS TO SEE

George (Marton Csokas): "Will I see you again?"
Dawn (Charlotte Gainsbourg): "Who knows? Maybe. Life is long."
—*The Tree* (2010)

10 22 2012—UNTITLED #13: WHAT PEOPLE SAY

People say they love their lover more than they do.
Or, people say they love their lover less than they do.

I have met only a few people whose words and feelings are actually integrated and synchronized.

10 23 2012—UNTITLED #14 (THE DANGER OF THE FLIER)

NIETZSCHE, *Beyond Good And Evil*, (Part Two, Paragraph #41, On "The Free Spirit"):
"One has to test oneself to see that one is destined for independence and command—and do it at the right time. One should not dodge one's tests, though they may be the most dangerous game one could play and are tests that are taken in the end before no witness or judge but ourselves."

The right time. Kairos. When is that? When was that? When will that be?
It is ability + time. Knowing + time. Being + time. Becoming + time. The call + answer.
It equals ethics.

One should not dodge one's tests.

What Nietzsche writes later in "What is Religious," about Christianity and atheism; about asking and listening. About God not only not answering calls, but not hearing them, or even knowing *how* to answer them, much less in ways we can understand or decipher. But there is also the additional dilemma of whether we can recognize when our calls (prayers) are being answered.

Last week I went to see a Tarot card reader with a question about love at a moment when I had no more answers. She gave me an answer, but when I asked *when?*, she said, "If I told you when you would surely miss it."

How can I miss a call (or rather an answer to a call), I wondered, that I am waiting for? That I am ready to receive. This means that hearing—testing—is not simply a matter of preparation or Hameltian readiness. So what then? How one organizes all of the above (ability, time, knowing, ethics, readiness, preparation)? Pulls it together in (and from oneself) in time.

"One might get a hold of the truth *too soon*," Nietzsche writes, as well as too late (*Hamlet*).

See also Avital Ronell's *The Test Drive* on reality testing. On testing everything. On being tested. But also in(ter)dependence (and I'm not sure that Nietzsche, or other people for that matter, fully understand this) is learning how to be dependent, admitting to our need (not just desire) of the other. How to need and let oneself be needed. How the other is our marrow, our sustenance. How we must keep vigil and be vigilant about being called upon, taking tests, and answering calls. To be commanded not by authority or power, laziness or habit—vanity—but by love and valor. By being ("these burnt children") even what has been taken from us. What seems destroyed, exhausted, and irrevocably wounded. ▪

10 24 2012—UNTITLED #15: INCANTATION

"Say just one word and you'll save both my life and yours."
—PASOLINI, *The Decameron* (1971)

10 24 2012—THE TIME OF INTERMISSION (PREPARE THE COMING WINTER)

Here is the filmmaker Jacques Rivette being asked about that essential difference: the difference between life and cinema. Here he is dressed in blue, surrounded by blue. Even the question itself casts a blueness—on him, on us. A blue that suddenly comes up even though it's the inherent blueness that makes one address the question (where we find things, where we don't. How we live, how we don't. What comes true, what doesn't) in the first place.

▪ CLAIRE DENIS & SERGE DANEY
Jacques Rivette, The Night Watchman (1990)
TEXT: *as if your work was everything that we don't experience in life.*
LINK, PT1: http://youtu.be/NISesvOMpAA
LINK, PT2: http://youtu.be/Zl8YUCgg2Cs

10 25 2012—THE TIME OF INTERMISSION, PART II (TIME WILL NEVER BE THE SAME)

Film critic Serge Daney and filmmaker Jacques Rivette on Frank Capra's *It Happened One Night*, which is 105 minutes long:

JACQUES RIVETTE: Now I'm convinced that, to go from Miami to New York in a film that has the same intensity of situation and characters, a serious director couldn't do it in less than three hours. For the same journey. So the means of transport are actually slower nowadays than fifty years ago! It takes much longer now to go from Miami to New York than in 1934.

▪ SCREEN
Jacques Rivette, The Night Watchman (1990)
TEXT: *...as if your life was everything that we don't experience in life.*

SERGE DANEY: The difference is that someone like Capra knew how his story would end when he started. So the end presented no problems and on that basis he could invent a lot in between, either digressively or elliptically. But there came a time when, for certain basic reasons that we mentioned, moral reasons, it was impossible for a post-Antonionian director like you to start a

film knowing exactly how it would finish… That Evil would triumph over good…

JACQUES RIVETTE: The dénouement has become impossible.

SERGE DANEY: Without a dénouement time becomes cyclical or circular and films can last 1 hour, 2 hours, 3 hours, 10 hours. The story would be less problematic than the fact that we've lost sight of the word "FIN." Maybe only the Americans ever had it.

10 26 2012—THE TIME OF INTERMISSION, PART III (NO MORE OFF)

Last night I watched the second part ("Night") of Claire Denis' film on Jacques Rivette, *The Nightwatchman* (*Le veilleur*, 1990). In it was the following statement by Rivette on his first film, *Paris Belongs to Us*. When I heard it, I realized that it is the perfect epigram for my book *Screen to Screen*, because the dialectic described has vanished, leaving us with no off. Just constant screen.

"When you change faces, they're all changed in the same sort of way."
—CHARLOTTE RAMPLING

Some faces actually depend on time—need time—because without it, there is no beauty. No depth to (the) face. Charlotte Rampling's face did not express or show anything until it had lived through at least 50 years (for me, Rampling has always been the epitome of Anglo-Saxon haughtiness and inscrutability). Now it does something. Her face still holds too still and is much too feline for me, but there is more that moves and shows there now. Before her face did nothing. Rampling had a face that was looked at, as Woody Allen's *Stardust Memories* demonstrates, not a face that looked, or even showed what was inside. People like faces like that. Fashion models have faces like that. Women are supposed to have faces that receive. That take in. That mask.

▪ **WOODY ALLEN**
Stardust Memories (1980)
LINK: http://youtu.be/K3GOu0HuMP4

▪ **ANGELINA MACCARONE**
The Look - Trailer (2011)
LINK: http://youtu.be/I6rTbA5vgNI

In the documentary *Charlotte Rampling: The Look*, Paul Auster, a friend of Rampling's tells her: "If you look at the history of movies, let's be fair, it is the medium for men to watch beautiful women on big screens and to lust after them. And this is part of movie magic."

In *Stardust Memories*, the construction of cinema as a space for watching and fetishizing women is laid bare: it is literally men (theatergoers) looking at a man (Woody Allen) onscreen looking at himself looking at a beautiful woman/actress (Rampling). For Allen this cinematic matrix is not only magic, it is why he became a director and an actor in his own movies.

When it comes to lamenting age and beauty, we, both men and women alike, only lament women's age and beauty (Paul Auster: "Looking at a beautiful woman in her 50s and 60s is not the same as looking at a 17 year old girl. It just isn't"), as if a man doesn't lose anything. Doesn't age. Doesn't grow old. Doesn't get wrinkles or lose his hair, doesn't put on weight, doesn't stop being a boy the way a woman stops being a girl. The only difference is that we can't accept the changes that happen to women, but we can and do accept the changes that happen to men. We can't *move through time* (can't look forward, only back) with women, but we can and do move through time with men. The cultural practice of looking at women and obsessing over not just female beauty, but female youth—what women supposedly "lose" through time, both on and off the screen—is a universal. Everyone is invested in doing it. It's true, a woman is not the same thing as a girl. But neither is a man the same thing as a boy. We mourn one passage while celebrating another. ▪

10 28 2012—UNTITLED #16: TIME WON'T TAKE CARE OF IT

Years ago, I read a novel by Sarah Schulman in which she wrote that time doesn't heal wounds, resolution does. In the autobiographical documentary *Charlotte Rampling: The Look*, Rampling says something similar about being marked by pain. In Rampling's case, it is the brutal blow (the easiest way for a man to mark a woman with his pain) her character receives across the face in Sidney Lumet's *The Verdict* (one of the verdicts is that women apparently cannot be trusted).

Rampling: "When some form of behavior becomes impossible to accept, you have to take some form of action. You can't just let it go. It's cause and effect. If you do something that deserves to be punished then you have to accept some form of punishment, otherwise you can't actually move on. If you're unable to mark the moment by something, and you just run away from it—a lot of people run away because the emotional impact is too strong, and they're frightened of it, and they don't know how to confront it, and they don't know how to confront the other, so they just run away. And so they just leave it. And so they think, 'Well, life will take care of it. Or time will take care of it.' But it actually doesn't. Those things fester. Those things linger on in your body. You need to have it shaken out of you. Withdrawing won't protect you." ▪

10 28 2012—*AMOUR* (HANEKE)

▪ **SCREEN**
Amour (2012), Michael Haneke.

10 29 2012—ONSCREEN OFFSCREEN

"He ruined my career,
but he didn't ruin my life."
—TIPPI HEDREN, on Alfred Hitchcock

▪ **ALFRED HITCHCOCK**
The Birds (1963)
CLIP: "The Birds Final Attack Sequence
with Full Symphonic Score"
LINK: http://youtu.be/LwOFP9putKM

"America's dead. It's never been alive."
—DEREK JARMAN, *Jubilee* (1978)

· THE ADOLESCENTS
Kids of a Black Hole (1981)
LINK: http://youtu.be/ifq24lljbQM

10 30 2012—HANGING ON THE TELEPHONE (OH, WHY CAN'T WE TALK AGAIN?)

I don't know how I could have missed it, but this Blondie song might be the pop-answer/equivalent to heeding the metaphysical call in philosophy. Avital Ronell's *The Telephone Book*, Heidegger, Nietzsche, Rousseau, *Hamlet*, readiness is all, ethics, kairos, waiting, obsessive listening—everything I've written about all year—are all here in this song. A song I have loved as far back as high school, which means that what I want to hear, I have always wanted to hear. *"I want to tell you something you've known all along."*

· BLONDIE
Hanging On The Telephone (1978)
LINK: http://youtu.be/rIO5ZoTNXe8

People who know me well know that I often talk about the age seventeen. What happens to people after. I've cried over the loss of seventeen, thrown up over it, drunk, in front of people. Friends and lovers. This is a true (sob) story.

Last spring, in the woods at a writing retreat, a guy I had a bad affair with said to a friend there, A., "Why is she so upset about seventeen? What happened at seventeen?" Amazingly, A. actually knew how to answer this question while I drunkly wept about it in the bathroom.

The question is not what happened at seventeen, but what happened *to* seventeen.

I was a force to be reckoned with at seventeen. I would like to go back, not for the number, or its supposed youth. But for the way people are at that age. The time at hand. All the time in the world. To live a night. To be a person. To be with a person. To find a person.

The way people often lose their nerve after. Their passion. The way people get worn. Down.

But sometimes it's the other way around, too: you gain—actualize—your potential over time. Become seventeen over time. In an ideal world, we keep our teenage hearts and grow into everything else. Deepen everything else. Sink into our openness.

The other night, just before Hurricane Sandy hit New York, I picked up my old copy of Stendhal's *On Love*, which caught my eye, as I spotted it sitting on the bookshelf across from my bed. I opened the book to a random page and found this:

"Sensual love: Whilst out shooting, to meet a fresh, pretty country girl [or boy, my addition] who darts away into the wood. Every one knows the love founded on pleasures of this kind; however unromantic and wretched one's character, it is there that one starts at the age of sixteen."

It's not seventeen, but sixteen is damn close. The last time I had a sensual kiss, which was this summer at school, I pulled this man, H., into a wood behind my house, and asked him to kiss me there instead. To keep kissing me, as we'd already started to kiss in front of my building. Then I told him to lie down on the grass with me, and we did. And while we kissed each other, I could see the sky, the mountains, the stars, the trees, the moon. Him. A month later, back home, him in one city and me in another, H. told me that everything went downhill for him at eighteen. He told me this after I wrote to him about being seventeen, and just before being seventeen together faded from view. ∎

Why is Freud's statement below so difficult for me to accept? Transience is not a question of the loss of worth. On the contrary. It is the loss of something that was rare and beautiful, yet despite this could not find a way to endure. Moreover, something is not simply *more* beautiful, as Freud states, because it is transient. It is that ephemerality is more devastating when something worthy of longevity does not last.

"…what is painful may nonetheless be true. I could not see my way to dispute the transience of all things, nor could I insist upon an exception in favor of what is beautiful and perfect. But I did dispute the pessimistic poet's view that the transience of what is beautiful involves any loss in its worth. On the contrary! Transience value is scarcity value in time. Limitation in the possibility of an enjoyment raises the value of the enjoyment. It was incomprehensible, I declared, that the thought of the transience of beauty should interfere with our joy in it… These considerations appeared to me incontestable; but I noticed that I had made no impression either upon the poet or upon my friend. My failure led me to infer that some powerful emotional factor was at work which was disturbing their judgement, and I believed later that I had discovered what it was. What spoilt their enjoyment of beauty must have been a revolt in their minds against mourning. The idea that all this beauty was transient was giving these two sensitive minds a foretaste or mourning over its decease; and, since the mind instinctively recoils from anything that is painful, they felt their enjoyment of beauty interfered with by thoughts of its transience."
–FREUD, "On Transience," from *Writings On Art and Literature*

No reason ever was given.

▪ **NEW ORDER**
Senses (1981)
LINK: http://youtu.be/az1loyEX_VY

11 04 2012—ORDINARY HURT (*FOUR NIGHTS OF A DREAMER*)

Badiou would say the same thing.

▪ **SCREEN**
Four Nights of a Dreamer (1977), Robert Bresson.

• **SCREEN**
After The Wedding (2006), Susanne Bier.

"I just died. Remember how we used to just die?"

I first cited the quote above from the 1981 neo-noir *Eyewitness* in my book *Beauty Talk & Monsters* in the story "Peter & Pictures." It still seems fitting, as no one dies anymore. As everyone is already dead in some form or another and personality has become a thing of the past.

▪ **SCREEN**
Eyewitness (1981), Peter Yates.

II 06 2012—FACES #4: LLOYD DOBLER

▪ **SCREEN**
Say Anything (1989), Cameron Crowe.

11 07 2012—HEART HITS

"If you read the whole body [of his films], you will realize that there's a heart. H-E-A-R-T behind all of it. And I don't mean a kind heart. It's a heart that makes you react, that makes you remember, that stops you from forgetting."
—SAMUEL FULLER, on John Cassavetes

11 07 2012—ALL ABOUT LOVE

"They were all about love. They were about the loneliness—being without it in *Minnie and Moskowitz*. The tortured quality that you have when you love a man—in *Woman Under The Influence*—and he loves you, but it doesn't remain constant all of the time, and just about breaks the spirit of both of them. It's sorely tested. And the loss of love, which is in some of his later films. He really had many years to do that, and he did. He used them."
—GENA ROWLANDS, on John Cassavetes

11 08 2012—UNTITLED #17

A lifetime of meaningless sex can make you go numb.
A lifetime of passionate romances can make you go crazy.

11 10 2012—FACES #5: CRIES AND WHISPERS

The best thing about François Ozon's *8 Women* (his genre films really don't work for me) is the way the women look into the camera.

▪ SCREEN
8 Women (2002), François Ozon.

11 11 2012—IT WAS LATE AT NIGHT (PSYCHE TIME)

This blew my mind. Finally the words for what I feel about night—*night time and night life*—and spending the night with someone. A lover, which is not simply a person you have sex with. What I think it is to have spent the three nights (the whole night of each night) we spent together:

"Night time is psyche time… To spend the whole night with someone is agape: it is ethical… It may not be marriage, but it will be sacramental even without the benefit of sacraments."
—GILLIAN ROSE, *Love's Work*

11 12 2012—EX NIHILO NIHIL FIT (LAST WORDS ON X.)

"Imagine seeing each other and not even talking about this."
—HARRY BURKE, "Love Letters"

▪ **SCREEN**
Four Nights of a Dreamer (1971), Robert Bresson.

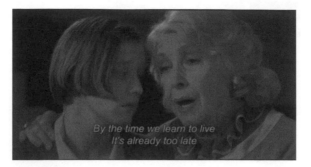

By the time we learn to live
It's already too late

▪ SCREEN
8 femmes (2002), François Ozon.

II 12 2012—JUDITH BUTLER ON LOVE: DOUBT IS NOT THE ANSWER

In Judith Butler's essay "Doubting Love" from the anthology *Take My Advice: Letters to the Next Generation from People Who Know a Thing or Two*, Butler identifies doubt as the primary relation to love. But I disagree. Doubt, or its bastardization, is precisely the position that the majority of people now hold when it comes to love, and we are currently stuck there. It is one thing when doubt becomes the paradigmatic starting point for trying to love more and to be more loving. If doubt were the springboard for examining our lack of faith, disbelief, paralysis, denial, cynicism, nihilism, and despair, it would be one thing. But it's not, as there is no shortage of disbelievers and doubters when it comes to love. But doubt is often the thing that keeps us where we are. From moving at all. We doubt so much, we never believe or act on faith.

I don't think love needs more doubt from us. I don't think doubt on its own is the answer to love. Doubt is often the way we perpetuate and increase our despair and let ourselves off the hook. If, however, doubt becomes the way we doubt our own limitations and capacity to love; our own openness and receptivity to love; our own sexist, racist, and homophobic conditionings and destructive relations to others—if, in other words, it makes us question the existence of things *as they are*—then yes, more doubt is needed. Doubt as part of the process of critical thinking and rigorous searching both inwardly and outwardly. But doubt can also be (and has been) corrupted and co-opted; used as a way to avoid, bypass, and brand thinking, feeling—much less loving—altogether. More often than not, for most of us—and for philosophers, too—so-called epistemological "doubt" is just an excuse for laziness, cynicism, and ambivalence. Doubt should not be taken lightly. It is both the cause and effect of precarity, and if it is not watched carefully, it will swallow everything else whole.

Yes, doubt is part of love, the way that doubt is part of life—part of everything. But there is

doubt that opens us and doubt that shuts us down. Doubt is part of the way people are increasingly bailing on everything, compulsively substituting one thing for another. Therefore doubt does not always equal deeper understanding and commitment, or *any* understanding or commitment—to anyone or anything. Or even to oneself. Often doubt means we don't give anything or anyone a chance. We dismiss everything. Doubters today *just* doubt—they don't care either way, they don't feel much apart from doubt—and they most certainly are not: "becom[ing] philosophical in and about one's passions."

But, it is true, for those of us who are *really* doubting in order to better understand, better love, "Love always returns us to what we do and do not know." And this opens us up and makes us surrender when surrender is needed. James Baldwin wrote that true lovers are as rare as true rebels, and I think the same is true for doubters. True doubters—doubters who are simultaneously engaged in life and with people, despite how difficult it is to do both, while also being deeply questioning—are equally rare.

Here are some passages from Butler's essay:
"On occasion when I am getting to know someone—when someone seeks to know me or, indeed, find in me the occasion for love—I am asked what my idea of love is, and I always flounder. There are clearly those who have their ideas of love, who enter into their conversations, their letters, their initial encounters with an idea of love in mind. This is admirable in a way. And I am somewhat embarrassed by the fact that I have no answer, and that I cannot, in the moment of potential seduction, [have] an entrancing view of love to offer the one with whom I speak. ...One knows love somehow only when all one's ideas are destroyed, and this becoming unhinged from what one knows is the paradigmatic sign of love."

And:
"[Freud] is the one who writes, 'A man who doubts his own love may, or rather, must doubt every lesser thing.' And this is the line I return to in my life, a line that cannot be read once, at least not by me. Freud is making a statement, but he is, implicitly, delivering as well a warning and an admonition. The one who doubts his own love will find himself doubting every lesser thing."

[...]
"There is no way around it: If you doubt your own love, you will be compelled to doubt every lesser thing and if there is no greater thing than love, you will be compelled to doubt every other thing, which means that nothing, really nothing, will be undoubted by you."

Where is the Kierkegaardian (Popova's write-up states that Butler describes herself as a "secular-Kierkegaardian when it comes to love") leap of faith in this? When it comes to love, I will stick with bell hooks, Alain Badiou, Roland Barthes, and Erich Fromm.

Here is a quote I like more. Paracelsus: "He who knows nothing, loves nothing. He who can do nothing understands nothing. He who understands nothing is worthless. But he who understands also loves, notices, sees... The more knowledge is inherent in a thing, the greater the love... Anyone who imagines that all fruits ripen at the same time as the strawberries knows nothing about grapes." ▪

"A call comes from within you and beyond you. A call is ontological and rooted in being. Your being is being called."
—AVITAL RONELL, *The Telephone Book*

11 15 2012—ANSWERING MACHINES: ON X. AND OTHERS

"Your mission, should you choose to accept it," writes Avital Ronell in *The Telephone Book*, "is to learn to read with your ears." We were in each other's ears, but never in each other's lives. Always tuned into each other. At the bar, at school, I sometimes only listened to other people as an excuse to "not" listen to X. His voice behind the curtain. In the background. Veiled behind the act—ours. Off in a room somewhere, even when I couldn't actually hear what he was saying. Even though we were always pretending not to hear each other. But he'd pop in and out of my conversations with people randomly, hanging on some overheard word, seguing in on it. There were no non-sequiturs with us, as we were all ears with each other. It's my ears that have always gotten off. I grew up to be the kind of woman who asked men to talk to her, right in the ear, right in the face, during sex. To talk at the moment when most people want to fall silent with each other. But no, I want to hear everything. To know everything. I want to be covered in words. Pinned down with words. Because "words land in the body" (Avital Ronell). And because hearing everything, especially when the lights are off, and I can't see, is what gives me the greatest pleasure. It's how I come. Listening for, as Ronell writes, "*that which resists presentation.*" What was I (and what was he; what were we to and with each other), but totally receptive (despite my violent resistance and rebuttal to that receptivity), vulnerable, and plugged into him from the start? And also totally unreceptive, or anti-receptive, to that total receptivity—what Kirkegaard refers to as an illusion that stands in the way. From the very first moment—picking up on all of his static, his airwaves, his glitches, his stutters, his looks, his absences, his interferences—how I didn't want the person who showed up to be the person who showed up. I didn't want it to be him, but I was also *made* to receive him, his silences and his white noise, which always resounded and sounded a high-pitched call. Until it stopped. Until I stopped hearing it. Where does it go when it goes? ▪

• PHOTO
The word 'love' grafittied across an entire building
(New York City, 2012).

11 16 2012—UNTITLED #18: I DON'T KNOW HOW WE MET

Sometimes you meet someone beautiful, so rarely beautiful, it's hard to look at them. Especially back at them. It's hard to imagine that once you looked at them and once they looked at you, and you were doing that together at the same time, and that is one of the great things to do with another person. It's hard to imagine you survived being looked at that way. Being with that way. How can you go without it the way you are going without it again? And that you laid together. And where does this go? Why does this go? How did it even happen? You don't know and you were there. You did it. Once you're no longer inside you are always back to being outside. How quickly that flips. How quickly you are looking in not knowing how you got in. Not just in, but right into the middle of things. How you got to be inside of something with someone. How what happened to you happened to you. How what happened feels like it will never happen again. How you don't remember how to do anything, not even the things you have done. How you are turned inside out thinking about how you were outside in. You think you'll never find your way into anything again. With anyone. How experience doesn't make you feel you remember the way. •

11 18 2012—DÉNOUEMENT

"I did love you once."
—*Hamlet*

Someone says they like you, but really they like everybody, which is really nobody. I hate this kind of person and this kind of person is everywhere these days and the people who like these kinds of people, who respond to them, and make it all so easy to continue, are everywhere too. And even when some person who likes everyone suddenly meets someone that they actually do like in a way that is unfamiliar, a game changer, in a way they're not used to liking anyone, in a way that they have forgotten or never known, they can't do anything about it because they don't know how to do anything about something or someone like this, because it is easier not to know, and they fuck it all up because, again, what do they, or anyone else for that matter, know about what to do these days with someone they actually like. So they go back to not liking anyone, to not caring either way, and the world is just fine and much easier this way. ▪

"However, *somebody* killed *something*: that's clear, at any rate—"
—LEWIS CARROLL, *Through The Looking-Glass*

I. BEGINNING

I was a pre-teen when Winona Ryder and Johnny Depp moved into a loft across the street from me in Tribeca, where I lived. An older neighbor friend, the sister of a classmate, told me they were living in her loft building, on the top floor. I went home and looked for them that very same day. I saw him at my corner deli, and on the street smoking, but never her. At night, I sometimes looked up at their windows and saw their lights on. The older friend said they had no furniture and seemed nice. Depp was not very impressive in person. Cute, but no big deal. His jeans had paint on them and his t-shirt had holes. You might not look at him unless you knew you were supposed to, which is really the singular difference between people onscreen and people off-screen: famous people are to be looked at.

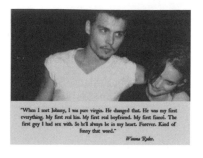

"When I met Johnny, I was pure virgin. He changed that. He was my first everything. My first real kiss. My first real boyfriend. My first fiancé. The first guy I had sex with. So he'll always be in my heart. Forever. Kind of funny that word."

Winona Ryder.

▪ **SCREEN**
He was my first everything. (Winona Ryder)

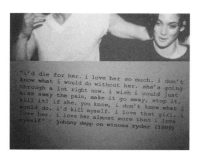

"i'd die for her. i love her so much. i don't know what i would do without her. she's going through a lot right now. i wish i could just kiss away the pain, make it go away, stop it, kill it! if she, you know, i don't know what i would do. i'd kill myself. i love that girl. i love her. i love her almost more than i love myself." — johnny depp on winona ryder (1989)

▪ **SCREEN**
I'd die for her. I love her so much. (Johnny Depp)

The story is Ryder didn't want to live in pre-gentrification Tribeca because it was too isolated and scary to her, so they moved out after only a few months. This is of course ridiculous. Who could be afraid of Tribeca, already considerably gentrified by the early 90s, unless they were supremely bougie? Ryder was supposed to be this bohemian girl; this down-to-earth hippie, who could live anywhere and had grown up on a California commune. But it turned out that the Lower West Side of Manhattan in the early 90s, primarily still a white artist's enclave at that point, was just too wild for her.

I loved Winona Ryder then. I, a weird-girl, could not believe that a weird-girl like her was on-screen when she showed up in *Beetlejuice* and *Heathers*. Her creaky voice, black eyes, and 1940s style dark hair, which she chose over her allegedly natural blonde. I even forgave Ryder her bad acting in period films like *The Age of Innocence*, *Dracula*, and *The House of The Spirits* because of how much her counter-image meant to me. Her look, her clothes, her early movies. Her boyish, impish, scruffy taxi driver in Jim Jarmusch's *Night on Earth*, before I even knew who Gena Rowlands was.

II. MIDDLE

Some actors are only made to play certain parts, revealing something about an age through their own age. Personal chronology becomes cultural chronology, and vice versa. Like John

Cusack, another black haired/pale skinned 80s/90s idol, as well as a youth actor whose great, and perhaps only gift, was to enact a different kind of youth (a counter-youth and counter-masculinity) in his youth. Winona Ryder was never *timeless*, she was *of the time*. Most especially that *brief* time in *her* life, her teenage years and early twenties. Perhaps this is why Jake Gyllenhaal's light hair was dyed jet-black for the retroactive—80s—*Donnie Darko*, and Christian Slater's jet-black for *Heathers*. Something about dark hair showing up in the late 80s and early 90s as a form of retribution for an aesthetically fascistic and representationally narrow decade. These are people who were not kissed by the sun, who were not California Dreamin,' or, as the German writer Heinrich Laube puts it, "These pale youths are uncanny, concocting God knows what mischief."

III. END

In 1989, Winona Ryder and Johnny Depp, a couple, both made public declarations about each other in the press:

> **WINONA RYDER:** "When I met Johnny, I was pure virgin. He changed that. He was my first everything. My first real kiss. My first real boyfriend. My first fiancé. The first guy I had sex with. So he'll always be in my heart. Forever. Kind of funny that word."

> **JOHNNY DEPP:** "I'd die for her. I love her so much. I don't know what I would do without her. She's going through a lot right now. I wish I could just kiss away the pain, make it go away, stop it, kill it! If she, you know, I don't know what I would do. I'd kill myself. I love that girl. I love her. I love her almost more than I love myself."

A couple of years later, Ryder and Depp broke up. Even though it didn't last, and they didn't die (or who knows, maybe they did. Ryder certainly died in some ways, and Depp did too, in his ways), here they are, two Hollywood stars at the top of their game, saying this about each other in print. Talking about dying when, according to Hollywood, which considers itself reason enough to live, these two have *everything*—not just *each other*—to live for. Today public relations would nuke a statement like this. Today no one ever takes old words lost to lost worlds like "die" and "forever" seriously. Nor would anyone even think to publically state this about someone else, someone they love, let alone an actor in print. Today public relations would tell—or worse, would no longer have to—Ryder and Depp not to talk like that in public because talking like that is morose and alienates fans, especially when the lovers in question are young, famous sex symbols. Can we imagine two actors saying this today, killing their burgeoning careers with melodramatic words like forever and die, when most celebrity couples won't even discuss their love lives, let alone admit to dying over a breakup? For a while, Gwyneth Paltrow, once good friends with Ryder, talked about her first big love, Brad Pitt, this way. But after they broke up, and she became a seasoned actor both on and off the screen, Paltrow, like Depp and Ryder, stopped talking like that, stopped talking about love period, which means that maybe a part of Paltrow stopped being able to feel that way. After all, how one talks is also how one lives.

By the end of Depp's public declaration of love for Ryder, however, the promise of forever is shattered. Depp admits that he loves Ryder "almost more" than he loves himself. The admission

is a red flag, a glitch in the love story, despite his "Winona Forever" tattoo, which he later edited to "Wino Forever." On the surface—the famous tattoo—Depp is literally able to drop his object of desire and replace it with something else, in this case, addiction. This is hardly surprising given the preemptive mourning Depp does in his account of Ryder, anticipating and engraving loss into his relationship at the very pinnacle of their love. If, as Freud argues in *Mourning and Melancholia*, melancholy is mourning in advance, the tattoo amendment itself is an affect of grief. Melancholy foreshadows mourning. As Avital Ronell and Jacques Derrida have shown us, inscription and encryption, addiction and dependency, are close relatives and stand-ins for one another. Even before Depp actually lost Winona he was *expecting* to lose her. Maybe even trying to. In the case of Depp's tattoo, forever endures as the only constant. It is what comes before and after forever that changes, and it is the addict who gets away with breaking his word. In "Wino Forever," inscription and encryption are updated and reframed more broadly as *addiction forever*. In *Crack Wars*, Ronell writes that "drugs resist conceptual arrest… Precisely because they are everywhere and can be made to do, or undo, or promise, anything. They participate in the analysis of the broken word." In order to break the promise of love—of forever—the addict steps in as the figure of unreliability. Just as melancholy is mourning *in advance*, the addict is the person you were never meant to depend on or trust; whose promise is broken in advance. In the end, this isn't a 19th Century novel, it is late 20th Century Hollywood, and Depp is, or was, a modern bad-boy and an expensive commodity who, at least professionally, out-lived Ryder (he has the tattoo to prove it), and that means some people can't afford to die. They can only pretend to. ▪

11 23 2012—FACES #6: *CLAIRE'S KNEE*

▪ SCREEN
Claire's Knee (1970), Éric Rohmer.

11 24 2012—THE DIALECTIC OF FAILURE

Talking to friends, reading books, watching movies—the same regrets, laments, and hopes come up over and over. The loop of being. The loop of asking questions for which there are sometimes no answers:

What if I never become what I want to become?

Or, what if I will never again be what I once was?

11 27 2012—UNTITLED #19

Let's face it. People can live without each other. Or, maybe they can't as Derrida would say, and that's why they do.

11 27 2012—MOURNING AND MELANCHOLIA, PART VI

"Embarrassed and almost guilty because sometimes I feel that my mourning is merely a susceptibility to emotion. But all my life haven't I been just that: *moved*?"
—ROLAND BARTHES, *Mourning Diary*

11 29 2012—UNTITLED #20: YOU DON'T ALWAYS HURT THE ONE YOU LOVE

You don't always hurt the one you love. That isn't at all true. Or it is true, but shouldn't be.

Whenever my mother consoles me about something and I thank her for it, she says, "I just love you." As if there is nothing to her kindness, or to love. She has always been a lover. The one who taught me everything about loving. For my mother, loving someone means just that: loving them.

Re-reading Roland Barthes' *Mourning Diary* tonight. In it, at the middle point of the book, Barthes writes something about his mother that I can say about my own:

"And I think: *Maman taught me you cannot make someone you love suffer.*
She never made anyone she loved suffer. That was her definition, her 'innocence'." ▪

11 29 2012—UNTITLED #21: MOURNING AND MELANCHOLIA, PART VII

1. "My emotional life: dialectic between craving for privacy and need to submerge myself in a passionate relationship to another."
–SUSAN SONTAG, *Reborn: Journals and Notebooks*, 1947-1963

2. "Exploration of my (apparently vital) need for solitude: and yet I have a (no less vital) need of my friends."
–ROLAND BARTHES, *Mourning Diary*

11 29 2012—UNTITLED #22

In *The Bluest Eye*, Toni Morrison writes (and I have quoted this many times), "Love is never any better than the lover. Wicked people love wickedly, violent people love violently, weak people love weakly, stupid people love stupidly. There is no gift for the beloved. The lover alone possesses his gift of love."

In *Mourning Diary*, Roland Barthes writes (he is speaking of emotional intelligence), "…intelligence is everything that permits us to live superlatively with another person."

This is where *knowing* how to treat someone well and *wanting* to treat someone well converge. ▪

II 29 2012—UNTITLED #23: ALL ALONE

What is adulthood but learning how to split up with people?

II 29 2012—NO SHORTAGE OF ROMANCE (ONCE IN A WHILE TWO PEOPLE MEET)

I was 14. You were 16. We could barely agree on anything. We were in love but didn't say so. Eventually you said so, but I didn't. You never forgave me. And there were all the things I couldn't forgive you for, which is why I never took you back. Lots of other things happened as well as nothing. In short: life. I don't know who ends up together or why anymore. This is a hard thing to live with. Yet another hard thing to live with. On the fire escape one night, in the middle of winter, at 14 and 16, we were sharing a cigarette at your house and this song came on the radio and it turned out we both liked it, and the feeling it gave me, was like the song itself. ▪

▪ **THE PRETENDERS**
Don't Get Me Wrong (1986)
LINK: http://youtu.be/P6u9C_SH3mQ

11 30 2012—THERE ARE BLUES (THERE IN YOU)

…There was you
…Then there was you.

…There in you
Then there was you.

• **BRIAN ENO**
Third Uncle (1974)
LINK: http://youtu.be/yai4bier1oM

11 30 2012—ON WHAT HAPPENS NEXT: I WANT THE FUTURE, BUT I ALSO WANT TO HOLD ON TO THE PAST

Freud's *Mourning and Melancholia* is at the heart of this. How do we not let go and let go? We always go too far either way. We hold on too much or we don't hold on at all. Can we do both at the same time? Can we want what we have and not want what we don't (that is, what we don't need)? If we only look ahead, if we only forget (or try to), it is a disaster. If we only look back, if we don't see what or who is in front of us as a chance to move forward when that chance is in front of us, it is a disaster. This is the heart of the matter.

Adam Phillips & Leo Bersani, *Intimacies*:
"What we call love is our hatred of the future; and it is because other people represent our future as objects of desire, what might happen to us next, we fear them." ▪

12 02 2012—LOST GIRLS: PICNIC AT HANGING ROCK

In *Picnic At Hanging Rock*, women—girls—disappear in(to) their quest for knowledge. The apple as rock. The rock as apple. A woman's search for knowledge in this world makes her go missing. Makes her invisible. To whom can she say what she knows? What she wants? To whom can she give what she has? Who will take her in and who will give her a place to live? She is as good as gone. As good as lost. As good as mad. This is just one theory. ▪

• **SCREEN**
Picnic at Hanging Rock (1975), Peter Weir.

This face (from the 2011 political drama *The Ides of March*) reminds me of this face (from the 1996 political drama *City Hall*).

It's the face of realizing what you believed, what you believed *in*, is a lie. It's the face of idealism shattered. Justice and injustice weighed on the scales of these two human faces that remind me of Falconetti's face in Dreyer's *Joan of Arc* and Deleuze's cinema-as-belief-in-this-world in *Cinema 2*. Cusack and Gosling are similar in this way. They don't just act with their faces (or, in Gosling's case, with the body. Cusack is an actor who in some sense has disavowed his body on screen), but are with their faces. Some actors are for belief in this world. We believe in Cusack and Gosling as actors because both play men who believe in the world they live in, even when they stop believing. ▪

▪ **SCREEN**
This face: Ryan Gosling in *Ides of March* (2011), directed by George Clooney.

▪ **SCREEN**
Reminds me of this face: John Cusack in *City Hall* (1996), directed by Harold Becker.

12 02 2012—INTO THE WILD (BLOODY SAM)

Sam Peckinpah understood one thing very well: everyone is afraid, and should be afraid, of men—a world of men—including other men. *Straw Dogs* is about this. How dangerous men are. How dangerous certain men are to certain men, and to all women. When Paul Schrader, another dangerous man, said: "The power of *The Wild Bunch* is that Peckinpah says look, 'I know this is an anachronism, I know this is fascist, I know this is sexist, I know this is evil and out of date, but God help me, I love it so," he might as well have been describing *Taxi Driver*. Schrader himself has admitted that if he had not written about Travis Bickle he would have become him. But I think he was able to write him *because* he was him (read Peter Biskind's *Easy Riders, Raging Bulls* for details). Like Schrader, who invented Bickle to commit or expunge his own violence, Dustin Hoffman's David Sumner in *Straw Dogs* psychically conjures up the violent fury of the men who intimidate, harass, and brutally attack him and his wife. In the end, David "gets them all," as he puts it to himself, to secure his own status as a man/husband in control. In *Straw Dogs*, "non-violent" (non-violence is a construct of domestication and socialization, the film says) men have to redeem themselves—their masculinity—with violence. In order to go back to being non-violent, which Peckinpah thinks is impossible, David must first prove that he has real violence in him. ▪

12 03 2012—BELIEF IN THIS WORLD

All of my work. All of my life. Is this.

"The modern fact is that we no longer believe in this world. We do not even believe in the events which happen to us, love, death, as if they only half concerned us. It is not we who make cinema; it is the world which looks to us like a bad film. Godard said, about *Bande à part*: 'These are people who are real and it's the world that is a breakaway group. It is the world that is making cinema for itself. It is the world that is out of synch; they are right, they are true, they represent life. They live a simple story; it is the world around them which is living a bad script.' The link between man and the world is broken. Henceforth, this link must become an object of belief: it is the impossible which can only be restored within a faith. Belief is no longer addressed to a different or transformed world. Man is in the world as if in a pure optical and sound situation. The reaction of which man has been dispossessed can be replaced only by belief. Only belief in the world can reconnect man to what he sees and hears. The cinema must film, not the world, but belief in this world, our only link. The nature of the cinema has often been considered. Restoring our belief in the world—this is the power of modern cinema (when it stops being bad). Whether we are Christians or atheists, in our universal schizophrenia, *we need reasons to believe in this world*."
–DELEUZE, *Cinema 2: The Time-Image*

12 03 2012—UNTITLED #24

I want to be saved. Not in the way men are supposed to save women. But in the way we are supposed to save each other.

"We both thought it was all over."

▪ SCREEN
Claire's Knee (1970), Éric Rohmer.

NOTES

Parts of this text have been previously published by the following:

"Solace"—*TINA*, 2009 (In French) and *Specter Magazine*, Oct 2011

"A Time to Fall"—*Anobium*, May 2012

"I Love You Till Goodbye"—*Two Serious Ladies*, May 2012

Excerpts of "One Dimensional Feminism," "As Seen On TV," "Kill Joy"—*make/shift magazine*, Sept 2012

"Ever Since This World Began"—*Berfrois*, Oct 2012

"Sonic Heart (Genealogy in Song)"—*Berfrois*, Oct 2012

"Ghost World (Like A Bad Dream)—*The New Inquiry*, Nov 2012

"Notes on Fame (Do You Know Who You Ae?)"—*Berfrois*, Nov 2012

"Johnny & Winona (Die With Me)"—*Berfrois*, December 2012 and *The White Review*, February 2013

Excerpt from "One-Minute Lovers,"—*The New Inquiry, Time issue, #14*, March 2013 and *Encyclopedia Vol. 3 L-Z*, Encyclomedia Press, 2014.

PUBLISHER/SPECIAL THANKS

Masha Tupitsyn
X.
& Tim Reid, for help and support.

REFERENCES

A Man Escaped or: The Wind Bloweth Where It Listeth. Dir. Robert Bresson. Gaumont Film Company, 1956.

Acker, Kathy. *Don Quixote: A Novel*. Grove Press, 1994.

Acker, Kathy. *Literal Madness: Three Novels: Kathy Goes to Haiti; My Death My Life by Pier Paolo Pasolini; Florida*. Grove Press, 1994.

Ahmed, Sarah. "Feminist Killjoys (And Other Willful Subjects)." The Scholar & Feminist Online, 2010. Web.

Ashes of Time. Dir. Wong Kar-wai. Jet Tone Production, Block 2 Pictures, Scholar Films Company, 1994.

Badiou, Alan. "Alan Badiou: A Life In Writing." Stuart Jeffries, *The Guardian*. May 2012. Print.

Badiou, Alan. Tr. by Peter Bush. *In Praise of Love*. Serpent's Tail (London), 2012.

Barthes, Roland. "The Greatest Cryptographer of Contemporary Myths Talks About Love." Interview by Philippe Roger. *Playboy*, 1977. Print.

Barthes, Roland. Tr. by Richard Howard. *Roland Barthes by Roland Barthes*. Hill and Wang, 2010.

Barthes, Roland. Tr. by Richard Howard. *A Lover's Discourse*. Hill and Wang, 1979.

Barthes, Roland. Tr. by Richard Howard. *Mourning Diary*. Hill and Wang, 2010.

Baudrillard, Jean. "The Spirit of Terrorism." *Le Monde*, 2001. Web.

Bauman, Zygmunt. *Consuming Life*. Polity Press, 2007.

The Beat. "Too Nice To Talk To (Dubweiser)." Go-Feet Records, 1980. 7-inch record.

Beckett, Samuel. "All Strange Away." *Rockaby and Other Short Pieces*. Grove Press, 1981.

Beckett, Samuel. *The Letters of Samuel Beckett:, Volume 2; Volumes 1941-1956*. Cambridge University Press, 2011.

Berger, John and Anne Michaels. *Railtracks*. Go Together Press, 2011.

Bersani, Leo and Adam Phillips. *Intimacies*. University of Chicago Press, 2010.

Björk. "Unravel." *Homogenic*. Elektra, 1997. MP3.

Blue. Dir. Derek Jarman. 1993. Film.

Bordo, Susan. *The Male Body: A New Look at Men in Public and in Private*. Farrar, Straus and Giroux, 2000.

Brenez, Nicole. "The Ultimate Journey: Remarks on Contemporary Theory." *Art Press: un second siècle pour le cinéma, hors-série 14*, 1993.

Bresson, Robert. Tr. Jonathan Griffin. *Notes on Cinematography*. Urizen Books, 1977.

Bulgakov, Mikhail. *The Master and Margarita*. Vintage, 2006.

Burke, Harry. "Love Letters." Rhizome.org, 2012. Web.

Bush, Kate. "Oh To Be In Love." *The Kick Inside*. EMI, 1978. MP3.

Butler, Judith. *Precarious Life: The Powers of Mourning and Violence*. Verso, 1996.

Butler, Judith. "Doubting Love." *Take My Advice: Letters to the Next Generation from People Who Know a Thing or Two*. Editor: James L. Harmon. Simon & Schuster, 2007.

Carroll, Lewis. *Through the Looking-Glass*. 1871.

Carson, Anne. *Eros the Bittersweet*. Dalkey Archive Press, 1998.

Carson, Anne. *Grief Lessons*. New York Review Books Classics, 2008.

Carson, Anne. "The Glass Essay." *Glass, Irony and God*. New Directions, 1995.

Carson, Anne. "Untitled (Flannery)." *Unsaid Magazine* (Issue 4), 2009. Web.

Certified Copy. Dir. Abbas Kiarostami. Abbas Kiarostami Productions, 2010.

Charity, Tom. "Oliver Assayas: Cassavetes, Posthumously." *John Cassavetes: Lifeworks*. Omnibus Press, 2001.

Charlotte Rampling: The Look. Dir. Angelina Maccarone. Prounen Film, 2011.

Cioran, E.M.. *On the Heights of Despair*. University of Chicago Press, 1996.

City Hall. Dir. Harold Becker. Columbia Pictures, 1996.

Claire's Knee. Dir. Éric Rohmer. Les Films du Losange, 1970.

The Clash. "Long Time Jerk." *Rock the Casbah*. Epic, 1982. MP3.

Comedians in Cars Getting Coffee. "A Taste of Hell from on High." Dir. Jojo Pennebaker. Sony Pictures Television, 2012.

Cría Cuervos. Dir. Carlos Saura. Elías Querejeta Producciones Cinematográficas S.L., 1976. Film.

Culture Club. "Time (Clock of the Heart)." Virgin, 1982. 7-inch record.

The Cure. "Untitled." *Disintegration*. Elektra, 1989. MP3.

Days of Being Wild. Dir. Kar Wai Wong. In-Gear Film, 1990. Film.

The Decameron. Dir Pier Paolo Pasolini. United Artists, 1971.

Deleuze, Gilles. *Cinema 2: The Time-Image*. University of Minnesota Press, 1989.

Deleuze, Gilles. Tr. by Mark Lester, Charles Stivale. *The Logic of Sense*. Columbia University Press, 1990.

Deleuze, Gilles and Felix Guattari. Tr. by Brian Massumi. *A Thousand Plateaus: Capitalism and Schizophrenia*. University of Minnesota Press, 1987.

Deliverance. Dir. John Boorman. Warner Bros., 1972. Film.

Derrida, Jacques. Tr. by Barbara Johnson. "Plato's Pharmacy." *Dissemination*. University of Chicago Press, 1983.

Derrida, Jacques. Tr. by Alan Bass. *The Post Card: From Socrates to Freud and Beyond*. Universty of Chicago Press, 1987.

Derrida, Jacques. *Specters of Marx: The State of the Debt, The Work of Mourning & the New International*. Routledge, 2006.

Derrida, Jacques. *The Politics of Friendship*. Verso, 2006.

Dewhurst, Robbie. "A Philosophy of Surrender." Semiotexte, 2006. Web.

Dick, Philip K.. *Do Androids Dream of Electric Sheep?* Del Rey, 1996.

Dika, Vera. "From Dracula-With Love." *The Dread of Difference: Gender and the Horror Film*. Editor: Barry Keith Grant. University of Texas Press, 1996.

Drive. Dir. Nicolas Winding Refn. FilmDistrict, 2011. Film.

Dufourmantelle, Anne. Tr. by Catherine Porter. *Blind Date: Sex and Philosophy*. University of Illinois Press, 2007.

Dyer, Geoff. *Zona: A Book About a Film About a Journey to a Room*. Pantheon, 2012.

Eno, Brian. "Third Uncle." *Taking Tiger Mountain (By Strategy)*. Island, 1974. MP3.

Easy Rider. Dir. Dennis Hopper. Columbia Pictures, 1969. Film.

Feuerbach, Ludwig. *Principles of the Philosophy of the Future*. Hackett, 1986.

Freud. "Mourning and Melancholia." 1917.

Freud. "On Transcience." *Writings On Art and Literature*. Stanford University Press, 2007.

Gass, William. *On Being Blue: A Philosophical Inquiry*. David R Godine, 1991.

Gloria. Dir. John Cassavetes. Columbia Pictures, 1980. Film.

Gombrowicz, Witold. *Fredydurke*. Yale University Press, 2000.

Goyte. "Sombody That I Used To Know." Eleven, 2011. MP3.

Gut Renovation. Dir. Su Friedrich. Outcast Films, 2012. Film.

Guyotat, Pierre. Tr. by Noura Wedell. *Coma*. Semiotexte, 2011.

Hamlet. Dir. Laurence Olivier. Two Cities, 1948. Film.

Hanna, Kathleen. "Kathleen Hanna." Interview by Laurie Weeks. *Index Magazine*, 2000. Web.

Harvey, P.J. and John Parish. "Cracks in the Canvas." *A Woman a Man Walked By*. Island Records, 2009.

Hedren, Tippi. "Tippi Hedren: Alfred Hitchcock Ruined Career, Not Life." *Huffington Post*, Aug 1 2012. Web.

Heidegger, Martin. *What Is Called Thinking?* Harper Perennial, 1976.

Hobbs, Angie. "Other Self: An Interview with Angie Hobbs." Interview by Jeffrey Kastner, Sina Najafi. *Cabinet Magazine*, Winter 2009/10. Print.

Holmes, Linda. "What Sleepless in Seattle Taught Me About Love in the Movies." NPR: Monkey See, 2012. Web.

hooks, bell. *All About Love: New Visions*. William Morrow & Company, 2009.

hooks, bell. *Communion: The Female Search for Love*. William Morrow & Company, 2002.

hooks, bell. *Outlaw Culture: Resisting Representations*. Routledge, 2006.

Howe, Fanny. "After Watching Klimov's Agoniya." *Come and See*. Graywolf Press, 2011.

Howe, Fanny. *The Wedding Dress: Meditations on Word and Life*. University of California Press, 2007.

The Ides of March. Dir. George Clooney. Cross Creek Pictures, 2011. Film.

"The Independent Women." *America in Primetime*. PBS, 2011. Documentary film.

James Baldwin: From Another Place. Dir. Sedat Pakay. Hudson Film Works, 1973. Documentary film.

Jarman, Derek. "Green Fingers." *Chroma: A Book of Color*. University of Minnesota Press, 2010.

(Saint) John of the Cross. "Dark Night of the Soul." 1578-1579. Poem.

Joy Division. "Decades." *Closer*. Factory Records, 1980. MP3.

Jubilee. Dir. Derek Jarman. 1978. Film.

Key Largo. Dir. John Huston. Warner Bros., 1948. Film.

Kierkegaard, Søren. *Fear and Trembling*. 1843.

Kobek, Jarett. *ATTA*. Semiotexte, 2011.

Kraus, Chris. *Summer of Hate*. Semiotexte, 2012.

Lancelot du lac. Dir. Robert Bresson. Mara Films, 1974. Film.

Levinas, Emmanuel. "Peace and Proximity." *Basic Philosophical Writings*. Editors: Adriaan T. Peperzak, Simon Critchley, Robert Bernasconi. Bloomington: Indiana University Press, 1996.

Lim, Bliss Cua. *Translating Time: Cinema, the Fantastic, and Temporal Critique*. Duke University Press, 2009.

Lindahl, Elder. "Face to Face" (2002). Pietisten.org. Web.

The Long Goodbye. Dir. Robert Altman. Lion's Gate Films, 1973. Film.

Lost Highway. Dir. David Lynch. Lost Highway Productions, 1997. Film.

Máncora. Dir. Ricardo de Montreuil. Napoli Pictures, 2008. Film.

Marriage Italian Style. Dir. Vittorio De Sica. Les Films Concordia, 1964. Film.

Maximo Park. "The Coast is Always Changing." Warp Records, 2004. MP3.

Mayer, Jed. "Raised in Fear: Phantasm and the Uses of Enchantment." IndieWire: Press Play, 2012. Web.

McCabe & Mrs. Miller. Dir. Robert Altman. Warner Bros., 1971. Film.

McCarthy, Andrew. *The Longest Way Home*. Free Press, 2012.

Medianeras (Sidewalls). Dir. Gustavo Taretto. INCAA, 2011. Film.

Mickey and Nicky. Dir. Elaine May. Paramount Pictures, 1976. Film.

Montaigne, Michel de. "On Friendship." 1533-1592.

Morrison, Toni. *The Bluest Eye*. Vintage, 2007.

The Music of Chance. Dir. Philip Haas. Transatlantic Entertainment, 1993.

Nancy, Jean-Luc. Tr. by Sarah Clift. *God, Justice, Love, Beauty: Four Little Dialogues.* Forham University Press, 2011.

Nancy, Jen-Luc. Tr. by Charlotte Mandell. *Listening*. Fordham University Press, 2007.

Negri, Antonio. *Negri on Negri: In Conversation with Anne Dufourmentelle*. Routledge, 2003.

New Order. "Age of Consent." *Power, Corruption & Lies*. Factory Records, 1983. MP3.

New Order. "Senses." *Movement*. Factory Records, 1981. MP3.

Nietzsche, Friedrich. *Beyond Good and Evil*. 1886.

Nietzsche, Friedrich. *Thus Spoke Zarathustra: A Book for All and None*. 1883-1885.

The Nightwatchman (Le veilleur). Dir. Claire Denis. Arte, 1988. Documentary film.

O'Connor, Flannery. *Wise Blood*. Farrar, Straus and Giroux, 2007.

The Passion of Joan of Arc. Dir. Carl Dreyer. Société générale des films, 1928. Film.

Powers, Nina. *One Dimensional Woman*. ZeroBooks, 2009.

Pretenders. "Tattooed Love Boys." *Pretenders*. Sire, 1980. MP3.

The Price of the Ticket. Dir. Karen Thorsen. American Masters, 1989. Documentary film.

Red Hollywood. Dir. Thom Andersen and Noël Burch. Thom Andersen and Noël Burch, 1996. Documentary film.

Rilke, Rainer Maria. Tr. by Robert Bly. *Selected Poems of Rainer Maria Rilke*. Harper & Row, 1981.

Ronell, Avital. *Crack Wars: Literature Addiction Mania*. University of Illionois Press, 2004.

Ronell, Avital. *Loser Sons: Politics and Authority*. University of Illinois Press, 2012.

Ronell, Avital. *The Telephone Book: Technology, Schizophrenia, Electric Speech*. University of Nebraska Press, 1991.

Rose, Gillian. *Love's Work: A Reckoning with Life*. Schocken, 2007.

Rousseau, Jean-Jacques. Tr. by Judith McDowell. *La Nouvelle Héloïse: Julie, or the New Eloise : Letters of Two Lovers, Inhabitants of a Small Town at the Foot of the Alps*. Pennsylvania State University Press, 1986.

Rousseau, Jean-Jacques. *Reveries of the Solitary Walker*. Penguin Classics, 1980.

Sanderson, Mark. *Don't Look Now (BFI Classics)*. British Film Institute, 2002.

Say Anything. Dir. Cameron Crowe. Twentieth Century Fox Film, 1989. Film.

Schulman, Sarah. *Empathy*. Arsenal Pulp Press, 2006.

Schulman, Sarah. *The Gentrification of the Mind: Witness to a Lost Imagination*. University of California Press, 2012.

Shadow of a Doubt. Dir. Alfred Hitchcock. Universal, 1943. Film.

Shikibu, Izumi. "Untitled Poem." Tr. by Jane Hirshfield. *The Ink Dark Moon: Love Poems by Onono Komachi and Izumi Shikibu, Women of the Ancient Court of Japan*. Vintage Classics, 1990.

Smith, Elliott. "Pitseleh." *XO*. DreamWorks Records, 1998. MP3.

The Smiths. "William It Was Really Nothing." Rough Trade, 1984. 7-inch record.

The Smiths. "You Got Everything Now." *The Smiths*. Rough Trade, 1984. MP3.

Sontag, Susan. "Camus Notebooks." *Against Interpretation: And Other Essays*. Picador, 2001.

Sontag, Susan. *Reborn: Journals and Notebooks, 1947-1963*. Farrar, Straus and Giroux, 2008.

Stendhal. *De L'Amour*. 1822.

The Stills. "Fevered." *Logic Will Break Your Heart*. Vice Records, 2003. MP3.

Stone, Rob. *Spanish Cinema*. Pearson Education, 2002. MP3.

Strauss, David Levi. "Nikons and Icons." *Bookforum*. 2007. Print.

Straw Dogs. Dir. Sam Peckinpah. ABC Pictures, 1971. Film.

The Strokes. "Take It Or Leave It." *Is This It*. RCA, 2001. MP3.

Sunset Boulevard. Dir. Billy Wilder. Paramount Pictures, 1950. Film.

Taïa, Abdellah. Tr. by Frank Stock. *An Arab Melancholia*. Semiotexte, 2012.

Talking Heads. "Once in a Lifetime." *Stop Making Sense*. Sire, 1984. MP3.

Thieves Like Us. "Headlong Into the Night." *Play Music*. Shelflife Records, 2009. MP3.

Tiqqun. Tr. by Ariana Reines. *Preliminary Materials for a Theory of the Young-Girl*. Semiotexte, 2012.

Tottenham, John. *Antiepithalamia & Other Poems of Regret and Resentment*. Penny-Ante Editions, 2012.

Touch of Evil. Dir. Orson Welles. Universal, 1958. Film.

The Towering Infero. Dir. John Guillermin. Warner Bros., 1974. Film.

The Tree. Dir. Julie Bertuccelli. Screen Australia, 2010. Film.

Tupitsyn, Masha. *Beauty Talk & Monsters*. Semiotexte, 2007.

Tupitsyn, Masha. *LACONIA: 1,200 Tweets on Film*. Zero Books, 2011.

Tupitsyn, Victor. "The Genealogy of Failure." *KhZh (Moscow Art Journal)*, no.85 (December), 2012.

Vincent & Theo. Dir. Robert Altman. Arena Films, 1990. Film.

The Verdict. Dir. Sidney Lumet. Twentieth Century Fox Film, 1982. Film.

Vertigo. Dir. Alfred Hitchcock. Paramount Pictures, 1958. Film.

The Walkmen. "The Rat." Record Collection, 2004. 7-inch record.

Walser, Robert. *The Walk*. Tr. by Susan Bernofsky. New Directions, 2012.

Weber, Samuel. *Theatricality as Medium*. Fordham University Press, 2004.

Winterson, Jeanette. "Jeanette Winterson." Interview by Chitra Ramaswamy. *The Scotsman*, 2011. Web.

Winterson, Jeanette. *The PowerBook*. Vintage, 2011.

Winterson, Jeanette. *Written on the Body*. Vintage, 1994.

The Wizard of Oz. Dir. Victor Fleming. MGM, 1939. Film.

Zaborowska, Magdalena J.. *James Baldwin's Turkish Decade: Erotics of Exile*. Duke University Press Books, 2009.